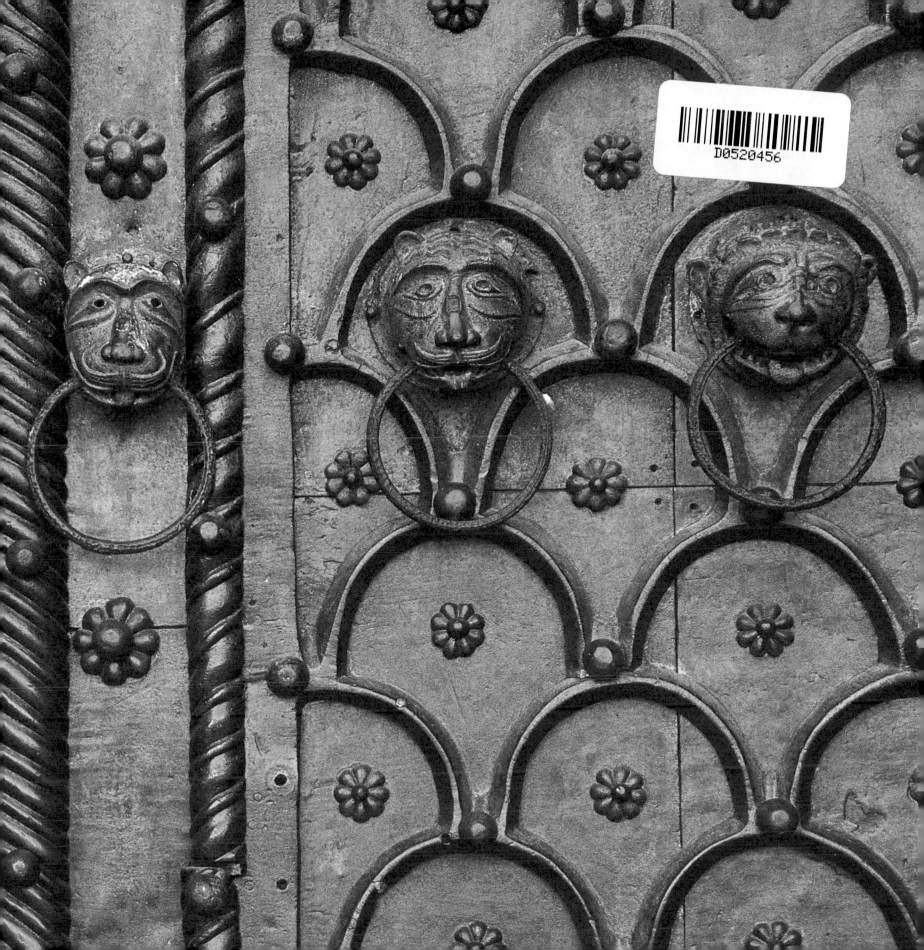

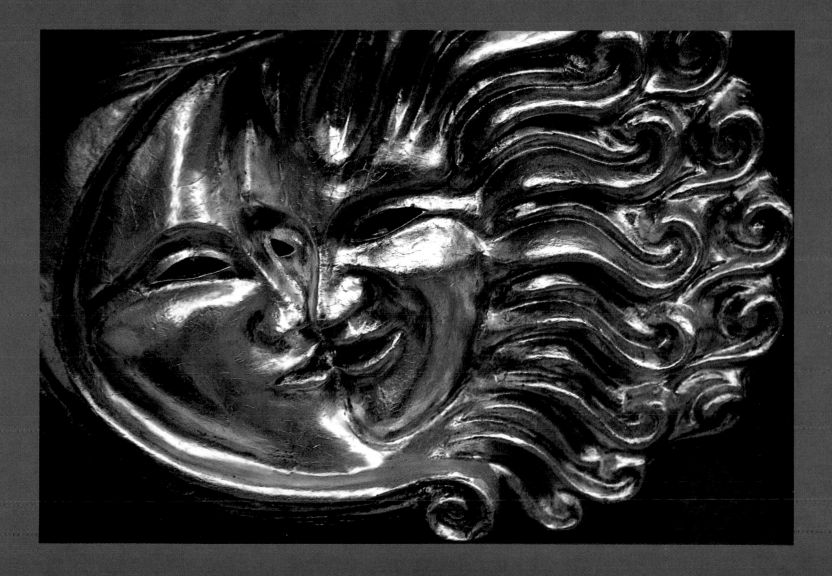

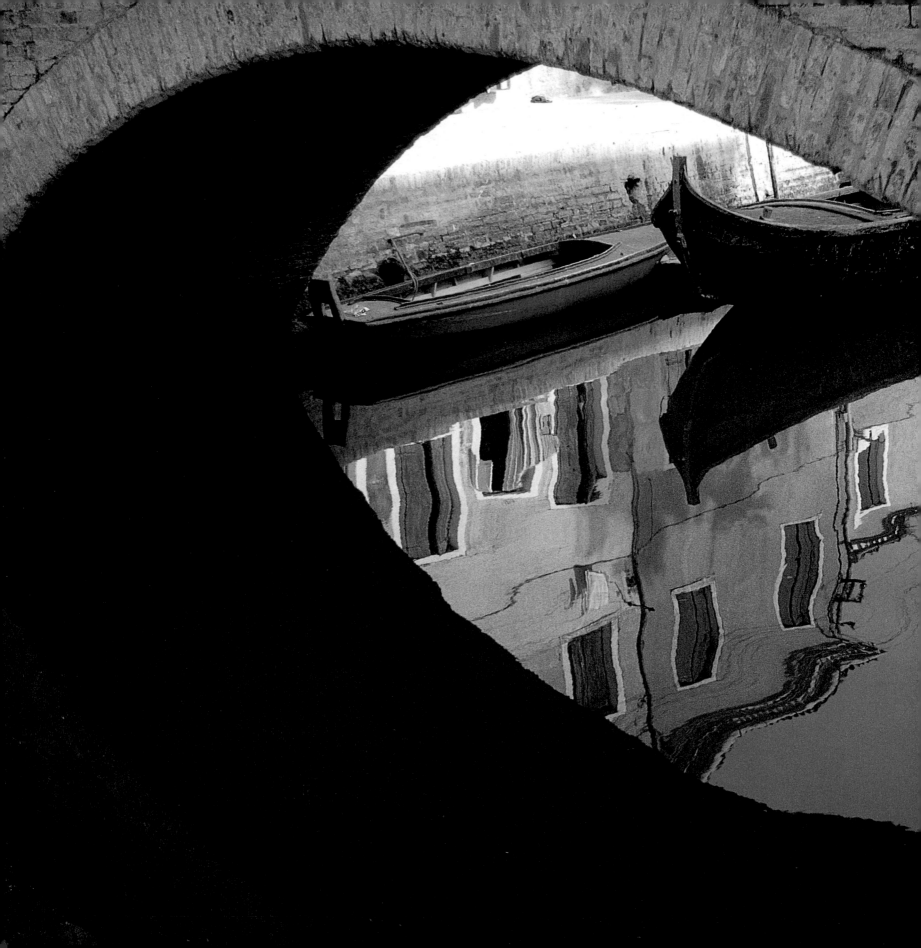

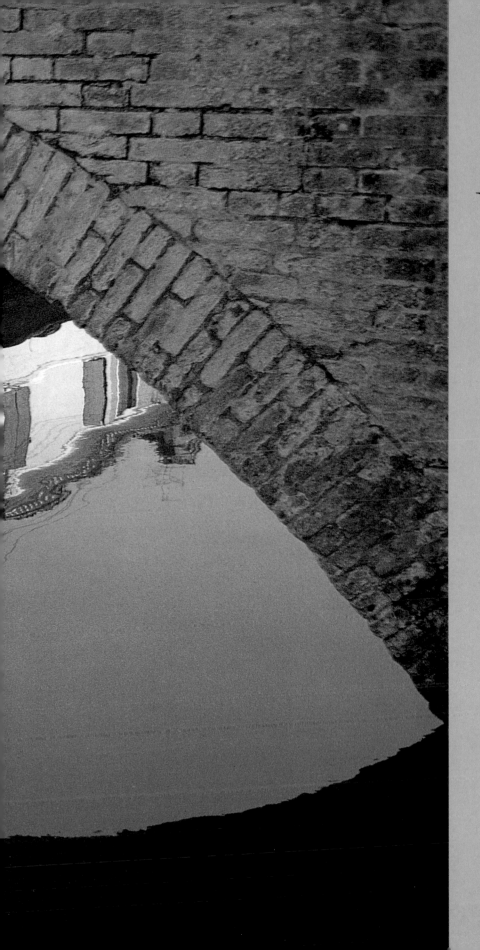

VENICE
AND
THE
VENETO

PHOTOGRAPHS BY
SONJA BULLATY
AND
ANGELO LOMEO

TEXT BY
SYLVIE DURASTANTI

ABBEVILLE PRESS ◆ PUBLISHERS
NEW YORK ◆ LONDON

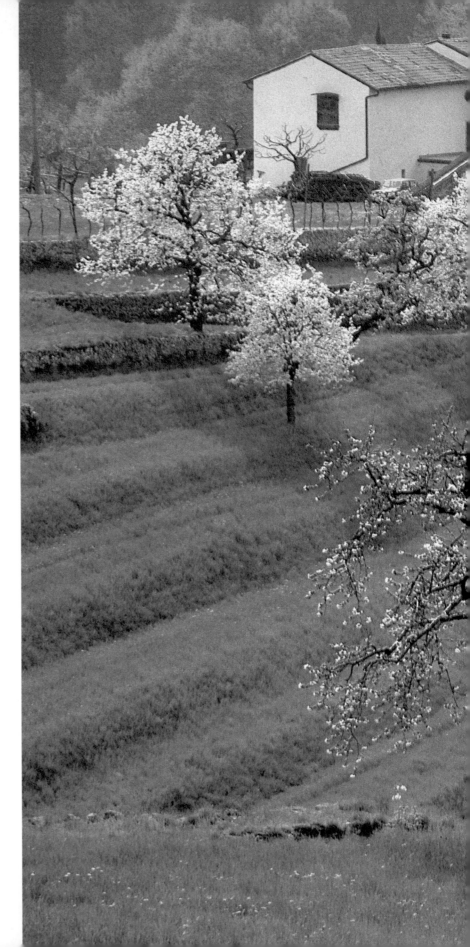

JACKET:

VIEW TOWARD SAN GIORGIO MAGGIORE, VENICE

JACKET BACK:

VIEW ACROSS THE LAWN OF PALLADIO'S
VILLA ROTONDA, VICENZA

PAGE I:

MOON AND SUN CARNIVAL MASK, VENICE

FRONTISPIECE:

REFLECTIONS FROM A CANAL BRIDGE, VENICE

RIGHT:

CHERRY TREES BLOOMING IN SPRINGTIME, NEGRAR

PAGES 6-7:

LA SALUTE, VENICE

EDITOR: Susan Costello
DESIGNER: Nai Y. Chang
TRANSLATOR: John O'Toole
PRODUCTION EDITOR: Abigail Asher
TEXT EDITOR: Mary Christian
PRODUCTION SUPERVISOR: Lou Bilka

First edition

4 6 8 10 9 7 5 3

Library of Congress Cataloging-in-Publication Data
Bullaty, Sonja.
Venice and the Veneto / photographs by Sonja Bullaty and
Angelo Lomeo ; text by Sylvie Durastanti.
p. cm.
Includes index and maps.
ISBN 0-7892-0166-6
1. Venice (Italy)—Pictorial works. 2. Veneto (Italy)—Pictorial
works. I. Lomeo, Angelo. II. Durastanti, Sylvie. III. Title.
DG674.7.B85 1998
945.'310929'0222—dc21 97-31397

For bulk and premium sales and for text adoption procedures, write to Customer Service Manager, Abbeville Press, 137 Varick Street, Suite 504, New York, NY 10013 or call 1-800-ARTBOOK.

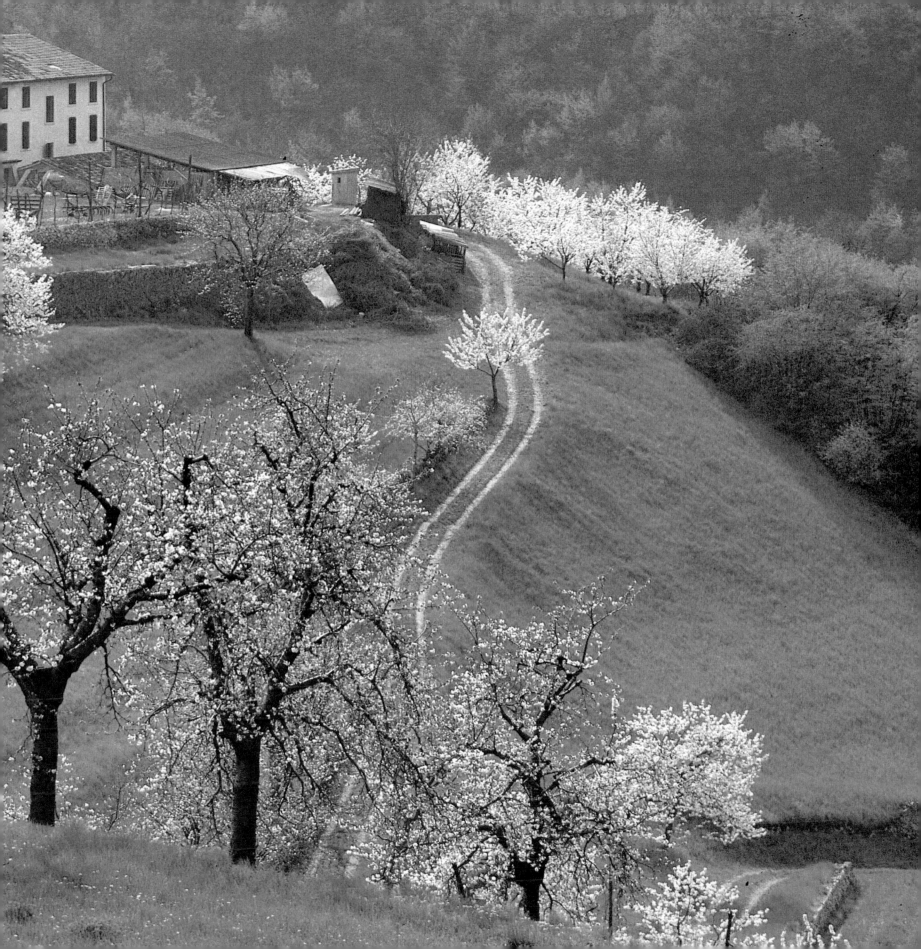

CONTENTS

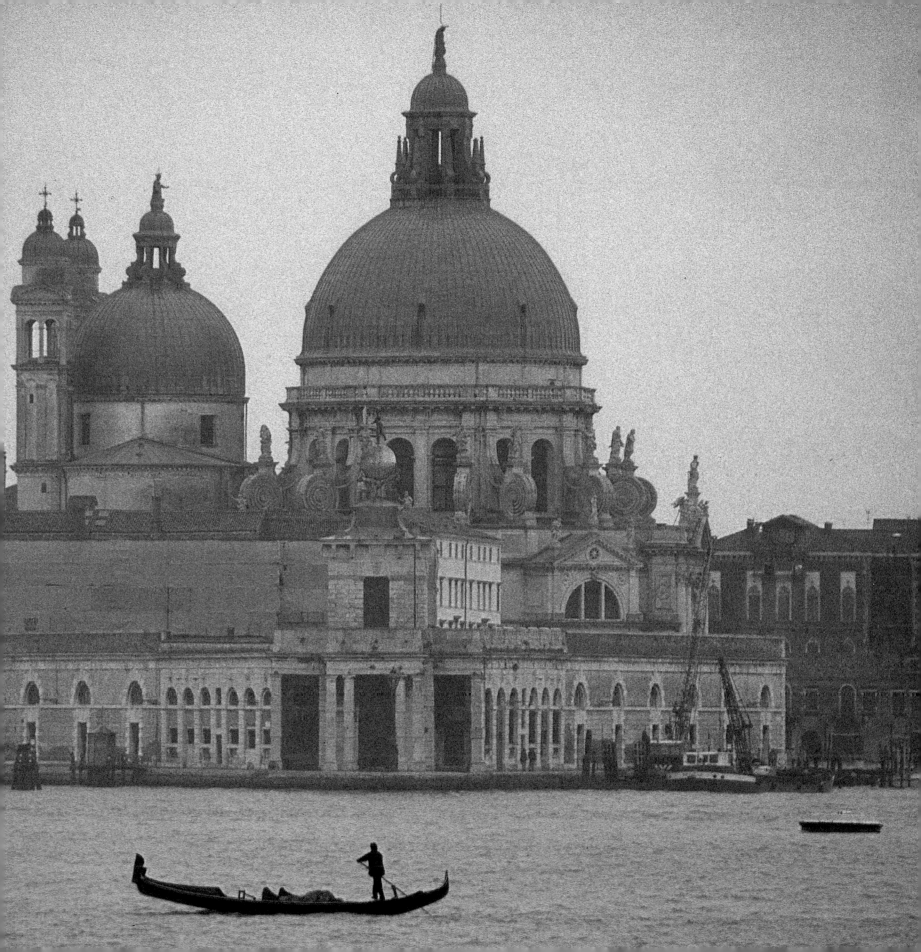

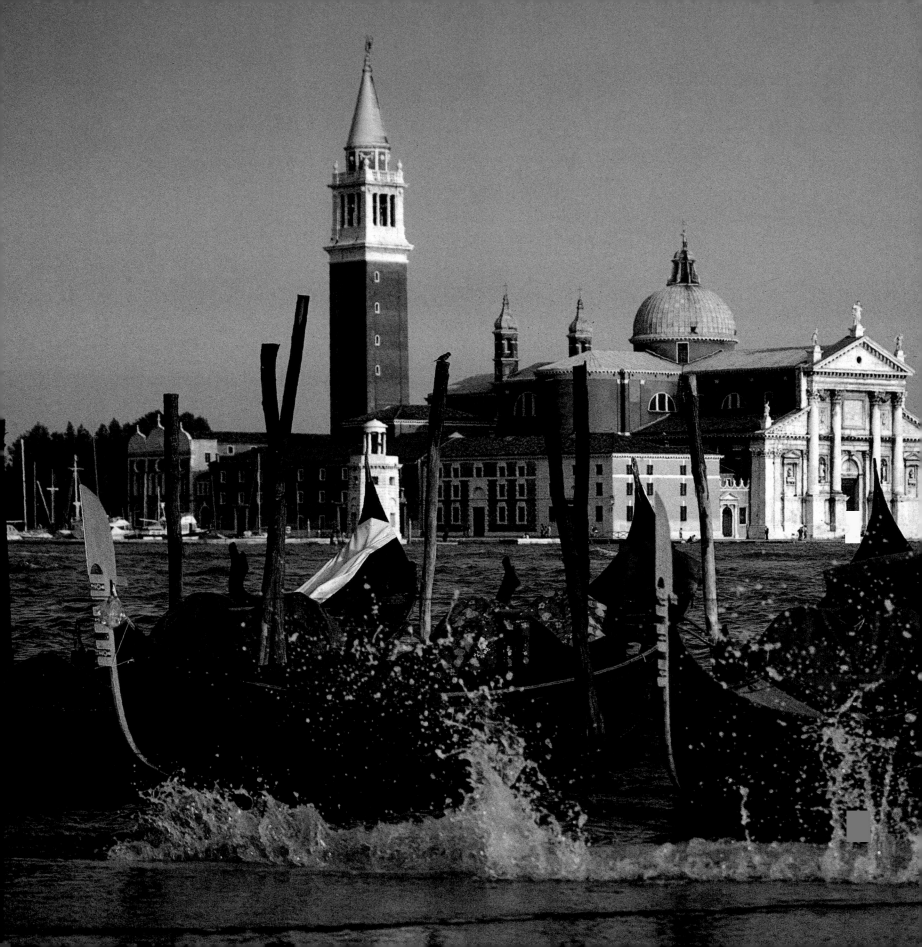

VENICE
LA
SERENISSIMA

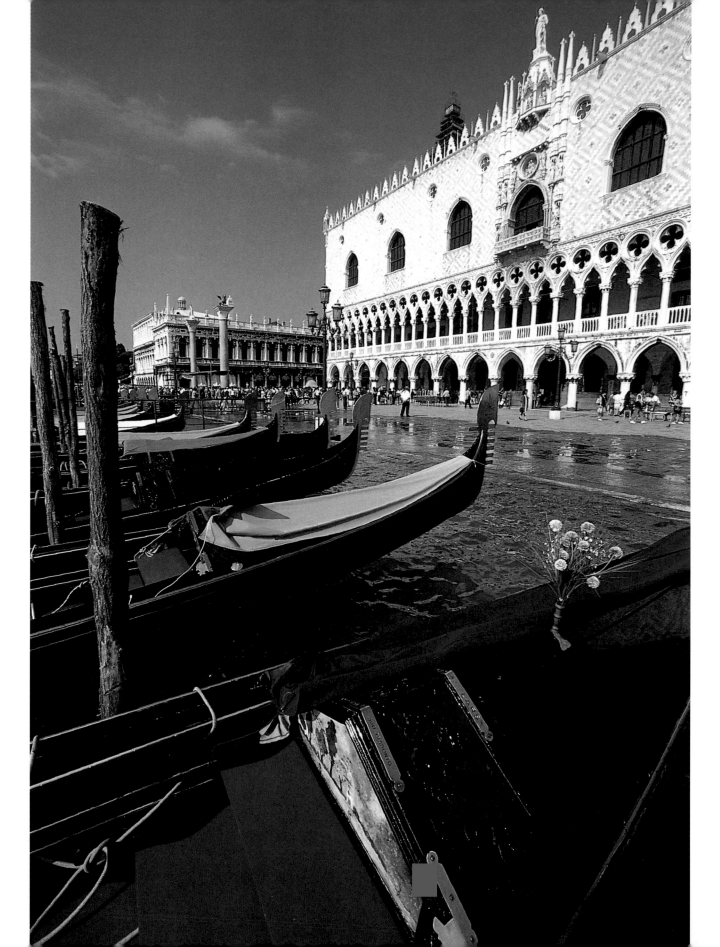

PAGES 8–9:
GONDOLAS
ACROSS FROM
SAN GIORGIO
MAGGIORE
◆ ◆ ◆
·*Venice*

HIGH WATER
AT THE DOGE'S
PALACE
◆ ◆ ◆
Venice

"When one wanted to arrive overnight at the incomparable, the fabulous, the like-nothing-else-in-the-world, where was it one went?" For some the answer to this question, posed by Thomas Mann, seems obvious: if it is the incomparable and the fabulous you want, then set out for the unexplored, untouched parts of the world, rare as they may be today. Surely you wouldn't dream of setting off for well-traveled regions, places worn out by the pictures of centuries of visitors! But with Venice you can take two possible approaches, which we might call the reverent and the naive. In its extreme the former, with its parade of innumerable references and obligatory erudition, proves daunting, requiring us to know everything possible about this city before going off to visit her. A thoroughly naive approach, on the contrary, demands an eye that is completely fresh and an ear that is deaf to the past. But how can anyone avoid the myriad depictions of this city found in the pages of so many writers, from Henry James to Marcel Proust to Hugo von Hofmannsthal to Ernest Hemingway? Venice has certainly been painted, described, evoked, and explained to a dizzying degree. And yet there are places in the world so complex that few eyes have really touched them, and endless words have only shrouded them in a veil that deepens their mystery. Venice is such a place.

Venice, a lagoon city par excellence, is a composite, equal parts stone and water. Surrounded, even saturated, by the Adriatic, Venice is not solidly moored to land by any fixed foundations. How could this city of stone be nothing but a raft, a floating platform laid out on more than two hundred small islands, separated by some two hundred canals, spanned by nearly four hundred bridges? Venice is one seaport that is truly *on* the Adriatic, a massive stone city set upon the waters.

Venice is doubly isolated, from dry land and from the rest of the Veneto region, by the Adriatic Sea. The city's lagoon is cordoned off by a long coastal ribbon of fragile sandbanks that are broken by three gaps, three navigable channels called Porto del Lido, Porto di Malamocco, and Porto di Chioggia. This immense enclosed pool of water measuring nearly two hundred square miles (nearly five hundred square kilometers) is in part a *laguna morta,* or "dead lagoon," washed by the sea at high tide only, and in part a *laguna viva,* "live lagoon," navigable along well-marked channels punctuated by signal buoys, or *bricole*. In this sense Venice not only forms a natural seascape but is above all a seascape profoundly shaped by man. An untutored eye might see nothing on the lagoon but mudflats and shallows that are more or less brackish, an estuary that is more or less stagnant. Venice is the result of patient, persistent re-creation. She has been hard won from the surrounding inlet and ferociously defended from the sea, and after so much activity, she is settling down—alas, perhaps for good, because the city is now in danger of sinking beneath the mud. The whole lagoonal region is subject to the natural phenomenon known as subsidence, or the gradual settling down of the earth, which is inexorably leaving Venice to the mercy of the waves. That Venice is disappearing before our very eyes instills fear in some, in others despair. Decay, however, not necessarily synonymous with death, can hold the promise of new life. And in Venice survival sits well with a certain suspension of time's rude stream.

This city has her unconditional partisans and her passionate enemies alike. For the former, Venice's masks and palaces remain serenely suspended in time, while the latter find only duplicity in her flaking facades, listless depression in her languor. Those who dislike Venice see a hard, stifling, petrified city wallowing in a *maremma,* a coastal fen; her admirers, a porous, watery place washed and regenerated by the elements, an almost airy, ethereal city. In the eyes of her enemies Venice was born, began to fade, and is now wasting away in her *laguna morta.* But for her enthusiasts the city rose up, prospered, and continues to survive in a *laguna viva.*

Either way, the origins of the city called La Serenissima were far from serene. When Attila the Hun laid waste to the town of Aquileia in 452, its survivors fled to the tiny island of Torcello. Thus Venice's grandmother, a once-important commercial center, and mother, a tiny island in the shallows, formed the legacy of Venice's character and aspect. The early inhabitants of Torcello were rapidly forced to emigrate to other islands. A century later these islands were colonized by the Byzantine Empire; two centuries later the cathedral of Torcello was built; three centuries later Venice shook off Byzantium's domination in part; and four centuries after the arrival of Torcello's refugee settlers, Venice raised her first sanctuary, dedicated to Saint Mark, whose remains had been brought back to the island city from Alexandria by two Venetian merchants. In the succeeding centuries Venice's engineers fought to keep the lagoon from silting up by diverting the flow of the rivers that formed the shallows, closing certain natural channels to avoid floods, and reinforcing the fragile coastal sandbanks *(lidi)* with low walls *(murazzi)* built of Istrian stone.

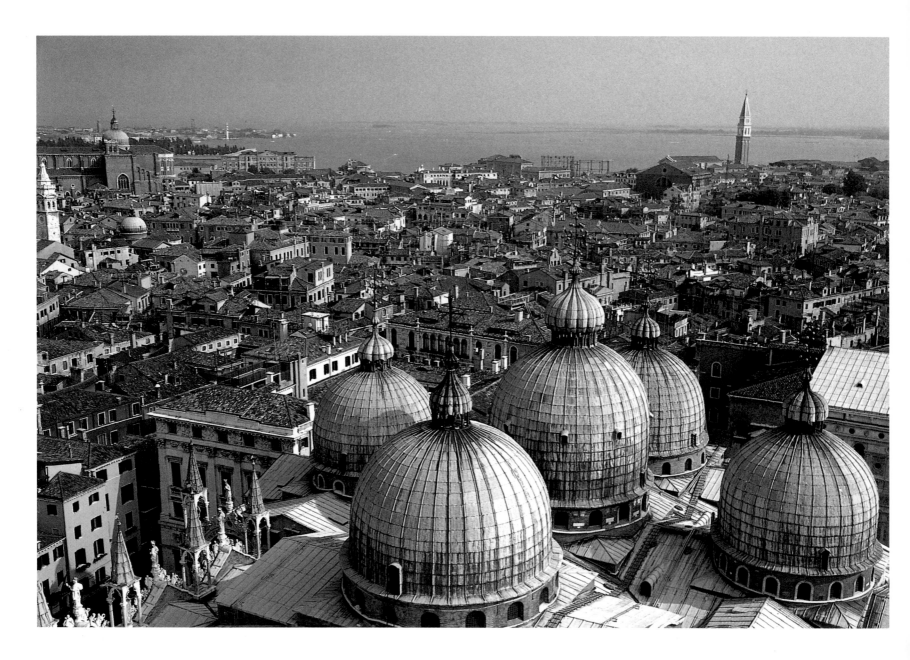

DOMES OF SAN MARCO, FROM THE CAMPANILE

◆ ◆ ◆

Venice

Whether you arrive by land, air, or sea, you will thus find Venice either seated upon, sprawling over, or soaring up from the waters of her lagoon, set in the very thick of her green and gray marsh, ensconced deep within her native mire, whose greenish color is streaked with pink streaks of salt. Venice is fluctuating and fluid to her very core. But what was this city before becoming what she is today? Those who eventually washed up there, a place without a stretch of dry land to welcome them, must surely have been desperate to find a haven in that marshy, unhealthy stretch of shallow sea; to bivouac in the midst of such wretched conditions; and then to lay the foundations of a city on sand and mud.

The honor of conjuring up the distant past that witnessed Venice's rise to greatness goes to John Ruskin, who in the middle of the nineteenth century endeavored to celebrate the vestiges of the stone bible that the city embodies in a bible of paper, his *Stones of Venice*. The English author transports readers into the past to give them a bird's-eye view, a fantastic, loving, aerial glimpse of the terraqueous Venetian plain. In his eyes, this shifting sand-filled landscape—inhospitable, even hostile to man—seems a region in transition, a composite, treacherous place between the mainland and the main, where terra firma is firm in name only, constantly swept and eroded by the ebb and flow of the waves. Venice's prehistoric decor might well have been envied by François René Chateaubriand in his *Mémoires d'outre-tombe*. Ruskin's view of Venice emerging from the mud of her native morass admirably contrasts tiny, almost intimate observations—underscoring both the desolate aspect of these barren wastes and the absence of man—with the truly historic gesture of erecting an edifice on Torcello.

The wild, gloomy landscape of Ruskin's study creates an altogether romantic portrait: "Amidst the murmur of the waste of waves and the beating of the wings of the sea-birds round the rock that was strange to them," men fleeing the Vandals chose to take shelter deep in an expanse of salt marshes dotted with small islands. You need not stretch your imagination much to picture these men and women. It is enough to tear yourself away from contemplating the "superb palaces" raised by their descendants once they had become the "lords of the sea," take a few steps outside this web of canals and maze of stone buildings, free yourself from her pomp and splendor. All you need do is pass over her "lurid ashen gray" estuary, where fresh- and saltwater vegetation freely mix. Then you would see, with Ruskin, what first met the eyes of those who fled there: "a waste of wild sea moor," offering camouflage against Vandals. There they threw up their first makeshift shelter like a barely seaworthy raft—forever on the point of sinking, but matching the surrounding landscape so perfectly it allowed them to survive.

Because wood was rare on those marshy islets, they took advantage of what was at hand, laying down plaited beds of branches and reeds over spongy mats of silt and peat and tangled clusters of seaweed and kelp before roughly squaring off posts for pilings that they drove into the sand to subdue the earth—or at least what would have to serve them as hard earth. Apparently, no less than a million such pilings were needed for the foundations of La Salute. To the bulging eyes of her underwater denizens, this "green slippery city," as D. H. Lawrence characterized Venice, is simply a "forest of pilings."

Having tried to imagine, along with Ruskin, what Venice once was, you might now want to understand what she became. The city would naturally exploit the sea and its resources. The surrounding salty water, teeming with fish, was a ready source of provisions and profit, her sustenance and her stock in trade—namely, fish, salt, and ships, according to the account of the sixth-century statesman and monk Cassiodorus. The wayfaring late-fifteenth-century memoirist Philippe de Commynes was astonished to see rising above an "exceedingly smooth sea," among the wild marshes and shaky pilings, "great habitacion [*sic*] upon the water." Such was Venice in the fifteenth century, and so she was to remain, perfectly urbane. La Serenissima nevertheless was conceived and laid out first and foremost as a commercial city. Although nowadays you might find it exasperating to see Venice turned into a huge art exhibition, the fact is, she is not a museum city at heart. As was Proust, countless visitors have been amazed by the surprises that unfold in Venice: around the bend of a canal, deep within a modest neighborhood, a vast *campo* suddenly appears before you, with a superb church or crumbling palace rising up at its center. This disconcerting arrangement is due to the fact that business in Venice was carried out on the *campi* in covered markets and under arcades, requiring the inhabitants to build warehouses and dockyards before turning their hand to *palazzi*. Venice's architecture is indeed far more eclectic than one would think from the narrow confines of the Piazza San Marco.

Some centuries after Commynes's astounded view of the city, Venice's renown had become so widespread and her image so tarnished that to discover—in the strict sense of the verb—this supposed wonder was no longer nearly as gripping for a traveler like the eighteenth-century chronicler Charles de Brosses. He noted the following in his *Letters:*

> To tell you the truth, my first encounter with this city did not surprise me as much as I had expected. . . . Yet once one has been there, has seen rising from the water on every side palaces,

churches, streets, entire towns, since there is more than enough for several; finally, the impossibility of taking a step in a city without having one foot in the sea—'tis a thing so surprising in my opinion that today I am less used to it than my first day here.

An exemplary instance of a delayed surprise! And of surprise continually renewed, occasioned by the most insignificant details of daily life. "Everything there takes place gently in water, and I believe that one could very easily snore away in the middle of the green market"—which supposes that the vegetable hawkers were stronger on melody than mouth. Was it living practically immersed in those slippery, fluctuating, lapping waters that gave birth to the lilting liquid accent of Venetians and a dialect that raises the frequent use of the "z" sound to the level of refined speech?

In the past, "with its gentle elidings, its odd transpositions, its lovable contempt for consonants and other nuisances," this "delicious fluid language" resounded perfectly over peaceful waters that carried a voice quite far. In de Brosses's day gondoliers were almost alone in making up the hum of the city; that lively, irregular, purely human acoustic background—free of the clamor that machines would later introduce—largely contributed to making Venice a haven of silence, a city where sounds were both borne and dampened by the liquid element. (Even as late as the turn of the twentieth century Venice would remain "emphatically the city of conversation" to Henry James's ear.) De Brosses carefully refrains from making the mistake of travelers who adopt a pompous tone to describe the most inconsequential things, but pass over "all that it cost them to enjoy the truly curious things." What is interesting in his account of Venetian mores is that he strives neither to be original at all cost nor to be selective. Nor does he shy from describing in detail what he feels has been given short shrift by sightseers before him, for example, the gondola:

> It is a vessel long and narrow like a fish, rather like a shark; in the middle is set a kind of carriage body, low-slung, shaped like a single-seated berlin, twice as long as a vis-à-vis; there is but one single door forward by which passengers enter. There is room enough for two in the back, and for two others on each side, seated on the bench that reigns there, but which almost always serves to allow those who are in the rear to stretch out their legs. All of that is open on three sides, like our carriages, and is closed at will, by either glass windows or wooden panels covered in black cloth, which either slide on grooves or are brought within the body of the gondola along the side. . . .

The gondola's prow is armed with a great iron swan-neck studded with six large iron teeth. That serves to stabilize it, and I would compare this piece of iron to the open maw of a shark, although it resembles a windmill. The whole boat is painted black and varnished; the compartment lined with black velvet within and black cloth without, with morocco pillows of the same color.

Inside this oddly shaped vehicle a passenger is altogether at home, "as if he were in his room, reading, writing, conversing, caressing his mistress, eating, drinking, etc., forever making a round of visits in town," thanks to the services of an able gondolier capable of "getting out of the worst hindrances to the flow of traffic" by taking advantage of "water's flexibility." De Brosses crossed La Serenissima in 1739. Ten years later British novelist Henry Fielding noted in passing (Tom Jones) that anyone eager to travel in order to observe a variety of customs might well spare himself much trouble by simply attending the Carnival of Venice, which brings together in one place all that there is to be seen in the different courts of Europe.

In 1787 the playwright Carlo Goldoni published his Memoirs, in which he included recollections of his native Venice. (That he spent some fifty years elsewhere in Italy and at the French court only made him a more cosmopolitan authority.) "All the world's cities seem more or less alike," he wrote, but "Venice seems like no other." And how can you not believe him when he affirms that "maps, plans, models, descriptions are not enough, you must see it"? What, then, does this Venetian see when he turns his practiced eye on his birthplace? "A considerable stretch of small islands so near one another and so expertly joined by bridges" that the whole seems like "a continent raised upon a plain and washed on all sides" by "a vast marsh more or less covered with water, at the mouth of several ports, with deep canals." Making your way to San Marco "through a prodigious quantity of vessels of every sort," alighting on the Piazzetta, turning into the streets of the Mercerie, and treading paving stones of Istrian marble "pitted with blows from the chisel to keep them from being slippery," you find yourself passing through "an area that represents a perpetual fair." Goldoni also praised the breadth of the Rialto Bridge, which spans the Grand Canal in one giant bound with a single arch, high enough to permit small boats and barks to pass unimpeded, yet wide enough to allow three lanes of foot traffic and support "twenty-four shops with their lodgings and lead-covered roofs." The famous bridge was built of Istrian stone between 1588 and 1592 on the site of an old wooden bridge, visible in Vittore Carpaccio's Miracle of the Holy Cross. The old one had been

the city's business center until a fire in 1514 destroyed it and all the banks that had prospered nearby, along with the former covered market, where bales of silk and spices from the distant Orient were unloaded. Goldoni recounts, too, how frightened of horses he had been in his youth the first time he found himself outside Venice. The four-legged creatures had in fact been banished from town early on by the construction of overarching stone bridges that rose high above the water. These bridges, which replaced simple wooden footbridges, favored canal traffic and the development of gondolas as the common means of transportation.

In 1850 the prolific Romantic novelist and critic Théophile Gautier noted in his *Italia* that writers and librettists had so used and "abused the gondola in comic operas, romances, and short stories" that it deserved to be described more precisely. Giving up the idea of covering Venice on foot, he decrees flat out that the Most Serene Republic was simply impassable without the vehicle: "The city is a madrepore, the gondola is the mollusk. It is only the latter that can wind through the inextricable network and infinite capillarity of her watery streets." Yet Gautier enters the city, now welded to the mainland—what Italians call *terraferma*—by way of a long bridge spanning

the waters of the lagoon, arriving by train from Mestre by night: "On both sides the lagoon, with that glistening darkness even deeper than night, stretched out into the obscurity." Once at the wharf, he and other travelers pile into a gondola bus for a hotel located on the other end of town. Lights are rare, but the sky is rent by lightning from time to time, marking the end of a storm. Occasionally, when night has the upper hand, the gondola, coated with pitch and painted black, must cut through layers of shadows, including "the oily, wet, deep shadows of the water; the tempest-tossed shadows of the night sky; and the opaque shadows of the two walls" between which the boat slips. Gautier thus approached Venice inside out, as it were, by way of the backstage, the wings, thanks to "a voyage in the dark." He was wise enough, moreover, to wait until the next morning to finally step out and discover the thing in broad daylight.

When Gautier enters San Marco, his first impression is of "a cave inlaid with gold and precious stones, splendid and somber, sparkling and mysterious at once." He sees the light quivering "like the scales of a fish" as it flashes over "small cubes of gilded crystal." And under a slanting sun, in the thickened shadows, figures "waver and grow blurred in one's view. The stiff folds of dalmatics appear to soften and

LANDING STAIRS
◆ ◆ ◆
Venice

float." Suddenly alive, the "still Byzantine forms" awaken; "their fixed eyes stir, their arms, struck in Egyptian attitudes, move; their sealed feet begin to move."

The same view is also glimpsed at times in Marcel Proust's *Remembrance of Things Past*—hardly surprising, for more than any other city Venice is a palimpsest, a slate on which impressions from different observers come to overlap in your memory. The dazzling, dizzying, miragelike effect that San Marco had on Gautier is inevitably recalled by the early-twentieth-century novelist, who found there the ideal place where "one never knows where the land ends and the sea begins," as Proust's fictional painter, Elstir, puts it. Indeed, why struggle against the flow of images and impressions gathered over the course of your reading when your setting itself displays so many facades, masks, potential reflections; when your backdrop is fluidity itself? Indifferently mixing marble and Istrian stone, brick and stucco, Venice always had a knack for making the best of it. The infinite marquetry of her original building blocks perfectly balances this irresistible intermingling of reminiscences drawn from life or gleaned from books.

During his sojourn Proust's narrator explores Venice's small canals in a gondola, follows the "meanders of this city of the East," discovers deep inside "an old neighborhood, populous and poor," a monument too beautiful not to clash with its surroundings: "A small ivory temple with its Corinthian orders and allegorical statue on the pediment," whose only peristyle was, absurdly enough, "a landing for market gardeners." Elsewhere, the narrator takes a gondola up the Grand Canal, floating between palaces on which the setting sun shines as on "a chain of marble cliffs." Glaring out against this monumental impression is the unexpected, almost disappointing character of the narrator's precious find—a small temple standing forgotten on a sordid wharf. The contrast sheds light on one of Venice's greatest charms, namely, the incongruity of certain chance groupings brought about by the passage of time. The narrator finds himself, for example, "in the middle of new neighborhoods like a character out of *The Thousand and One Nights.*" Having lost his way in a tightly knit network of tiny *calli,* he stumbles on a place that would never suggest such a trove, "a vast and sumptuous campo" completely "surrounded by charming palaces," revealed to him in the moonlight. Here again the city's beauties arise from her jarring disharmonies—a discordance that makes Venice the complete opposite of Florence, for example. The Adriatic seaport is not at all a city of art steeped in a single narrow style. She may have emptied countless inkwells and now rises amid some of the deepest pools of purple prose and poetry, but La Serenissima is nothing oppressive in and of herself. For that reason, in Venice, more than anywhere else, you can cultivate a true devotion to detail, and trust without hesitation to byways and back lanes.

A few years after Proust and during the flurry of skyscraper building in New York, Paul Morand couldn't help but compare Venice with New York, one spread flat in her lagoon and the other soaring straight up into the sky. By a trick of the mind, he thinks he sees one in the other, imagining Venice "becoming once again what she had been in the fifteenth century, a kind of Manhattan, a predatory city, excessive, screamingly prosperous, with a Rialto that was the Brooklyn Bridge of its day, the Grand Canal a kind of Fifth Avenue for millionaire doges." Was it to counterbalance the despair that this lethargic, listless city can inspire that Morand envisioned it as being so vulgarly dynamic? It is certainly exhilarating to watch the traffic that circulates there, the vaporetti, gondolas, outboard boats, and barges. Everything travels by water: food deliveries, municipal building materials and crews, taxis and mail, law enforcement and trash collection, wedding and funeral parties. And as Morand points out, this city is an eminently practical town, for "with its garbage Venice constructs new islands, putting her own waste to good use." Such is the spirit of the "republic of beavers" that Ezra Pound found there.

The sumptuous breadth of past architectural styles is exaggerated further by the deterioration that has bereft Venice's buildings of all superfluous elements, leaving palaces stripped of their gilding and reduced to a mere outline of their former glory. Throughout Venice, crumbling mansions with gaping holes, dilapidated balconies, and pockmarked colonnades embody an Oriental notion dear to nomads and tourists accustomed to picking up and traveling: that houses are not necessarily tombs for the living. Need one have grown up "under vast porches that sea-borne suns tinge with a thousand glints" to feel like a native in Venice? You might puzzle over that very question when you enter San Giacomo dell'Orio and discern in the half light, beneath the vaulted ceiling, "great pillars, upright and majestic" that transform the chapel into one of those basalt caverns that Charles Baudelaire depicts in "La Vie antérieure" (The former life). All of Venice can be seen in that church, in the haphazard accumulations of columns, two of which were simply stolen from Constantinople during the Fourth Crusade. The flamboyant adventurer Gabriele d'Annunzio must have felt something similar when he described one of these as "the fossilized condensation of an immense verdant forest." Like a perfect petrified arborescence, this trunk might seem to be the sole survivor of a larger expanse of green felled by time, except it seems to emerge from deep underground, as if the earthbound chapel were no more

than the outcropping of a marshy crypt braced by a piling of coral. As if the vegetable and mineral kingdoms had fused to create Venice, as if this city were but the mirror image of another settling beneath her and the waves, an inverted town destined to remain afloat a little while longer. Faithful to her origins in the ooze and the sea, Venice was erected with the help of simple wattles, rough-hewn wood posts, and incalculable embankments of mud, gravel, lichen, seaweed, and shells heaped up to protect her from the endless sea and air.

Yes, Venice is a raft, at times sinking under the weight of everything that has been said, written, and retold again and again about her. To see the city as she is, we ought to clear our eyes, perhaps turn our attention to Venice's painters. However, the eighteenth-century painters Antonio Canaletto and Francesco Guardi are of no help to art lovers seeking a transhistoric, unadorned Venice. The former's name is, of course, irresistibly linked with Venice in most people's minds. Canaletto was the master of two genres, *vedute,* or townscapes painted from nature, and *capricci,* those created wholly from the imagination. But because he worked almost exclusively for English patrons, Canaletto rapidly diluted his palette with pearly tones and lusters, sacrificing realistic details and daring compositions in favor of large panoramic views. Guardi, on the other hand, is one of those painters whom Proust criticized for having represented, in reaction to an artificial Venice, a pseudorealist one, a town of "humble campi and tiny deserted *rii.*"

Instead, try looking not to those artists who tethered her image to a specific age but rather to one who, more than any other, was able to wrest her from time's grip. Venice is infinitely better rendered in the modest sketches left by one foreign master than in works by artists who were born or lived there. Joseph Mallord William Turner, when he eventually visited the city, encountered both a setting already made familiar by his chosen master Claude Lorrain's idealized antiquity and the effects of lighting and atmosphere that Lorrain had especially favored. Turner found a Venice of imaginary palaces and ideal ruins, ruins that were, and still are, fresh, newborn. It was his discovery of the Campo Santo in 1819 that led the painter to free himself from the anecdotal, the descriptive, the true to life, and to pursue more fully the pure play of light. His view of the Adriatic seaport is not simply impressionistic before its time, it is already lyrically abstract. Turner conjures up for us a buoyant, shimmering, limpid Venice, but above all a city released from the weight of past interpretations in paint and print. His is an almost immaterial Venice, a purely atmospheric place suspended between flashes of light, a wavering scrim of heat, wisps of fog, and patches of drizzle.

Venice is one place where you must avoid the ruts left by other visitors, stay off the beaten path even if it seems paved with beaten gold. If not, you may see only a showcase city that is an unbroken series of knickknacks and curios, an insular city wrapped up in itself and closed to foreigners—the "stultifying place," as Emile Zola found it. That natural-born city dweller even pronounced it impossible—impossible!—to get around in the City of the Doges. His arguments border on the absurd: "A walk or drive is impossible. No spring, nor autumn . . . never a lane wandering between two high banks, a path between the hedgerows, a white road through the wheat. Not a bird. . . . You do all over again the following day what you did the day before." With Zola one hears the typical reasoning of the impenitent, hurried tourist who has no idea of local customs and pleasures.

Of course the French novelist's unfair judgment of Venice as an arid city is overwhelmed by thousands of other, happy impressions, beginning with what Zola's contemporary, Henry James, has to say about Venice, after numerous stays there: "The gardens of Venice would deserve a page to themselves." James, unfortunately, never wrote that page, but his *Italian Hours* is filled with minute observations whose very brevity is their secret charm; his comments even give us a good idea of the wonder that a glimpse of Venice's scarce vegetation can inspire:

> You reconstruct the admirable house according to your own needs; leaning on a back balcony, you drop your eyes into one of the little green gardens with which, for the most part, such establishments are exasperatingly blessed, and end by feeling it a shame that you yourself are not in possession. (I take it for granted, of course, that as you go and come you are, in imagination, perpetually lodging yourself and setting up your gods; for if this innocent pastime, this borrowing of the mind, be not your favorite sport there is a flaw in the appeal that Venice makes to you.)

That overwhelming urge to usurp the enjoyment of the place—thereby stimulating our imagination—is perhaps what makes us feel closest to James. Without his confession he might well have remained in our mind's eye a man dressed in black and choking in a stiff collar, or a summer vacationer sporting a cream suit and taking in a spectacular and impossibly distant Venice through a pince-nez.

Obviously James is no impartial observer. His Venice is all in the details, as he makes clear in *Italian Hours* once again:

> When I hear, when I see, the magical name I have written above these pages . . . I simply see a narrow canal in the heart of the

city—a patch of green water and a surface of pink wall. . . . The pink of the old wall seems to fill the whole place; it sinks even into the opaque water. Behind the wall is a garden, out of which the long arm of a white June rose—the roses of Venice are splendid—has flung itself by way of spontaneous ornament.

Perhaps, like James himself, we need to trust to Ruskin to escape the fascination of Venice the city of pomp and pageantry—the "curiosity shop" as James refers to it several times—where a visitor is all eyes and all ears, and nothing else. Maybe we have to look away, turn our attention from contemporary Venice to the first colony founded not far from the city. Ruskin makes out a "rude brick campanile" amid a meadow that is "a plot of greener grass covered with ground ivy and violets." This sketch of a small island lying just a short cruise from Venice is dominated by a rather surprising amount of vegetation for visitors who haven't tracked down all the gardens buried deep within the stone city. Ruskin goes on to point out that one ordinarily reaches this campanile and its surrounding run-down buildings by actually alighting on the far side of the island, an inlet "overhung by alder copse" that gives way to a meadow "roughly enclosed on each side by broken palings and hedges of honeysuckle and briar."

It must have been the freshness of Ruskin's description here that prompted James to follow his lead. Stopping his gondola "at the mouth of the shallow inlet," he disembarks to stroll "along the grass beside a hedge." The emotion that grips him at this moment moves him to make this confession: "The charm of certain vacant grassy spaces, in Italy, overfrowned by masses of brickwork that are honeycombed by the suns of centuries, is something that I hereby renounce once for all the attempt to express; but you may be sure that whenever I mention such a spot enchantment lurks in it." There is certainly something touching in imagining the staid James walking on the grass in his fine dress shoes. But still more touching is the novelist's refusal to describe the landscape because he is so enchanted by it. James, who often depicts Venice as a pure vision seen from a balcony or glimpsed from a gondola gliding down a canal—a vision of stone and water occasionally heightened by a touch of green or filled with flowery scents—here steps into what he elsewhere treats as mere background or fabulous spectacle. He comes across, for example, a half-naked urchin, "running wild among the sea-stunted bushes, on the lonely margin of a decaying world, in prelude to how blank or to how dark a destiny?" And unlike so many little American boys, often seen and soon forgotten, "this little unlettered Eros of the Adriatic strand" will remain etched in his memory for the rest of his days.

Oddly enough, it is in that text, entitled "Venice: An Early Impression," that James declares, as early as the third paragraph, that "the mere use of one's eyes in Venice is happiness enough." He goes on to add, speaking of the magic of Venetian light, that "you should see in places the material with which it deals—slimy brick, marble battered and befouled, rags, dirt, decay." James roundly decrees that nobody can truly claim to know Venice without having set foot on the humble island of Torcello. So what is there to see on Torcello? "Light," says James, and nothing more. Apart from that, there is what he himself sees and presents as a sort of nonlandscape, "nothing at least but a sort of blooming sand-bar intersected by a single narrow creek which does duty as a canal" and dotted with one or two huts, "the dwellings apparently of market-gardeners and fishermen." When the vaporetto sounds its horn and nudges the landing, when the moorings are cast overboard and you hop ashore, one of the first delights of the island, as you follow a tiny stone quay bordering a narrow canal, is to cross a small humpback bridge, the Ponte del Diavolo. But the very last thing one would expect to enjoy so near Venice is striding through the tall grass of a meadow at the end of the quay, before coming to the modest bell tower that stands on the island. Once you have walked down this path, you too will understand that the enchantment James describes is simply the pleasure of relaxing your eyes in "a perfect bath of light," of letting your gaze wander precisely where there is nothing to see. At last you are no longer all eyes and all ears and nothing else, you can surrender to a more global impression, the amalgam of vague, almost indistinguishable internal sensations. The vaporetto has cast off; the dull, distant hum of the city has faded; the odor of grass crushed underfoot mixes with the salty air; all other visitors have disappeared; and the world is now revealed to you in its naked essence. What better preamble to entering the sanctuary? And once inside, after your initial confusion, your eyes now accustomed to the freshness of the half-light, just when you have given up the idea of looking at anything in particular, you suddenly discern the tall, somber silhouette of a Madonna. The elongated form of the Byzantine Madonna of Torcello fits the curvature of the church's apse so strikingly, you need to step back if you want to capture at a single glance this grand, almost rudimentary figure—her lowered gaze, her hand raised, her rigidity, and her solitude. The marble Greek columns topped with Byzantine capitals, the alternating marble and mosaic flooring, the impressive Madonna, even the small friezes depicting a comic-strip Last Judgment, complete with naive serpents wriggling through the eye sockets of skulls—this curious collage suggests that Venice's future was decided right there in that one church, as Ernest Hemingway instinctively believed:

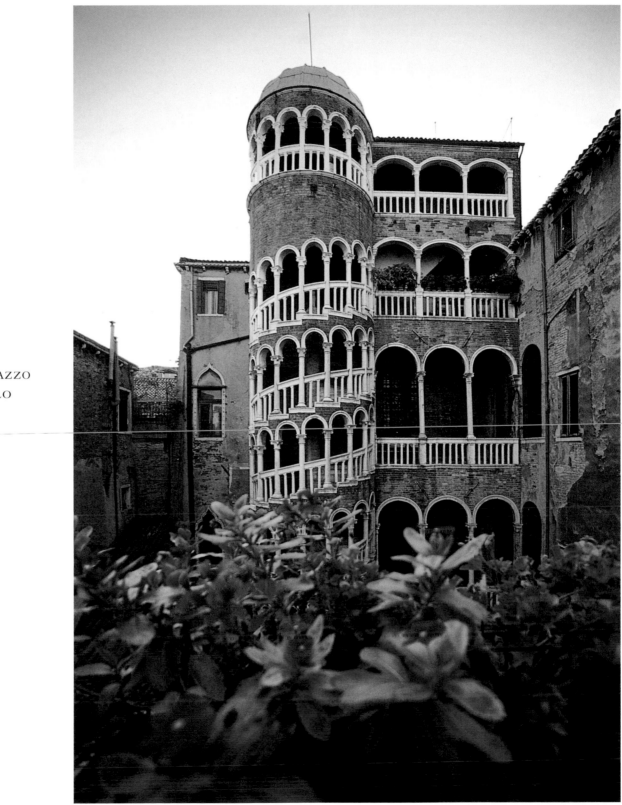

SPIRAL STAIR OF THE PALAZZO
CONTARINI DEL BOVOLO
◆ ◆ ◆
Venice

It was a Torcello boy who was running arms into Alexandria, who located the body of St. Mark and smuggled it out under a load of fresh pork so the infidel customs guards wouldn't check him. This boy brought the remains of St. Mark to Venice, and he's their patron saint and they have a cathedral there to him. But by that time, they were trading so far to the east that the architecture is pretty Byzantine for my taste. They never built any better than at the start there in Torcello. That's Torcello there.

Once you have visited Torcello, seen what it has to show you, all of a sudden it will seem essential to understand Venice not simply as a city raised up against the sea and the elements. Suddenly you can envision her as an island made up of numerous accretions, as one more imposing island among many others forming an archipelago of islands and islets scattered across the lagoon. And it will also seem imperative to admit the eminently composite, even heterogeneous, character of her architecture. How else are you to see the "treasury of bits" that James wrote of in connection with San Marco? So with your expectations of forming a complete, coherent picture of Venice happily jet-tisoned, you now go about taking her in on the sly, as it were, in bits and pieces, an image here, an echo there, letting chance be your guide. One day you spot a stone licked and lacquered by the water, a brick baking in the sun; the next, the brick is rendered a deep red by the rain, the stone bone dry; and the day after that, the entire city is washed clean and bright between two cloudbursts. Store up in your mind all these disparate things, all the more beautiful for being spare: "old loose-looking marble slabs," "great panels of basalt and jasper," "tabernacles whose open doors disclose a dark Byzantine image spotted with dull, crooked gems," even (as James himself remarked) "old benches of red marble . . . attached to the base of those wide pilasters of which the precious plating, delightful in its faded brownness, with a faint gray bloom upon it," owes its charm to "its honorable age."

Le Corbusier's understanding of the city was much the same. He believed that Venetian architecture, putting to good use "every technique, every material" over the centuries, offers "every divergent point of view, opposition, overthrow of power" in the realm of aesthetics. The succeeding styles of the basilica of San Marco's Romanesque, Byzantine, and Gothic architecture; the Romanesque, Gothic, and Renaissance styles of the Doge's Palace or Palazzo Ducale; the mixture of Turkish,

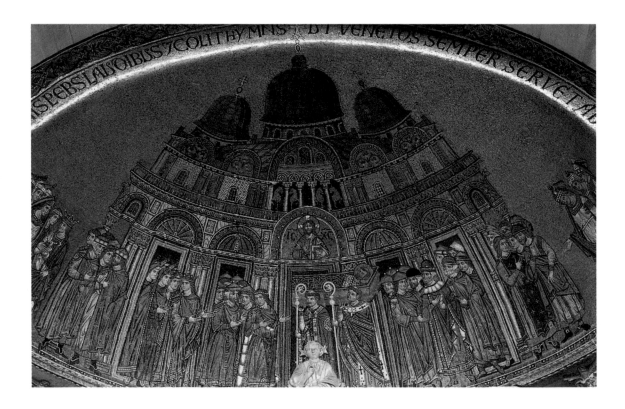

MOSAICS OVER A DOORWAY OF
THE BASILICA OF SAN MARCO
◆ ◆ ◆
Venice

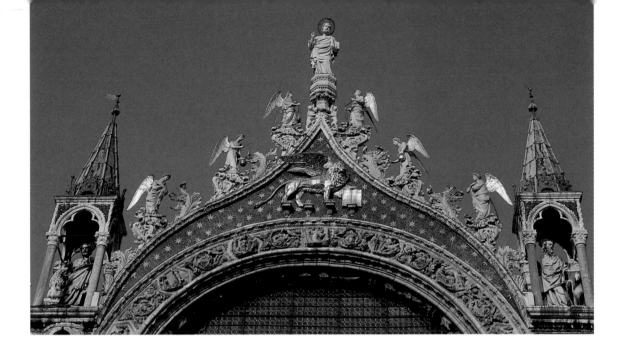

Gothic, and Renaissance of the Procuratie Vecchie; the two massive Byzantine columns brought from the Orient, one supporting the lion of Saint Mark, the other with Saint Theodore standing upon a crocodile; the Campanile's pure Romanesque style—the diverse architecture of the Piazza San Marco composes "a symphony organized horizontally on the lagoon." Opposite, the church of San Giorgio Maggiore sounds the extraordinary finale of the Palladian Renaissance.

And if by chance, in your wanderings, you find yourself with a companion at your side who feels the need to take in a scene in one great aesthetic impression, who laughs at your passion for detail, let him. To glean a whole trove of impressions of Venice, you should stroll—better yet, dawdle—with the idleness and infinite concentration of a child walking along the beach and picking up bits of stray wood, knots of seaweed, and shells. Have you ever felt the sudden urge to slip off your shoes in the villas of Pompeii or Herculaneum and tread barefoot over the mosaic flooring, wrinkled, puckered, and pleated by the uncontrollable shock waves of a tremor? Then, in San Marco or elsewhere, dare to run the palm of your hand over the uneven texture of time-burnished gold mosaic cubes, to feel beneath your feet the irregular surface of a terra firma that you can see for yourself is honeycombed and permeable like a sponge. Water, lest we forget, even threatens the basilica of San Marco. Paul Morand, who visualized the great church as a "mosque whose declivitous and swollen tiling seems like juxtaposed prayer rugs," saw its terrain as deformed by the thrust of the ocean waves, modest though quite obstinate rollers ("ground swells" in every sense of the word) that surged beneath the Piazza San Marco where, bad weather permitting,

"water seeps from the cobblestone joints." Maybe one day you, too, will see one of those road workers whom we might call a navvy, were it not that the word itself seems dangerously poised to plunge into the waves. There was one digging away on the Piazzetta San Barnaba, buried up to his shoulders in a small, squarish hole dug right in the middle of the paving stones, just some fifteen feet from the canal. The more you looked around him, the more the earth seemed visibly soaked—so intimately steeped in and colored by the green mire, you expected to see a bubbling fountain spurting up between his boots at any moment. It was immediately obvious: Venice had sprung a leak, was about to sink—or conversely, about to run completely dry. Hard as it is to imagine, that did occur following an earthquake in the fourteenth century: "For two hours the Grand Canal was dry."

In the end, you probably ought to trust each and every one of those who will tell you how and when you must see Venice, at what time of day, in what season, in whose company. In that regard James Abbott McNeill Whistler, as opinionated as ever, won't let you down. For the painter, Venice must be seen after the rain. And he is not mistaken. Viewing the city through the polished lens of a recent shower is the best chance you have of catching sight of fabled Byzantium shining behind Venice.

The Russian-American poet Joseph Brodsky was the lover of still another Venice—colder, more wintry. Indeed, to hear him describe it, the Adriatic seaport is almost a Saint Petersburg of the south. He found himself flooded by an overpowering sense of well-being as soon as his nostrils were hit by the "smell of freezing seaweed" in the air. For Brodsky that particular scent was always synonymous with "the

feeling of utter happiness" because, first of all, as a poet he was charmed by the sonority of the Russian word for seaweed, *vodorsli.* But he was especially moved for a reason that he situated "beyond the confines of biography, beyond one's genetic makeup—somewhere in one's hypothalamus, which stores our chordate ancestor's impressions of their native realm of—for example—the very ichthus that caused their civilization."

Brodsky's triply original temperament—as an admitted descendant of the phylum Chordata, as a Russian, and as an exile—enabled him to enjoy certain little pleasures others would perceive as inconveniences. The first of these is the city's *nebbia.* Not only does that fog wrap Venice in billowing clouds of cotton like a thick muffler against the chill, it effectively puts an end to all commerce and movement: "The fog is thick, blinding and immobile. The latter aspect, however, is of advantage to you if you go out on a short errand, say, to get a pack of cigarettes, for you can find your way back via the tunnel your body has burrowed in the fog; the tunnel is likely to stay open for half an hour." And there is a hidden advantage, furthermore, to the *nebbia,* for "having failed to be born here, you at least can take some pride in sharing its invisibility." The second drawback comes from living with one foot in the sea, a blessing, too, in a way: "*Acqua alta,* says a voice over the radio, and human traffic subsides. Streets empty; stores, bars, restaurants and trattorias close. Only the signs continue burning, finally getting a piece of the narcissistic action as the pavement briefly, superficially, catches up with the canal. Churches, however, remain open, but treading upon the water is no news to either clergy or parishioners." A third overlooked delight is something a poet born in Saint Petersburg would understand immediately: "This is the winter light at its purest. It carries no warmth, no energy," having abandoned them en route. It is so weak that "you sense this light's fatigue as it rests in Zaccaria's marble shells." These are rare pleasures indeed, however bleak they may appear to the city's permanent residents.

Still other visitors have taken away with them a less peaceful impression of the Venetian winter. This is how Robert Coover sees the Piazza San Marco when it falls prey to *acqua alta:*

> *Un tal pandemonio* as we used to say, *un tal passeraio, un tal baccano indiavolato,* you'd think, sitting here, you were in a ship on a boiling ocean! Waves crash against the columns and resound in the arcades below us, as if to loosen the palace from its very moorings and send it out to sea, the sunken street lamps standing there like rows of lilac-tinted channel-markers out there showing us the way! Wastebins bob in the Piazza like buoys,

inverted umbrellas tumble past like broken winged birds, toothy predatory gondolas dart through the very porches of the Golden Basilica squatting helplessly in its stormy bath, and those red banners up there flap in the wind as though they might be wild wet sails, urging us upon our fatal course, as the entire trembling city seems suddenly intent on plunging downward to a watery doom.

Clearly, the Venetian raft could sink beneath a veritable library of quotes. To each his Venice, to each his view. Yet the very building up of these contradictory outlooks is surprisingly similar to the haphazard architecture of Venice herself, her brick, marble, stucco, and mosaic.

Of the thousands and thousands of pleasures that poor blinkered Zola missed, which should we mention? There is, for example, the *traghetto* to Giudecca. Hop on the boat plying between Zattere and Zitelle some afternoon when the sun is hammering down on the city and take a trip to that well-known quarter of the city. (Does the name Giudecca come from the Giudei, the Jews, who were confined to that area; or from the *giudicati,* "the judged," the aristocrats who were banished there? Justice may be long in coming and may only be poetic, but nowadays when you are suffocating in greater Venice, the thing to do is to betake yourself to Giudecca.) Setting out from the sunny pontoons you've just left behind, you have the delicious feeling that you've put a safe distance between you and the accursed precinct of San Marco, with its massed troops of tourists. You might push on through the sleepy streets to the end of the island to see a fine example of Germanic industrial architecture, the Mulino Stucky, built as a flour mill in 1895 and used well into the twentieth century. Or perhaps you immediately take advantage of the cool interior of Sant'Eufemia, a small church that offers an incredible mixture of architectural styles with its sixteenth-century porch, its columns, its eleventh-century nave, and its Venetian-Byzantine capitals. Afterward you'll have no qualms about giving in to the urge to relax on the deserted terrace of Harry's Dolci in order to read the papers by the canal while ordering a *spremuta* or an iced tea served in a cloudy beading pitcher with little capsized lemon wedges bobbing in the amber liquid.

There is also the Ghetto—the world's first and the ultimate root of the word—which seemed so medieval to Théophile Gautier, and so modern to us. As the nineteenth-century writer depicted it, "the lanes grow narrower and narrower; the houses rise like Babels of hovels stacked one atop the other. . . . Some of these houses have up to nine stories, nine zones of rags, refuse, and foul industries. . . . This stinking, swarming neighborhood, this watery slum, was, simply enough, the

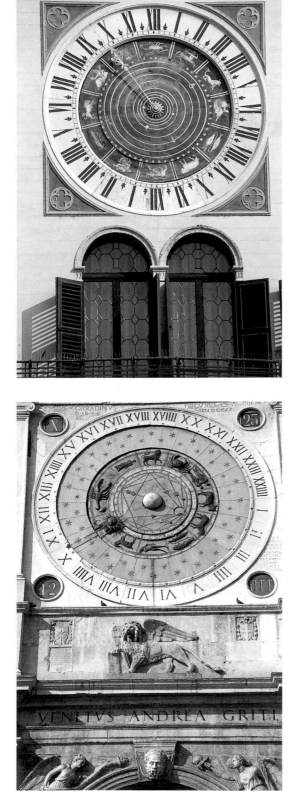

CLOCKWISE, FROM UPPER LEFT:
ZODIAC CLOCK
◆ ◆ ◆
Bassano del Grappa

SAN GIOVANNI
BELL TOWER CLOCK
◆ ◆ ◆
Treviso

ARSENALE CLOCK
◆ ◆ ◆
Venice

CLOCK TOWER ON
PIAZZA DEI SIGNORI
◆ ◆ ◆
Padua

Ghetto . . . which had retained the characteristic squalor of the Middle Ages." On the other hand, what can be more familiar to us today than these early Venetian skyscrapers, like the high-rise apartment blocks of ancient Rome? And what can be less exotic than this melting pot on the Adriatic, where the city's Jewish community was confined after 1516? That is, after all, the etymology of *ghetto,* from the island called Getto ("foundry" in Venetian, for the one that once stood there): the Ghetto is thus the melting pot to which all those who were cast out from the rest of the population were assigned. Enter a local *enoteca,* or wine shop, and have a bite to eat, either an ordinary plate of *polpette* (small, piping hot potato croquettes), or the more refined *nervi di bovi,* white, smooth, iridescent, and fine-drawn beef innards, washing down your meal with an *ombretta* wine. If ever there is a storm brewing, however, don't let yourself be tempted by a menu that proudly announces *panna montata alla vecchia maniera* ("cream whipped the old-fashioned way"). The apologetic owner will invite you to come back in fifteen minutes, after which he will again ask you to take another little stroll, and so on, until the weather changes—otherwise your whipped cream will curdle!

Maybe you'll have the chance to visit the island of San Michele, Venice's island of the dead, on a fine hot day. After you've taken a drink from the first water fountain you happen on, and hunted down Pound's or Stravinsky's tomb, perhaps you'll stumble on the deserted trestle on which a few grave diggers have just eaten their lunch in the shade. If you're not put off by the paradoxical presence of the departed, maybe you, too, will settle down on a wooden bench to snack on a salted raw tomato and some *provolette affumicate* (also called "the pope's balls"!) with a hunk of bread, before slaking your thirst with a gulp of fresh water from the fountain. And while the cicadas' sharp staccato chirring in the cypresses fills your ears, perhaps you'll stretch out on the bench for a quick nap. If you're not irremediably of a stern northern temperament, you will no doubt grasp why Mediterranean cemeteries look more like gardens run wild. And perhaps then you will sense that one of the secrets of this civilization is keeping in touch with the deceased, maintaining a kind of friendship, in a way. If you are lucky enough to feel that, you will be at peace.

Rereading that novella by Thomas Mann that has associated death and Venice forever in many minds, you may come across these two passages. In the first, Aschenbach, at the end of his cruise across "the foul-smelling lagoon" that brings him from the Lido to town, is struck by the oppressive heat of the city's narrow lanes—the air of which, thick with the uninviting odors wafting from the houses, shops, and restaurants, saturated with rancid oil, perfumery, and cigarette smoke, hangs low like an exhalation. Retreating toward the poorer neighborhoods in an effort to flee the crush of the market streets, he is further harassed by the stench of the canals and the pestering of beggars. He hardly has settled himself on the margin of a fountain in a peaceful square when he realizes he must leave Venice. In the second passage, later in the story, a different Aschenbach crosses Venice, once again in a gondola: "The air was heavy and foul, the sun burnt down through a slate-colored haze. Water slapped gurgling against wood and stone. . . . They passed little gardens, high up the crumbling wall, hung with clustering white and purple flowers that sent down an odor of almonds. Moorish lattices showed shadowy in the gloom. . . . Yes, this was Venice, this the fair frailty that fawned and that betrayed, half fairy-tale, half snare." Between these two very contradictory impressions lies, of course, that salutary distance that comes when the gaze is transfigured by love. For Aschenbach, however, his unforeseeable love becomes his supreme pitfall, trapping him in both his dream Venice, the city of legend, and a Venice ravaged by an outbreak of cholera. To any and all visitors to this enigmatic construction of sea and Istrian stone: know, then, how to practice the art of evasion, without which, if we are to believe James, half the enjoyment of Venice is lost.

Returning from San Michele toward the city proper, perhaps now you will cast a more benevolent eye on the city's masks and putti. Perhaps you will look on all the creatures of the Venetian bestiary with more tenderness. The city teems with animals. On the prows and sides of gondolas are rearing sea horses. On the great doors of the Arsenale, the capitals of columns, the spouts of fountains, and the pediments of buildings are innumerable lions, roaring or in repose, winged or rampant, meditative or aggressive, wild or impassively wise. It is not really strange to run across this populous menagerie of horses, dragons, griffins, lions, mermaids, sea horses, phoenixes, and sea monsters. No, what is odd in this city, where the air is perpetually stirred by flights of pigeons, even fouled occasionally by the smell of their droppings and the stink of cats' urine, is that there are hardly any animals other than the stone and stucco beasts that are painted or carved, finely chiseled or crudely roughed out. The whole collection is largely imaginary, pure fantasy even. In Venice the lion naturally stands alongside the phoenix, the horse alongside the dragon. Seeing this zoo, you'll have no trouble imagining Venetian sailors back from their distant travels, taking in their fellow citizens with more or less detailed descriptions of nonexistent monsters. But the truth may not be limited to such a prosaic explanation, after all. With the haughty indifference that led them to blend absolutely distinct styles in composing their composite city, didn't the Venetians mix what they had seen with

their own eyes and what they had only heard of, treating themselves to a setting that willfully blurs the lines separating dream, nightmare, and waking reality?

Whatever the reason, there is one species of monster Venetians have been careful not to add to their fantastic bestiary, doubtless because they have seen too many of them, too often, since the last century. Those monsters migrate in docile droves, rarely venturing from the well-traveled path. They are the chief obstacle you must avoid if you want to enjoy La Serenissima. On the other hand, try as you may, you can no longer escape certain horrors done to the city to attract them, the worst being the spotlights illuminating Venice's monuments after sundown. It is obvious you probably want to stay away from those "herds of fellowgazers" whom James belittled whenever he felt most audaciously Venetian. For James this was on wintry nights, or toward teatime in gloomy weather.

If in those choice moments, however, James hoped to eliminate all tourists from his field of vision, he was just as keen on keeping the Venetians. All that seems banal must be meticulously excised. So be it. And everything that appears picturesque must serve as background. Fine. But what about the extremes to which the dangerous separation of the banal and the picturesque pushes a Venice-lover like James? In his day he could already see for himself that "their habitations are decayed; their taxes heavy; their pockets light; their opportunities few." What of it? James concludes that the dire poverty is just part and parcel of the show—even the pleasure—that Venice has to offer any passionate pilgrim to her shores. He thought that the poorer classes should be content with the privileges that nature granted them, namely, "lie in the sunshine . . . dabble in the sea . . . devote themselves," especially in the winter, to the joys of a perpetual conversation while falling "into attitudes and harmonies," dressed in "bright rags." Lie in the sun, dabble in the sea, chat—what could be more natural? Less natural is striking a pose for the benefit of others, however fond and passionate they be. It goes without saying that native Venetians are either in movement or in repose. If there is a pose, it is projected by the gaze of the devotee of local color. And that devotee is prepared to compromise truth for his taste for the picturesque: for example, while altogether aware that many Venetians in his day often went hungry, James notes with a certain envy that they live on a diet of sun, leisure, light talk, and their magnificent surroundings. Indeed, a great deal is needed "to make a successful American," but a mere "handful of quick sensibility" to make a happy Venetian. We might forgive James his specious reasoning here, for it allows him to take staying in Venice and experiencing the little daily pleasures the city provides over read-

ing Ruskin, say, or even "old records." All the same, by adjusting the division between the picturesque and the banal, the negligible and the spectacular, you cannot help but miss a good part of what makes Venice unique. Those who crave local color, however, beware: you are only tolerated in the city, as Gautier well understood. Having heard about the soup *ai pidocchi* of an old fisherman on the island of San Pietro, beyond the Giardini Pubblici and the tip of Quintavalle, at the far end of the Riva degli Schiavoni, Gautier dropped in and insisted on being served beneath an arbor smelling of grapevines, figs, and flowering gourds. Following the famous soup, he was brought oysters *aux fines herbes,* crayfish, sole, poached mullet, and fried sardines, the whole washed down with a bottle of Valpolicella and a drop of Picolit. Gautier did not contest the steep bill, for he understood that foreigners pay a good third more than native Venetians "for the costs of translation." We wonder how the writer found the energy to go for a walk in the Giardini Pubblici after such a feast. Gautier's secret is that he loves Venice, indeed is taken by her in more ways than one and doesn't mind. And to imitate him is surely worth a try. You might not only enjoy a constitutional after giving in to a plate of eel with polenta, but also repeat to yourself the modest reminder that to be tolerated in Venice, a visitor must know how to pay up with good grace, even when slightly overcharged. Less exotically, you might settle for a few *tramezzini* on some sunny terrace, or, as the mood strikes you, one of those heaping plates that contain "so much seafood that the noodles become seaweed," if, like Morand, you wish to pay homage to the culinary genius of the place.

Venice has been abundantly described and painted and, since James, profusely photographed and filmed. Rather than try to recapitulate the voluminous literature and copious iconography devoted to the subject, the only possible attitude is to courageously toss out a good part of it. Some might find it a bit impudent even to claim to jettison any of it. Yet there's no denying that these artistic and literary souvenirs amount to layers and layers of paint, and pages and pages of print, that come between Venice and the gaze you fix on her. Nowadays the tourist who aspires to be a simple lover of the city need not "do" Venice in a group and can dispense as well with the services of a cicerone (although a paper guide, or at least a map, is always welcome). But there is no getting around the fact that "the tourist does not devour Venice, but talks about Venice . . . the oral commentary on San Marco, the Palazzo Ducale, Tintoretto." For Henri Lefebvre, it is precisely because of this diet of words that Venice, the city beyond compare, eludes insatiable consumers of commentary. Venice inspires an apparently endemic nostalgia that is impossible to satisfy. You hear

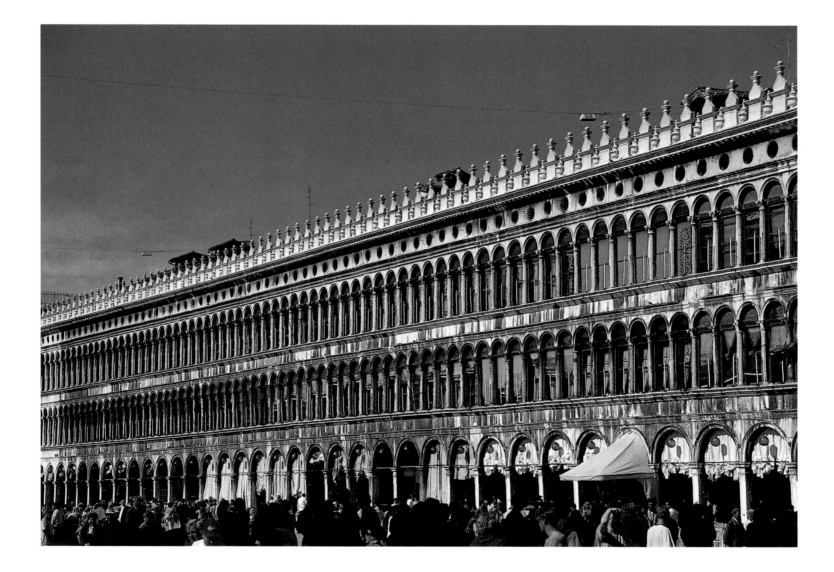

CAFES AND SHOPS IN AN ARCADE
OF THE PIAZZA SAN MARCO

◆ ◆ ◆

Venice

such an emotion expressed in its pure state by the native inhabitants of certain lands, places they and their families have *always* lived in. It is also found in a native state along the entire perimeter of the Mediterranean, or especially in almost any village in Corsica, but also in the middle of the Atlantic, on the small islands of Cape Verde. Its refrain is nearly always the same: "Ah, if you had only been here thirty years ago!" But Venice's *paesani,* her native islanders of long standing, will sigh, "Ah, if you had only been here three hundred years ago!" In Cape Verde, the claim is almost convincing: passing though valleys that are magnificently luxuriant in some spots, rigorously barren in others, you ask the local inhabitants why. "Ah, if you had only been here thirty years ago!" someone answers. "The countryside wasn't devastated by the goats yet, the mountains were still covered in woods, the vegetation stopped the clouds, and rain would pour down, maintaining the plants." Back home, you come across a text one day in which Darwin records more or less the same reflections, and then you grasp that this reflex among native inhabitants is actually quite well intentioned.

To experience this city, to grasp her at least mentally, you also have to risk seeing her through the eyes of her worst critics. With her back to terra firma, Venice is likewise a stultifying stone prison cut off by the sea, a "scenic city" that lends itself to every sort of treachery, a "swampy dungeon full of dangers that foreshadows death." One of the first words that his native city wrings from Giovanni Casanova in his *Memoirs* is especially eloquent in that regard. His cry of "adieu Venice!" is one of relief. Before raising his cheer, however, he barely devotes a word to describing Venice. She is a kind of imperious given, it would seem, from which he had to break free, whatever the cost. And it took Casanova nearly the entire length of his life and story to eventually evoke what Venice was for him. Without depicting it directly, the native scapegrace, who took a famous turn as an escape artist (a feat that made him the toast of Europe), thinks he recognizes it in another Mediterranean port, as if he could only conjure up his birthplace through the diffracted lens nostalgia provides. La Serenissima is not the least serene; those who see her as sinister (witness the dark maw of the Bocca del Leone) or grotesque (think of the white-and green marble drapery of I Gesuiti) will surely find the neologism she inspired Herman Melville to coin, "Venetianly corrupt," to the point. If that is how they feel deep down, then they should definitely steer clear of this city; at best they can hope to run into someone able to show them an entirely different Venice. To experience Venice on your own, you really must trust to your heart. Proust tells us as much when the narrator of *Remembrance of Things Past* speaks of the emotion that floods through him in the Scuola degli Schiavoni as he recognizes,

in a painting by Carpaccio, the very coat that Fortuny was able to pluck from the shoulders of a member of the Calza guild "to throw it over those of so many Parisians," Albertine in particular. Or when the "tall, inlaid chimney stacks" in the same painting immediately remind him of "so many Venices by Whistler." Is it possible to see this elusive town other than with the same eyes the narrator turns upon his sweet cheat, who has vanished from his life?

William Gibson's novel *Idoru* presents two young girls plunging into the virtual Venice of an interactive computer game that one was given for her thirteenth birthday. The computer game offers a water maze of bridges, arches, walls, and a piazza surrounded by facades of marble, porphyry, polished granite, jasper, and alabaster ("the rich mineral names scrolling at will in the menu of peripheral vision"). The same little girl even knows that Hitler (to whom current pop tunes occasionally allude—which gives her a vague idea of Hitler's personality) apparently shook off his guards in order to wander the streets of the town early one morning. "It's a city in Italy. It used to be a country," she tells her friend, who asks, "This is where the water comes up to the bottoms of doors, and the streets, they are water?" To which she replies, "I think a lot of this is underwater now." How else might one imagine a virtual Venice than the distant reflection, the trembling digital image resuscitating a ghost town? The prospect of Venice's disappearing one day seems so improbable that we can only envision it as a catastrophe. Were such an event to occur, it would prove inexorable but slow. We have, it seems, all the time in the world to watch Venice in her agony. And if we were then to enter San Marco in a gondola, we might lean out over the waters and ponder what we were losing. When the real Venice, swallowed up by the envious sea, has returned to the element that generated and regenerated her for many centuries, no virtual one will ever supplant her; in William Hazlitt's words, only a city built in the air might surpass this city of water.

To prepare ourselves for that day, we ought to turn our attention now to the charms of her wider surroundings. On the lagoon itself lies the pretty little port of Burano, for instance, with its gaily decorated houses and shops selling machine-made lace from Hong Kong and Taiwan; but we are certainly free to prefer a tiny harbor like Chioggia to that well-manicured place. Cross the town's fish market and you understand how Goldoni got the idea for *Le Baruffe chiozzote* (Rows in Chioggia), one of the funniest of his "Billingsgate" comedies, so called because they capture the salty language of this race of fishwives and fishermen. Or you may rather want to make an excursion to the cloister of the Franciscan monastery that stands beneath the cypresses of

the peaceful islet of San Francesco del Deserto. Or perhaps a return visit to Torcello. But wherever you go around the lagoon, you must try, if only once, to come back around sunset to savor one of the delights of Venice that Frederic Rolfe, alias "Baron Corvo," beautifully rendered, the pleasure of contemplating the "twilight world of cloudless sky and smoothest sea, all made of warm, liquid, limpid heliotrope and violet and lavender, with bands of burnished copper set with emeralds, melting . . . into the fathomless blue of the eyes of the prides of peacocks, where the moon rose, rosy as mother-of-pearl."

Perhaps one day you will also dream of setting foot on terra firma—but then, Venice herself took a few centuries before turning to her hinterlands to drain and develop their marshy stretches. And you, too, might allow yourself the illusion of being a true native and treat yourself to the summertime pleasures that have lured many generations of Venetians outside the city, not to return until winter. Gautier described the seasonal routine of the nineteenth-century Venetian: "Summers are spent back in the provinces, in country houses festooned with grapevines along the Brenta, or in small rustic farms in Friuli." If, on the other hand, the urge to be out and about in hills covered in vineyards and cypresses overcomes you, it's time to hie yourself to Asolo, the perfect place to wander footloose in the open air. The name of this small town in the hills of Veneto is itself almost heard (is it mere coincidence?) in *asolare,* a literary term that means "to take a breath of fresh air," or "to wander about."

Without going as far afield as Asolo, it is in the same spirit of idling away the hours that Palladian villas ought to be seen and understood. Indeed, the more you look at them, the more clearly you grasp the dual nature of the structures that the sixteenth-century Venetian aristocrats raised for themselves: practical and sumptuous. All of these stately homes were designed as unfortified villas. Other architects, Jacopo Sansovino for instance, were capable of erecting palaces in the middle of the Veneto countryside. Andrea Palladio alone had a flair for building cheaply and quickly, drawing on Roman villas for his inspiration. He created a style of architecture that was to captivate the rest of Western aristocracy, which shamelessly copied or adapted it (with varying degrees of success) for two centuries thereafter. No doubt the great Italian architect benefited from an exceptional setting. When Charles de Brosses traveled over this region he noted that "perhaps the terrain lying between Vicenza and Padua is alone worth the trip" to Italy, its lands overrun with "creeping grape vines." The Palladian villas there are either rustic manor houses created for people who intended to live like true country squires, or luxurious, ostentatious mansions. Those built in the small towns and their environs boast two

floors and porches with projecting pediments. Those standing on vast properties and designed with a rural function in mind have a more modest one-story central core flanked by *barchesse,* wings that enclosed stables, sheds, and pigeon houses.

At the foot of Asolo in Maser, for example, the practical rural aspect of the Villa Barbaro and its *barchesse* (which were designed to shelter animals) is balanced by a whole floor decorated with frescoes by Paolo Veronese and trompe-l'oeil windows depicting imaginary perspectives, along with a grotto and a *tempio* containing the Barbaro family chapel. Hardly nine miles from Venice stands the Villa Foscari, known as La Malcontenta, its superb facade overlooking the waters of the Brenta. Morand found the river so polluted by the twentieth century that he immediately understood the tears of the weeping willows on its banks; what would he have said had he seen La Malcontenta surrounded by the Marghera's oil refineries, which have since invaded the neighboring marshes? The belvedere is sumptuousness taken to the extreme—another example is La Rotonda near Vicenza, with its four porches, which affords as many spectacular views. Sceptics naturally will object that there are but nineteen Palladian villas in all. To which we might happily reply that on terra firma there are Vicenza, Verona, Padua! And Treviso, Montagnana, Conegliano! And so on, so many other towns where Palladio has left his mark.

Of course you must visit Vicenza, if only because the town and surrounding countryside contain nearly a dozen palaces or public buildings (whose incomplete interiors are concealed behind outstanding facades), a basilica, and several villas (at times extensively damaged by warfare, weather, or want of attention by their strapped owners), which are all the work of Palladio. Likewise you must see Verona, if only for its Roman amphitheater, the Arena (the third largest of its kind in the world); its Romanesque church, San Zeno Maggiore (imagine a religious building erected in memory of a bishop called Zeno!); its Gothic Castelvecchio; its Renaissance palaces; its homes with red marble facades. This, the second largest town of the Veneto, proves that life did exist beyond Venice, near Venice, even before Venice.

As for Padua, you will want to see that town for its double sky: for this, retrace the footsteps of Proust's narrator who, momentarily tired of Venice, "after crossing the garden of the Arena in the bright sunshine," enters the well-known Arena chapel decorated by Giotto, "where the entire vault and the background of the frescoes are so blue it was as if the radiant day had passed the threshold, too . . . and had come to rest for a moment, in the shade and cool of the interior, its pure sky, a sky barely a little darker for being relieved of the gilt touches of daylight." You will certainly forget everything before "this

ANGEL ON SAN ROCCO CHURCH

◆ ◆ ◆

The Dolomites

sky transposed to the blue-tinged stone." Then you will set off again, go to the town's university, visit Europe's oldest dissection theater, see the vestiges of Andrea Mantegna's frescoes in the Eremitani and those of the Scuola di Sant'Antonio, and a thousand other treasures. Finally, in memory of Stendhal, who regularly dined there at three in the morning, you ought to go and relax at the Caffè Pedrocchi, "il caffè senza porta" (doorless, that is, because it never closed), one of the most famous and the most incredibly neoclassical of Italy's cafés.

But, you ask, do you mean to write off the brick ramparts and their twenty-four towers that continue to stand guard around medieval Montagnana? Or Treviso's canals, arcades, and the frescoes that have survived in her stately residences? What of the sublime perspective that Conegliano's Castelvecchio affords—a view of the Venetian plain on the one hand, and the foothills of the Dolomites on the other, which is worthy of her native son, the painter Cima da Conegliano? And the fresco frieze with its brilliant chiaroscuro effects adorning the Casa del Giorgione in Castelfranco? What of the Strada del Vino Bianco and the Strada del Vino Rosso that run from Conegliano to Valdobbiadene, and Conegliano to Oderzo? The hills covered with cherry trees in bloom around Negrar, the creeping vines of Soave and Valpolicella?

If you're asking these questions because you've already seen all of these places, then you must simply be eager to return. If, however, you're asking because you've only heard about these wonders, you may be in deeper trouble than you think. Like Gautier before you, you're in danger of falling so in love with what you're only just discovering that you may never be able to get away from Venice and the Veneto. Toward the end of his visit (which, mustering all of his power, he prolonged until autumn), despite the inconveniences—the morning fog over the lagoon, a sudden shower forcing him to take refuge beneath the arcades of the Procuratie Vecchie or the first porch that presented itself, the chill of the evening air—Gautier would barely stop to swallow a hasty bowl of soup *ai pidocchi,* a plate of polenta, an ice cream at the Florian. He ran himself off his feet avidly taking in the sights, "fourteen hours a day," without stop. And had he dared, he would have continued "by torch." If you feel yourself going down that same treacherous path, begin your visit around Asolo, and by all means take it easy. Allow all your senses to revel in this fabled place.

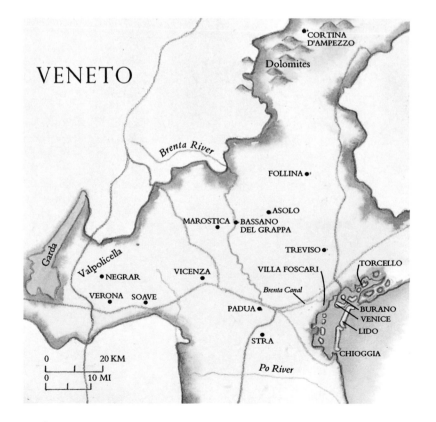

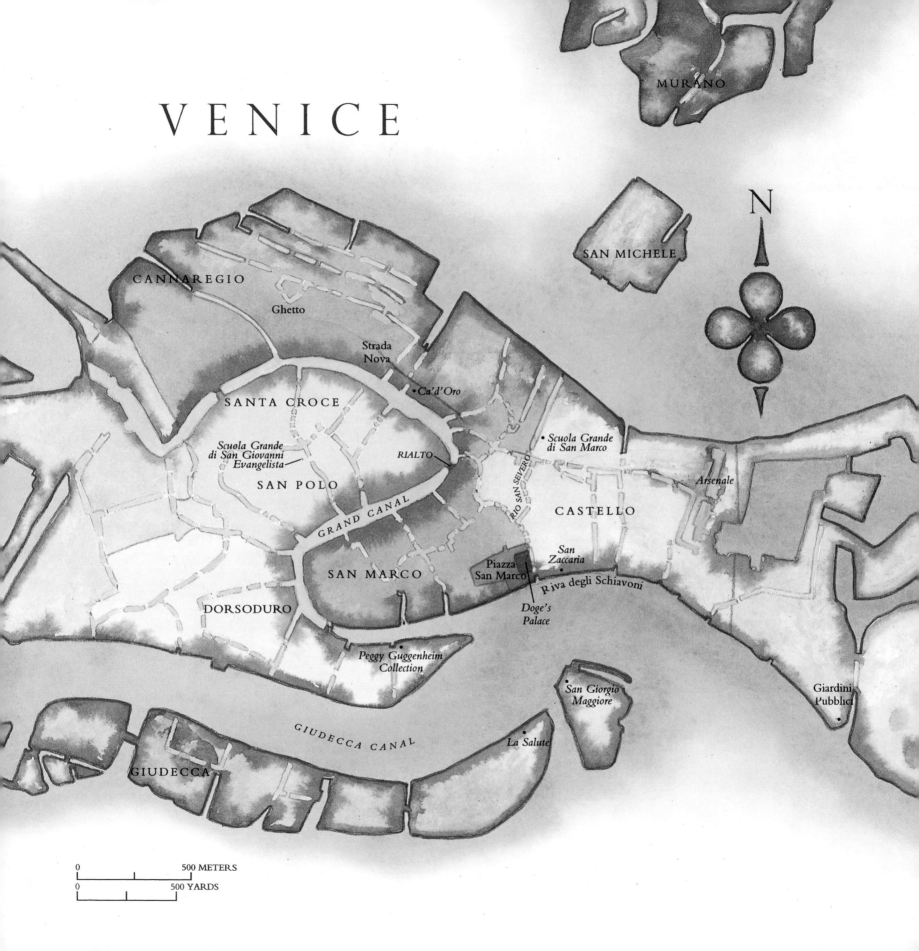

VENICE

MURANO

SAN MICHELE

N

CANNAREGIO

Ghetto

Strada
Nova

SANTA CROCE

• Ca' d'Oro

Scuola Grande
di San Giovanni
Evangelista

RIALTO

• Scuola Grande
di San Marco

SAN POLO

Arsenale

GRAND CANAL

CASTELLO

RIO SAN SEVERO

San
Zaccaria

SAN MARCO

Piazza
San Marco

DORSODURO

Riva degli Schiavoni

Doge's
Palace

Peggy Guggenheim
Collection

San Giorgio
Maggiore

Giardini
Pubblici

GIUDECCA CANAL

La Salute

GIUDECCA

0 500 METERS

0 500 YARDS

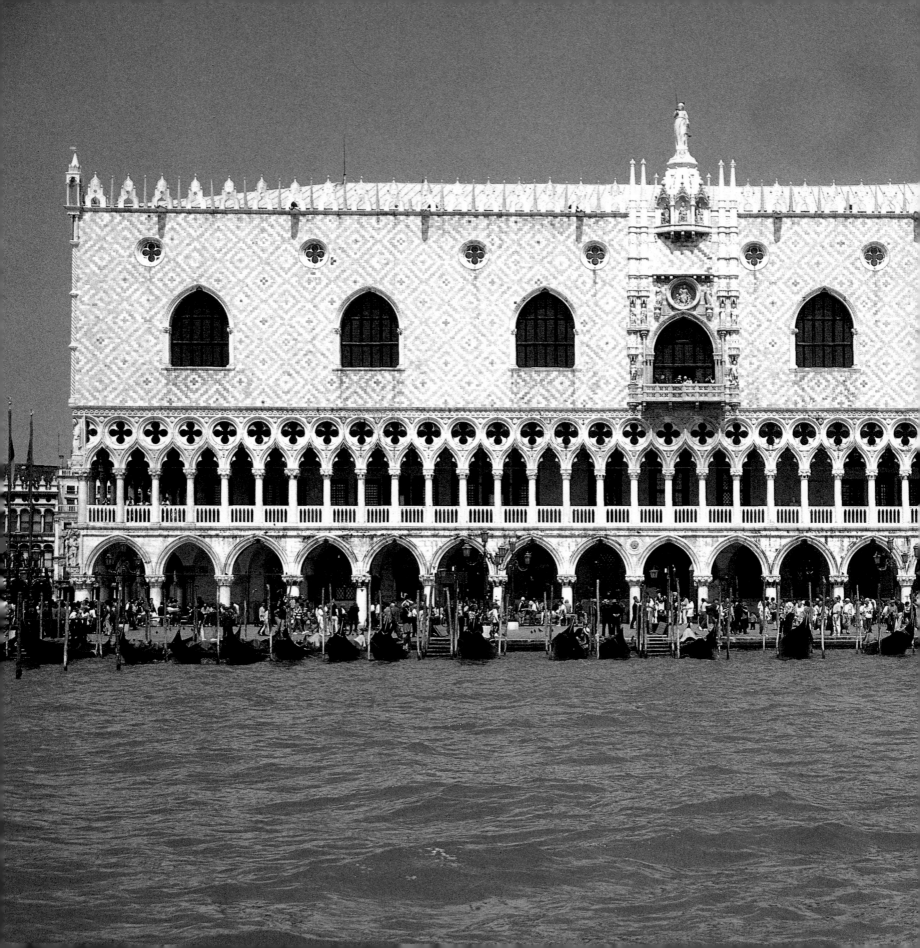

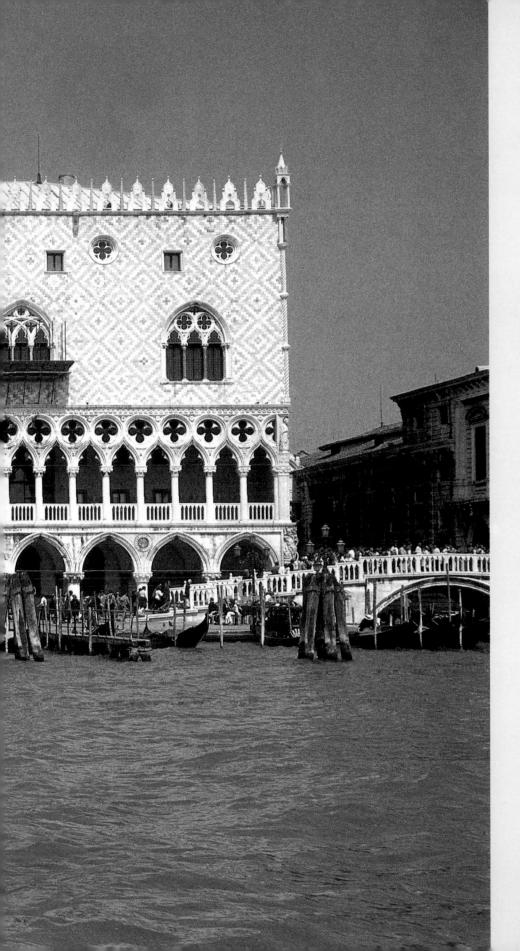

A WATERY REALM

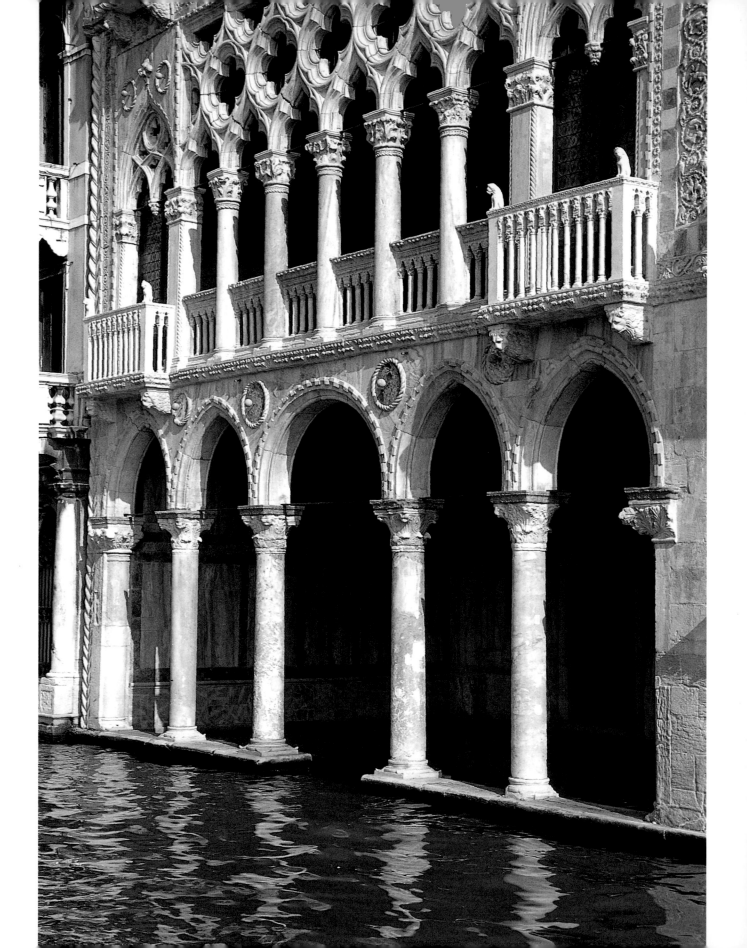

If there is one place that is truly a "kingdom by the sea," that place is Venice. Venice is a watery realm with canals for thoroughfares, quays and bridges for streets and sidewalks, and palaces raised on a platform made up of countless piles. A peaceful Oriental mirage in the heart of Italy. A painting come alive, a stage setting inhabited by real people, where travelers feel like simple passers-by dreaming of immortalizing all the marvelous scenes and moments that slip by. As Rainer Maria Rilke said, "All day long you brim over with pictures, but you would be hard put to it to point to any one of them. Venice is an act of faith."

PAGES 32–33:
THE DOGE'S PALACE
◆ ◆ ◆
Venice

OPPOSITE:
FACADE OF THE CA' D'ORO
◆ ◆ ◆
Venice

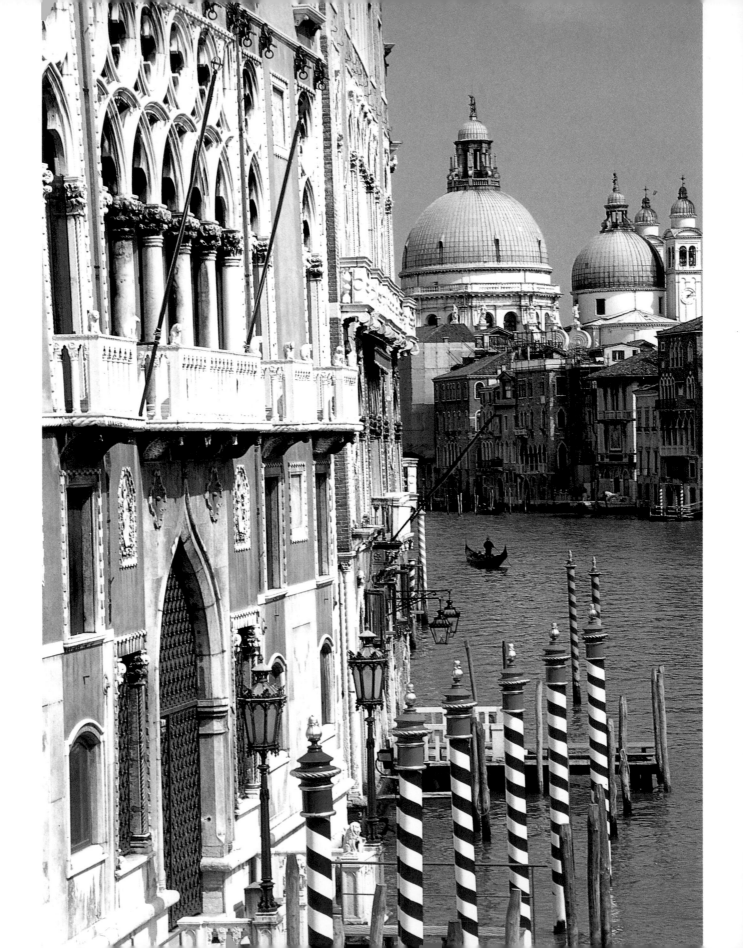

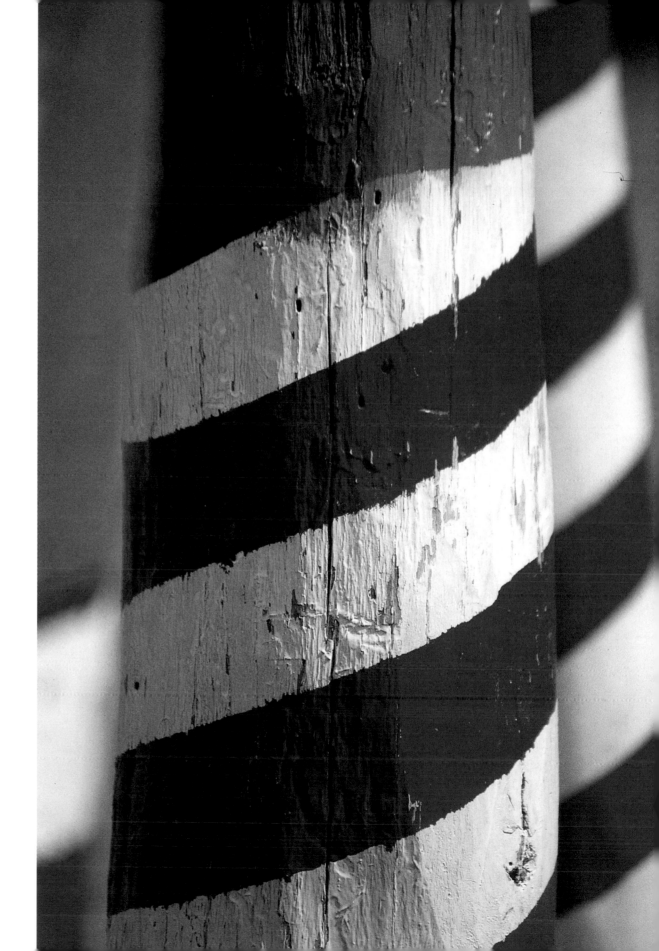

OPPOSITE:
ALONG THE GRAND CANAL
TO LA SALUTE
◆ ◆ ◆
Venice

RIGHT:
MOORING POSTS
◆ ◆ ◆
Burano

PAGES 38-39:
GOTHIC AND RENAISSANCE
FACADES ON THE
GRAND CANAL
◆ ◆ ◆
Venice

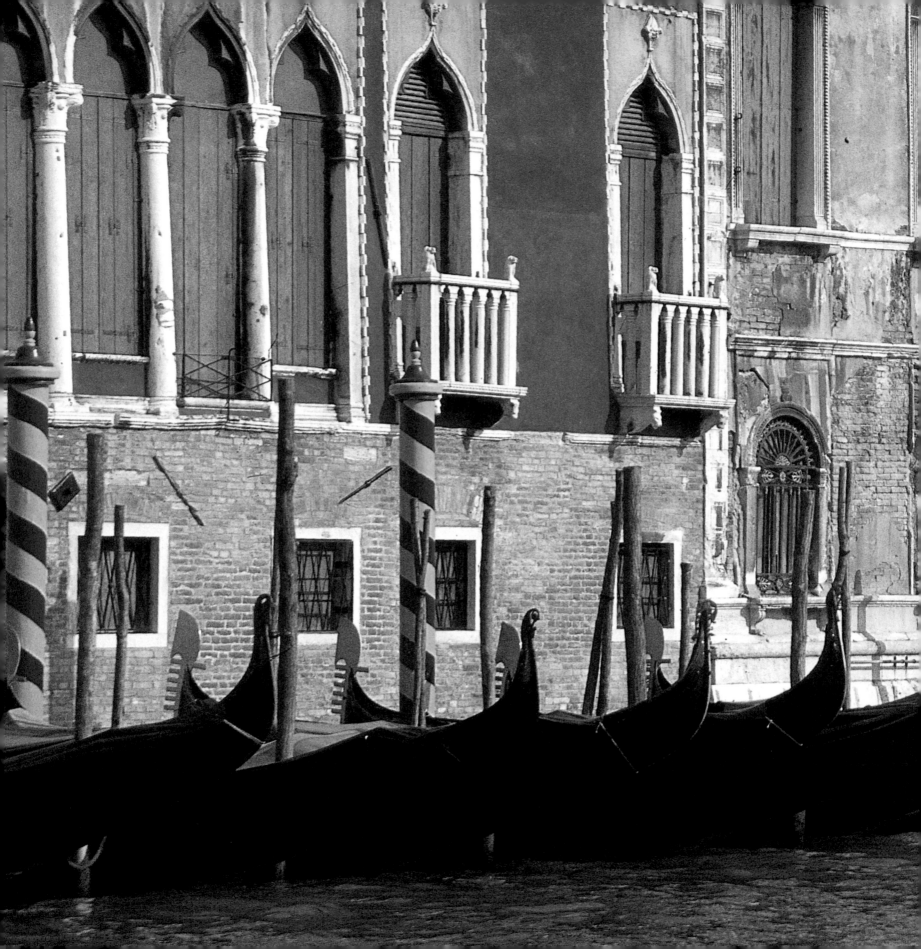

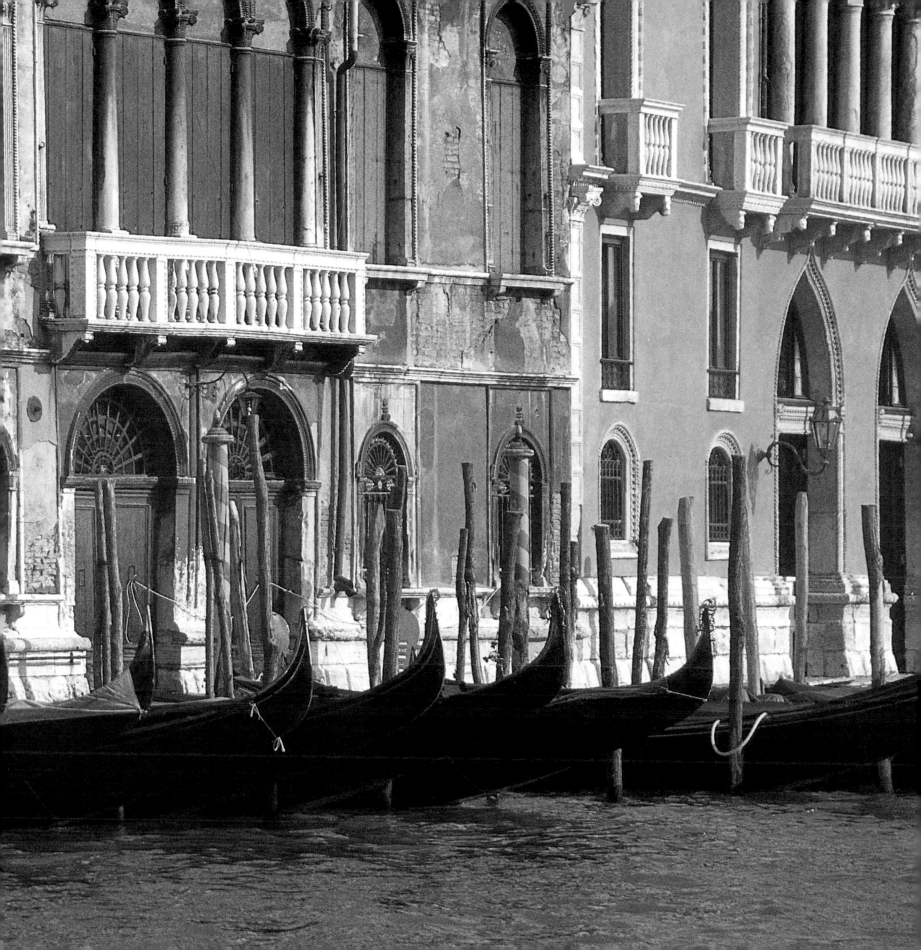

IDLING GONDOLAS

Venice

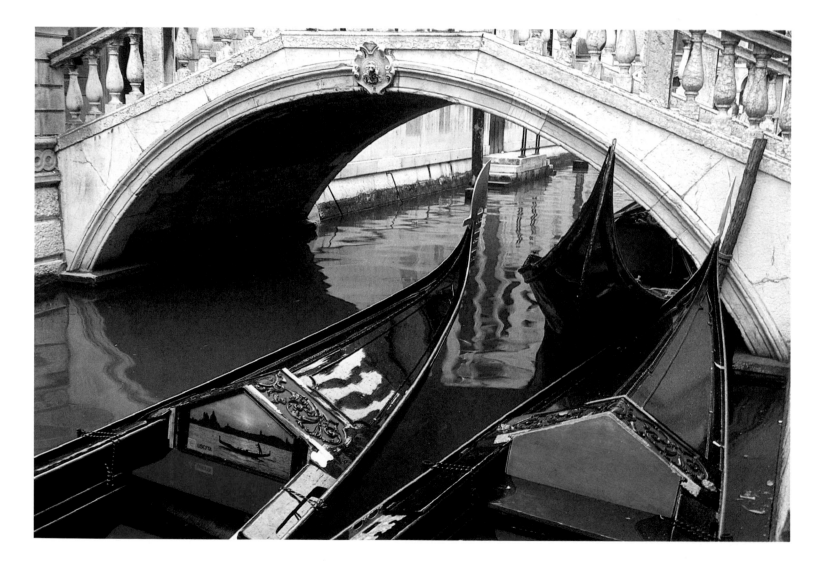

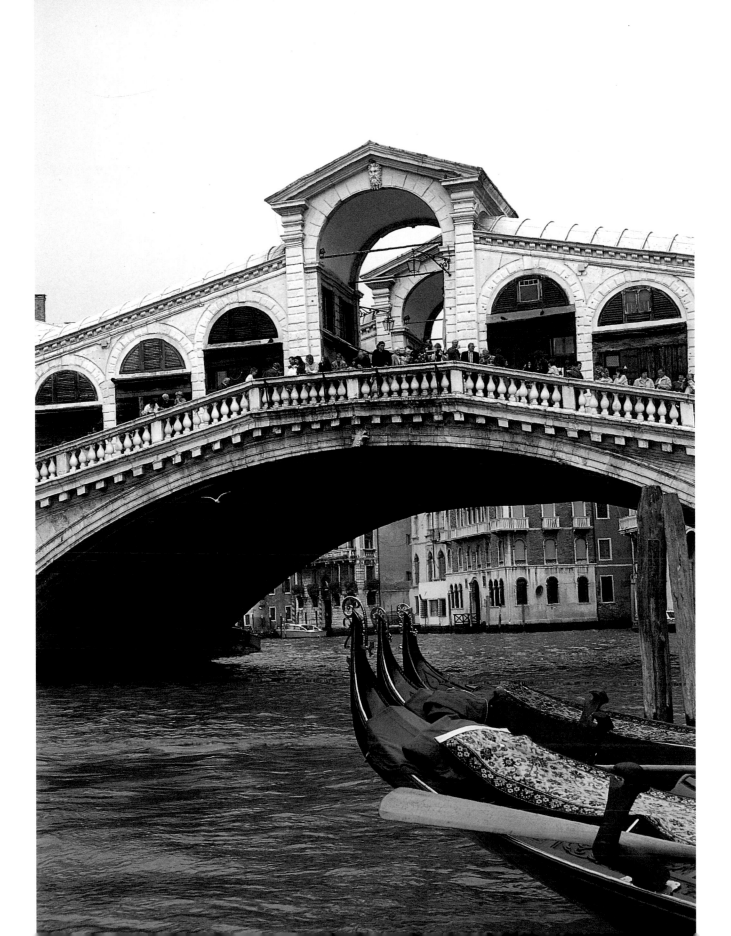

AT THE
RIALTO BRIDGE
◆ ◆ ◆
Venice

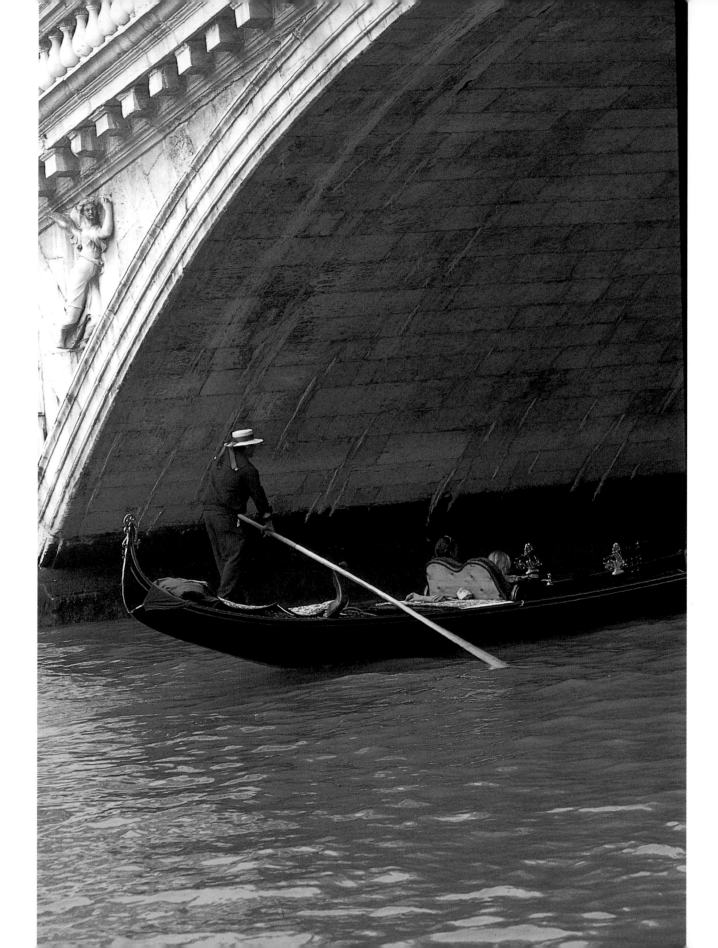

UNDER THE RIALTO
BRIDGE
◆ ◆ ◆
Venice

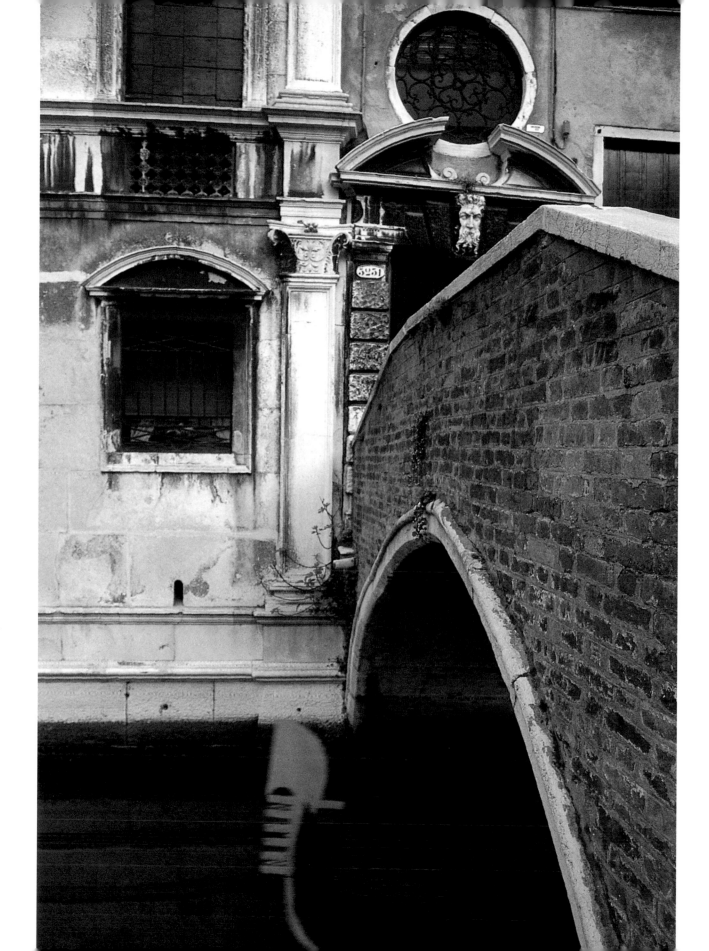

BRIDGE OVER
RIO SAN SEVERO
◆ ◆ ◆
Venice

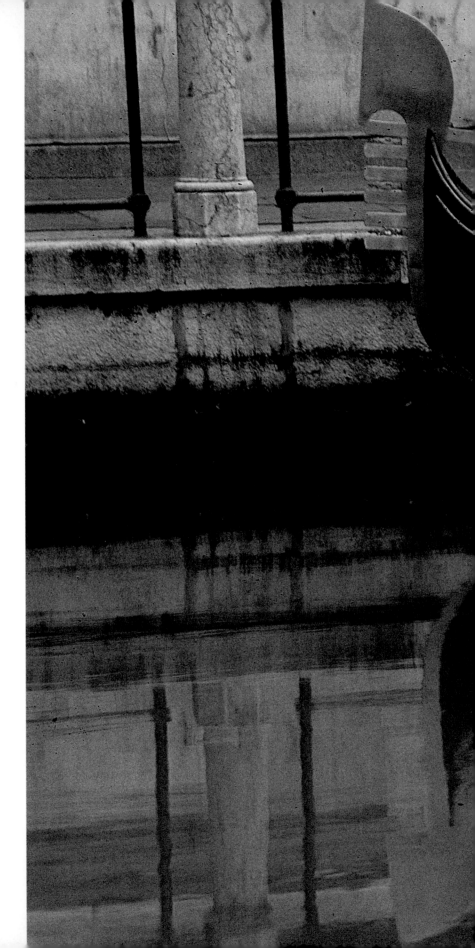

FLEET OF GONDOLAS AWAITING PASSENGERS

◆ ◆ ◆

Venice

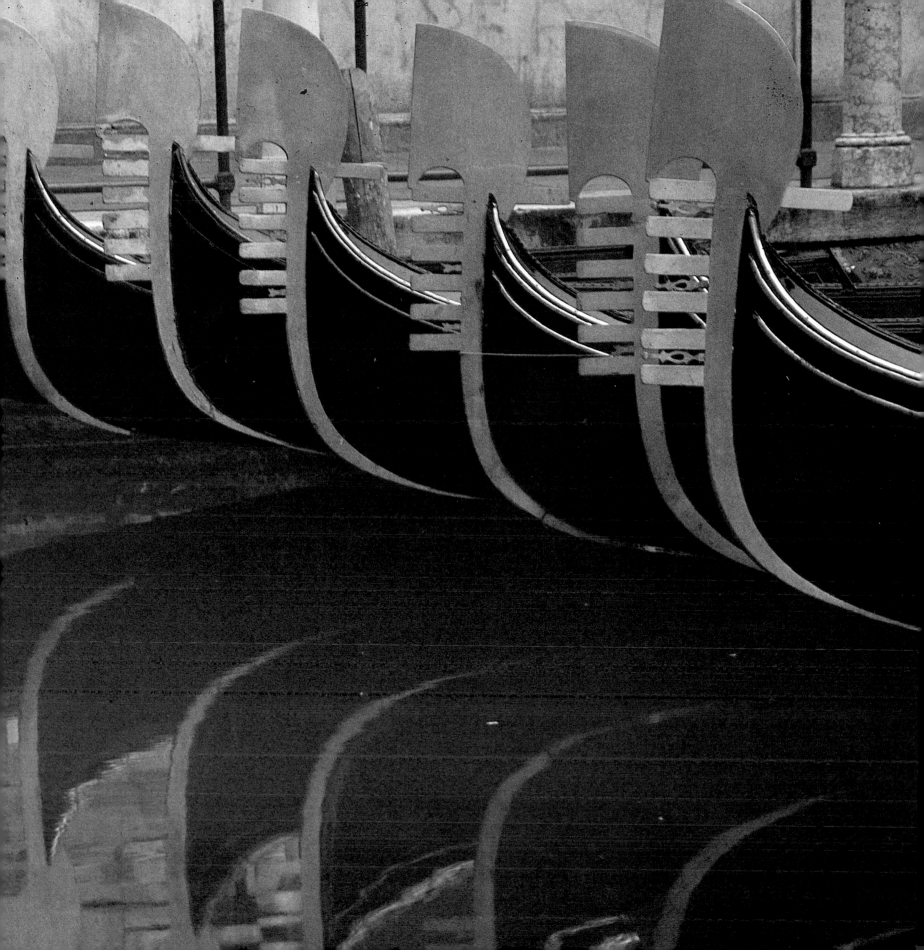

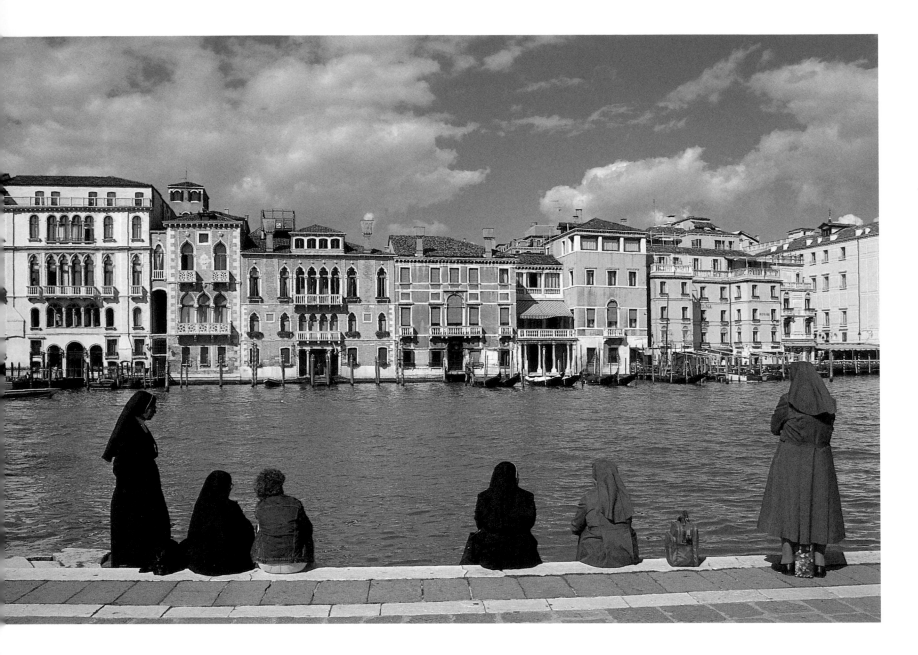

GRAND CANAL FROM LA SALUTE

◆ ◆ ◆

Venice

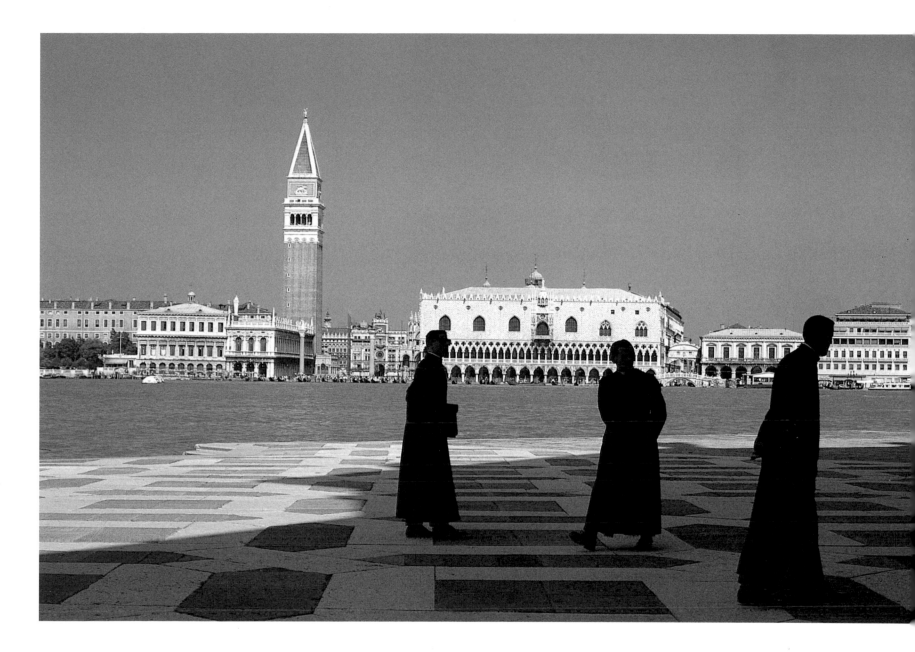

SAN MARCO FROM SAN GIORGIO MAGGIORE
◆ ◆ ◆
Venice

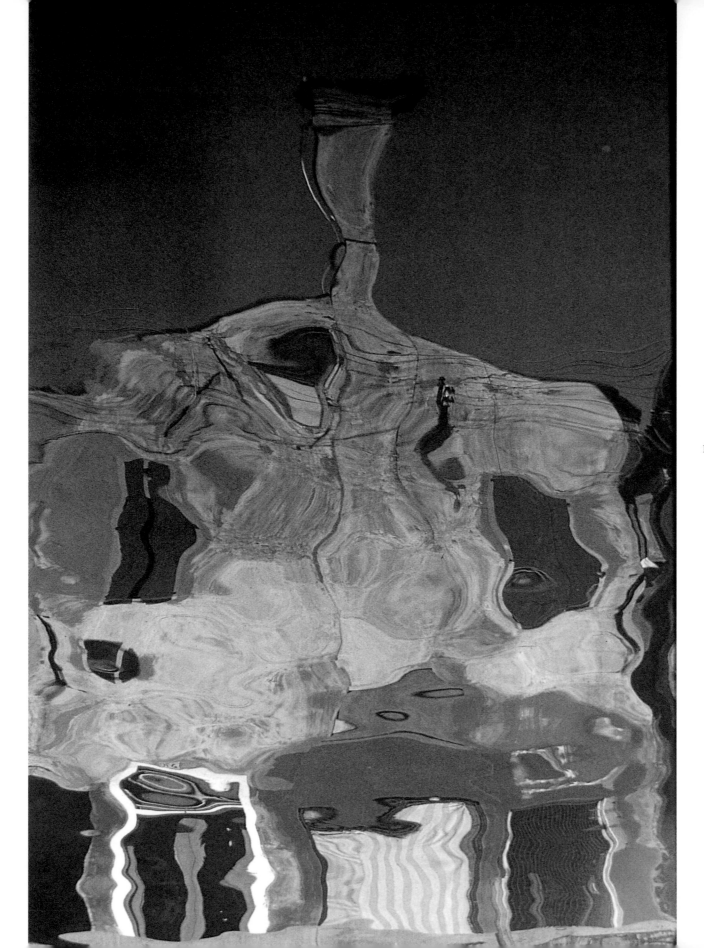

REFLECTIONS
◆ ◆ ◆
Burano

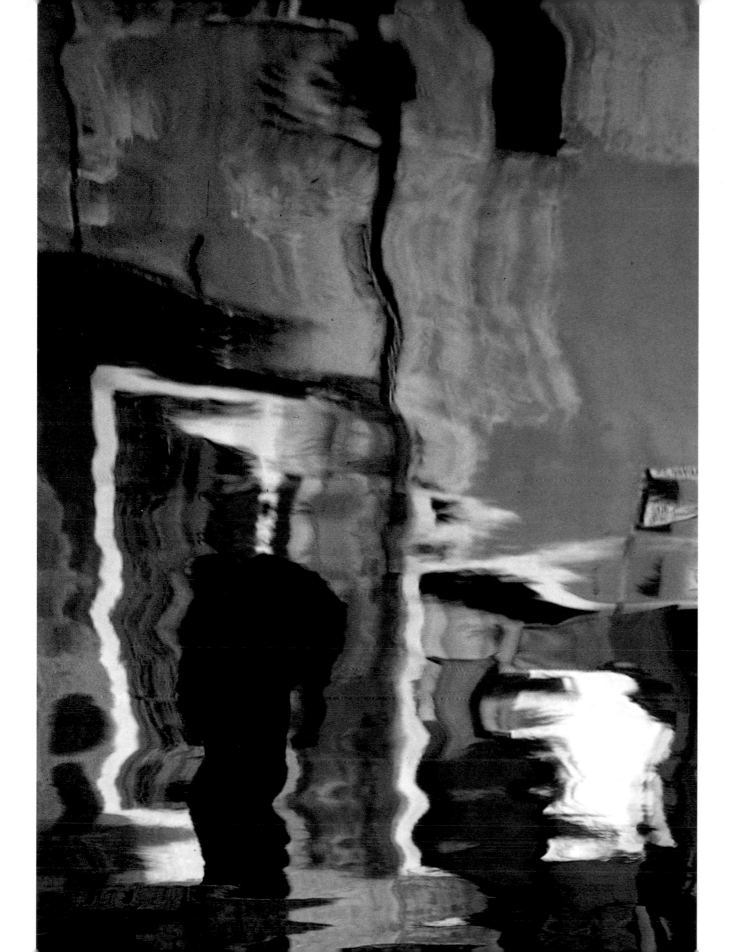

REFLECTIONS
◆ ◆ ◆
Venice

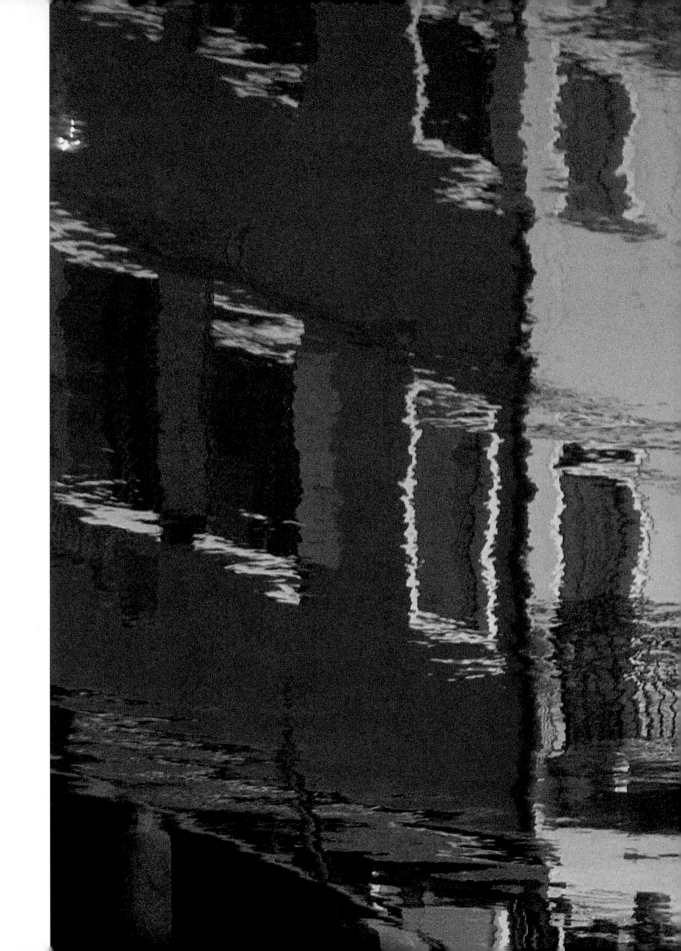

REFLECTIONS
◆ ◆ ◆
Burano

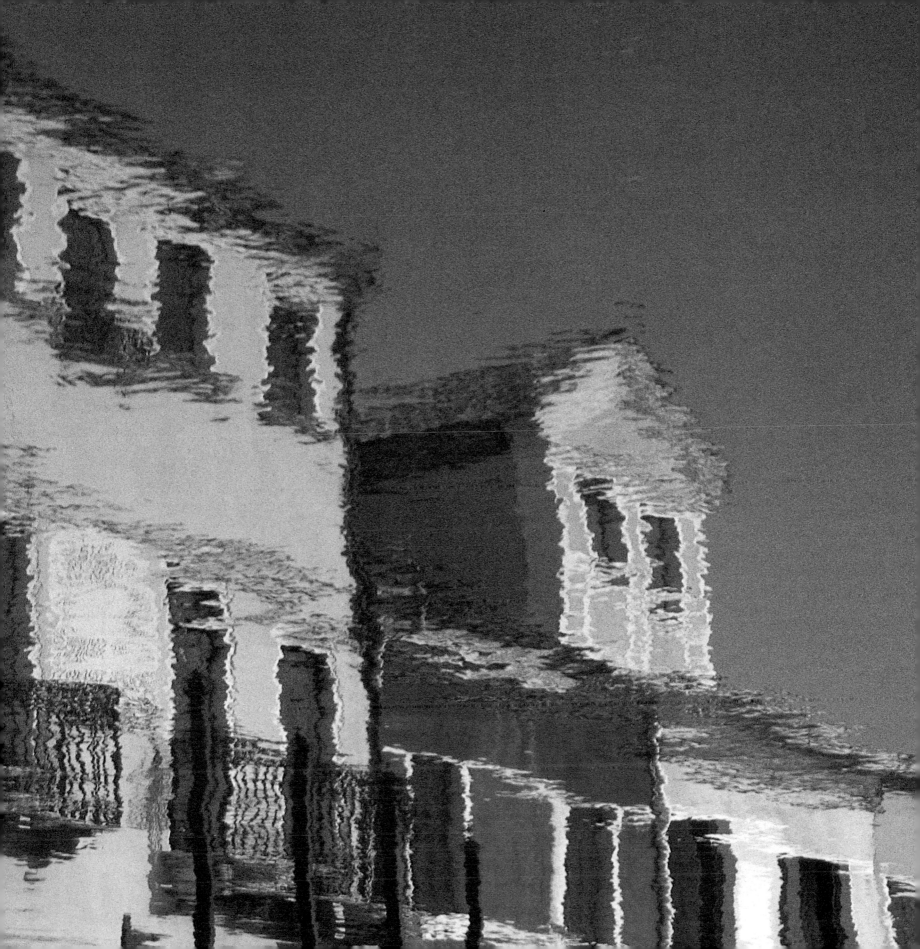

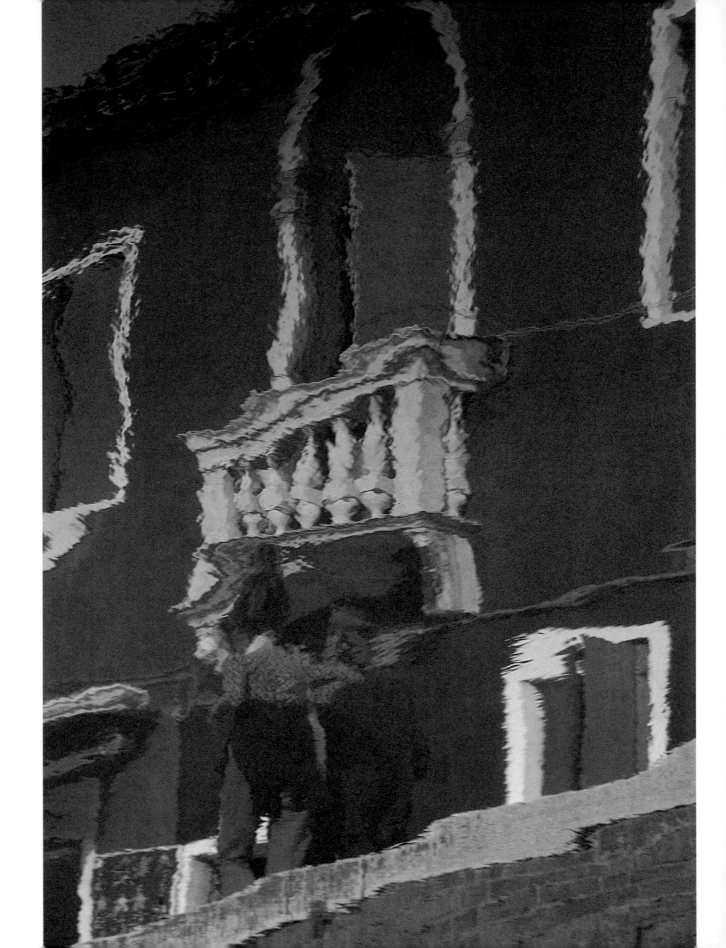

REFLECTIONS
◆ ◆ ◆
Burano

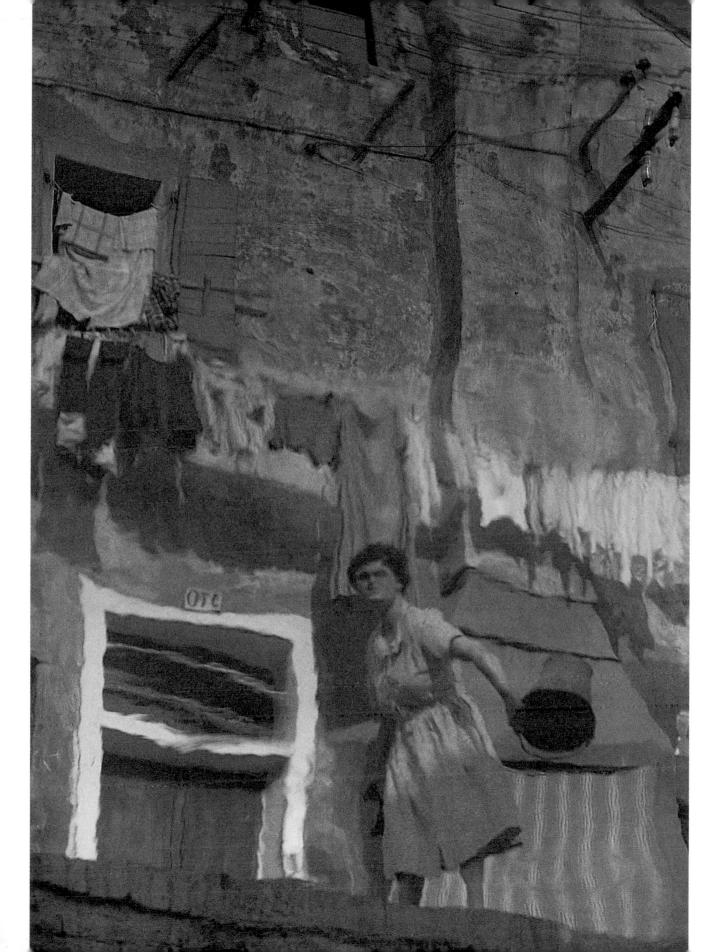

CANAL IN THE
DORSODURO
◆ ◆ ◆
Venice

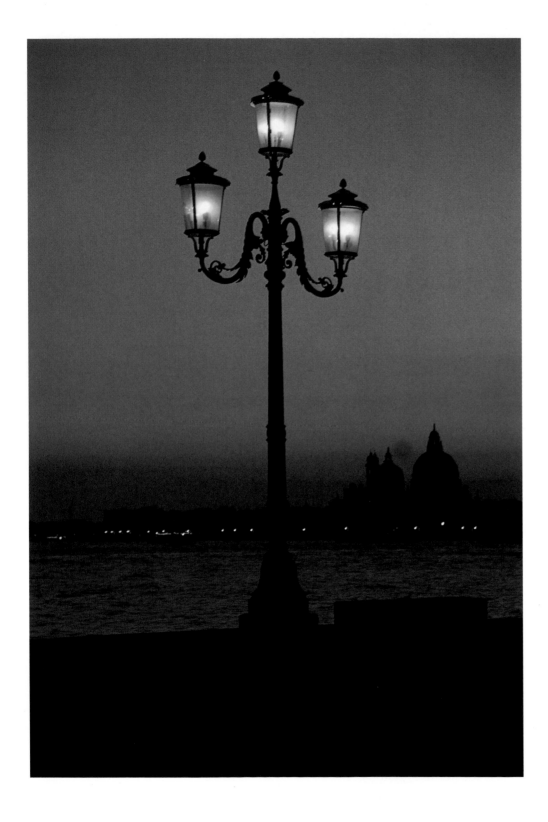

THE LAMPS ARE LIT ON THE
RIVA DEGLI SCHIAVONI
◆ ◆ ◆
Venice

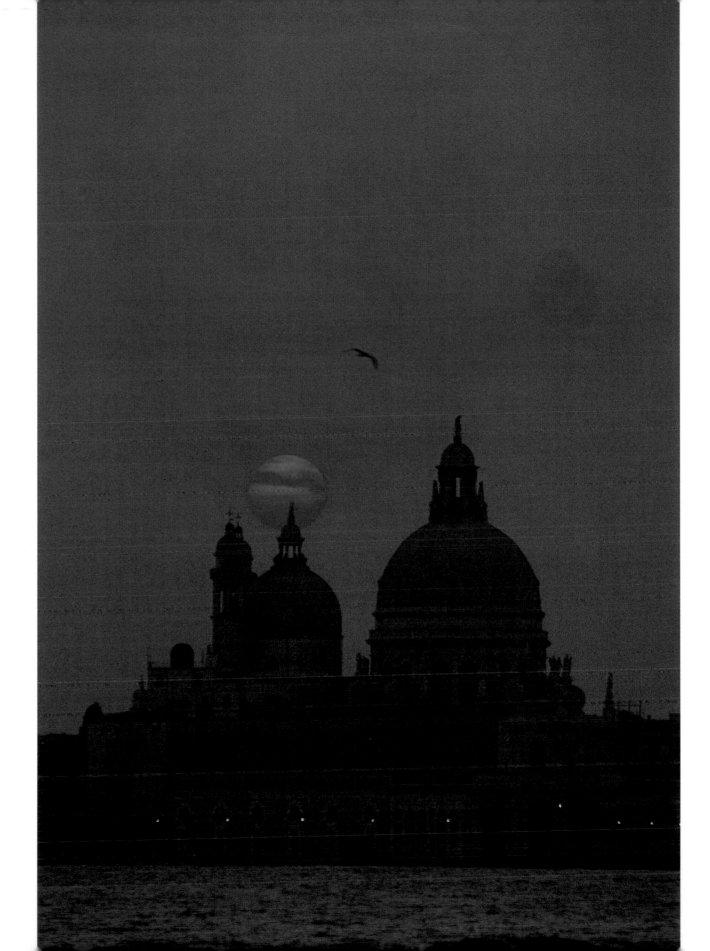

THE SUN SETS OVER
LA SALUTE
◆ ◆ ◆
Venice

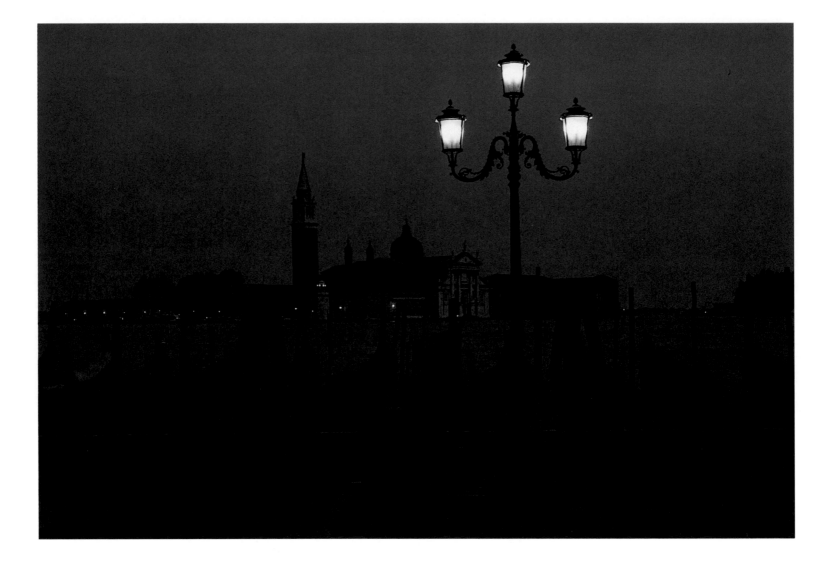

VIEW OF SAN GIORGIO MAGGIORE
AT NIGHTFALL
◆ ◆ ◆
Venice

BOBBING GONDOLAS

◆ ◆ ◆

Venice

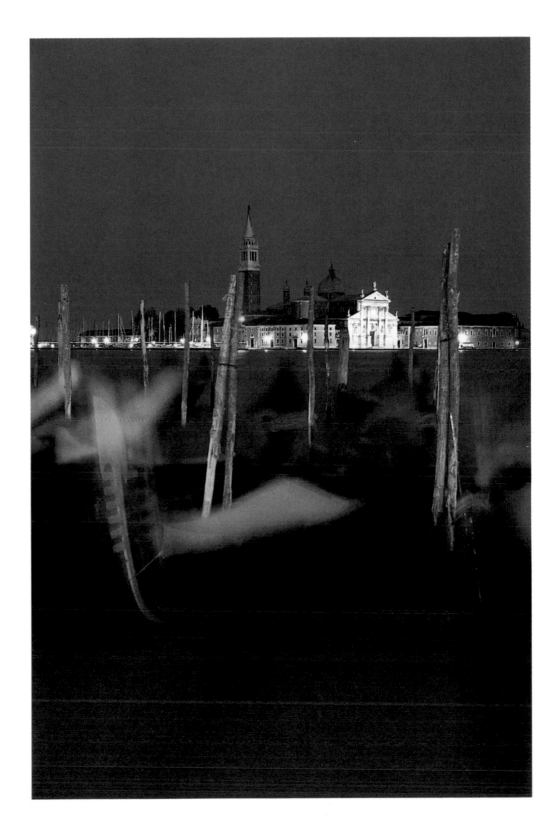

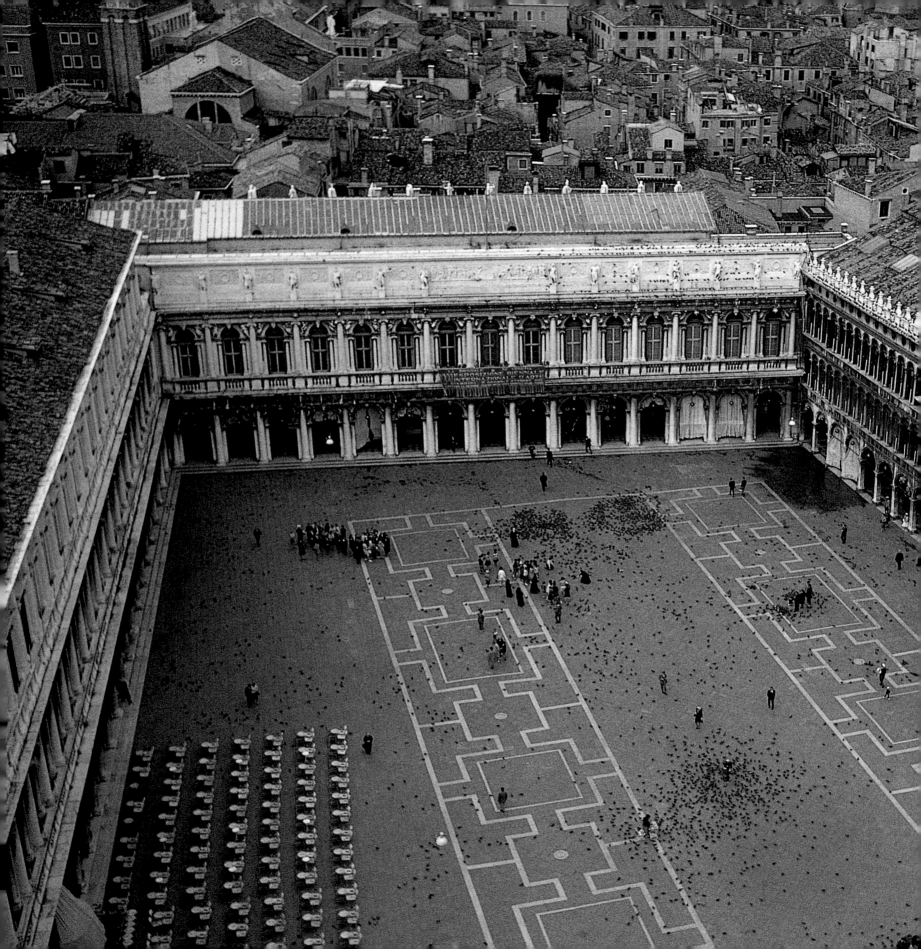

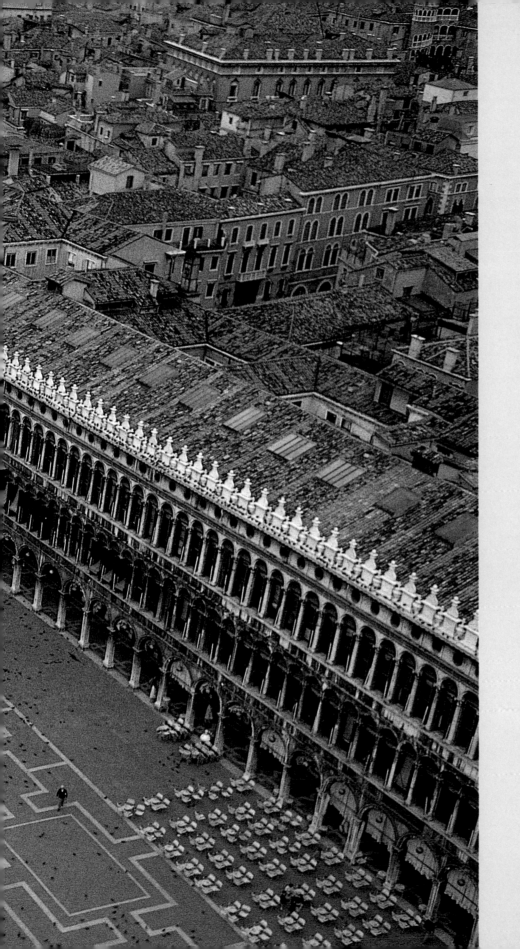

PIAZZA SAN MARCO

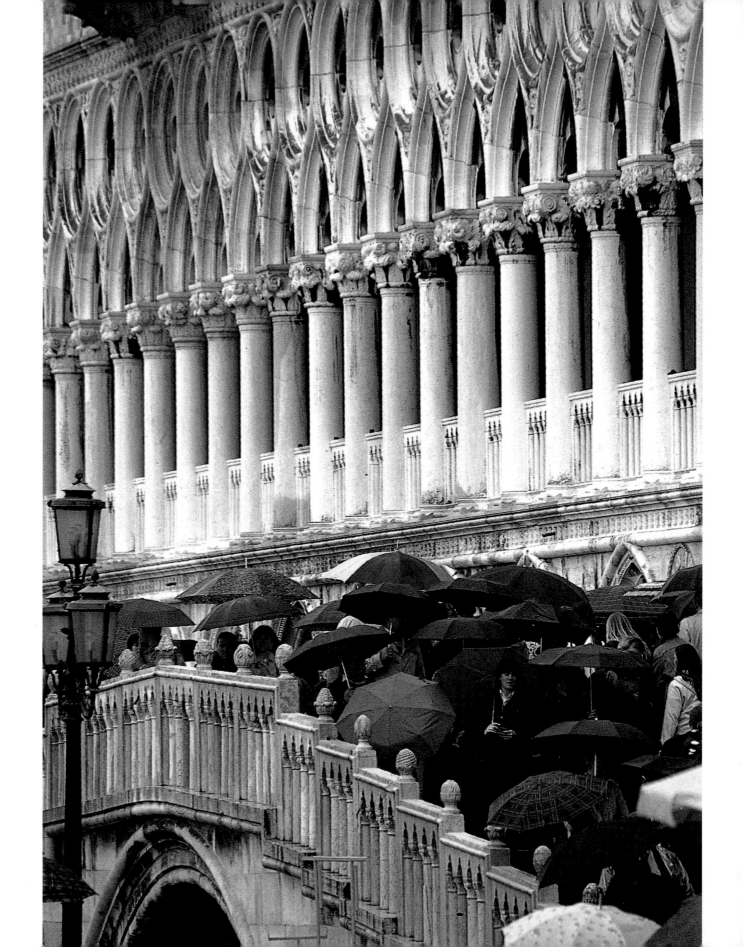

All of the city's other squares
are nothing more than modest *campi* to true Venetians. In
their eyes, the only real piazza is the Piazza San Marco. The
Piazza San Marco—packed or deserted—is a compelling image whether the day is just dawning, already well advanced,
or drawing to a close; whether Venice is serene or somber.
Perhaps it is as Herman Melville observed: "Gilded Mosaics,
Pinnacles, looks like a holiday affair. As if the Grand Turk
had pitched his pavilion here on a Summer's day."

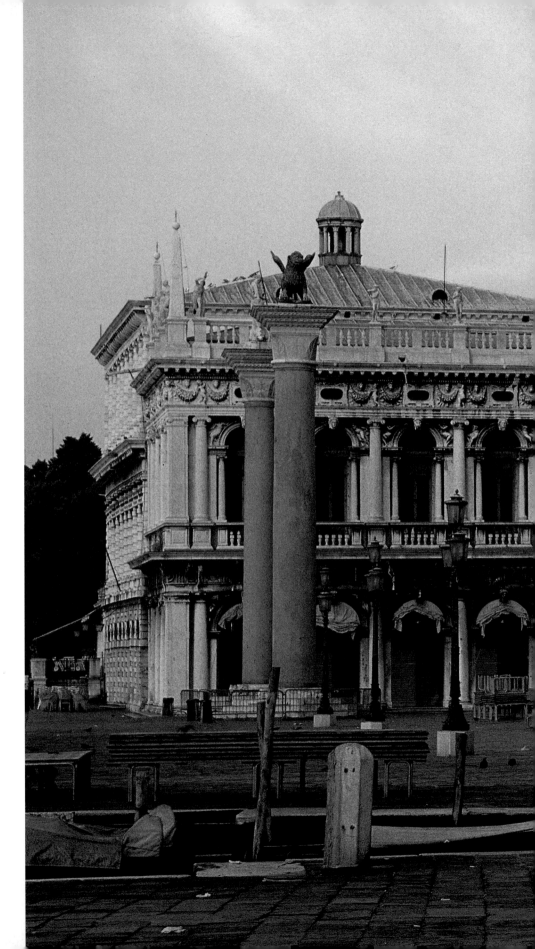

THE PONTE DELLA PAGLIA AT DAYBREAK

◆ ◆ ◆

Venice

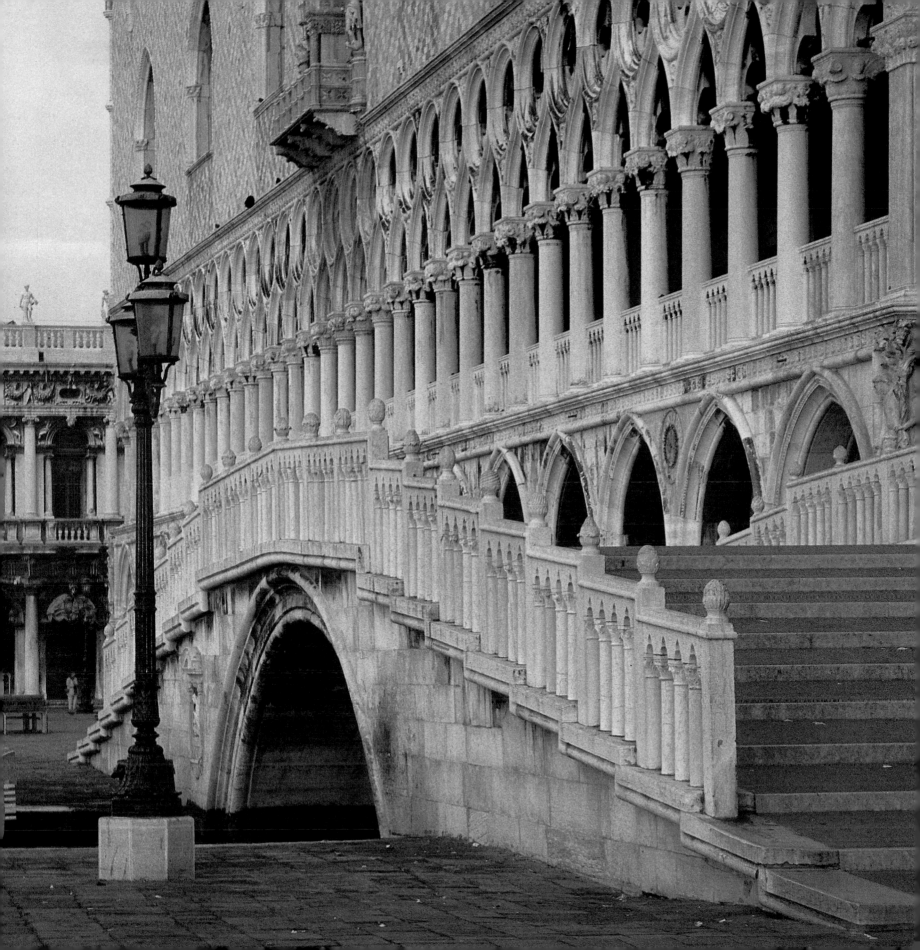

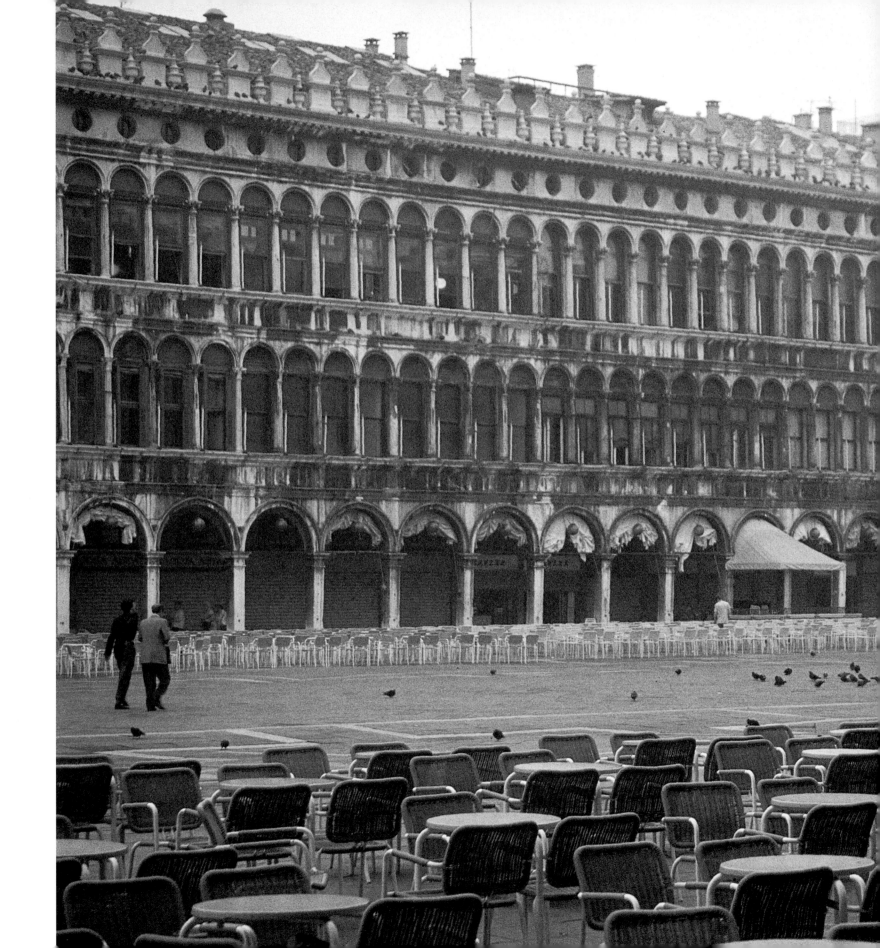

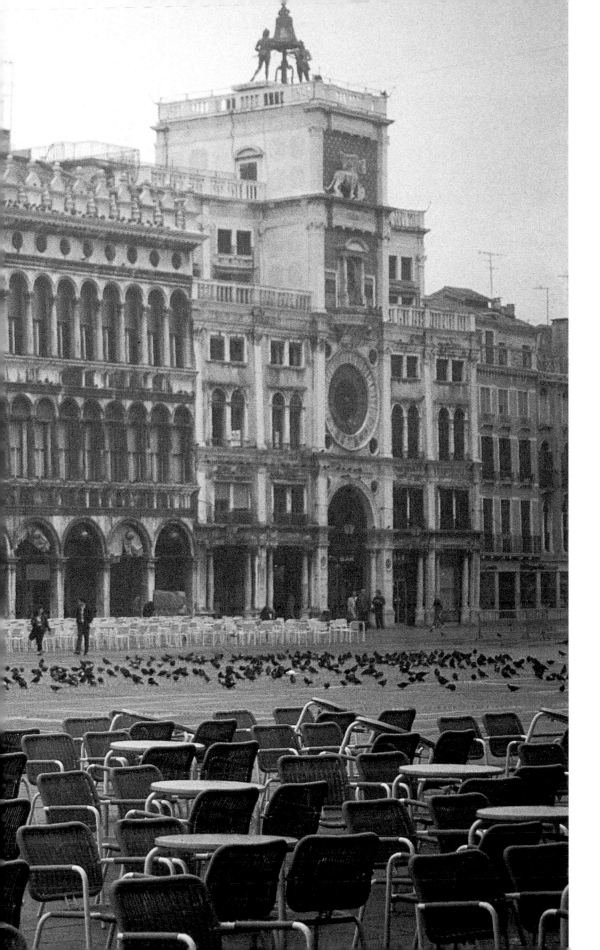

EARLY MORNING IN THE
PIAZZA SAN MARCO
◆ ◆ ◆
Venice

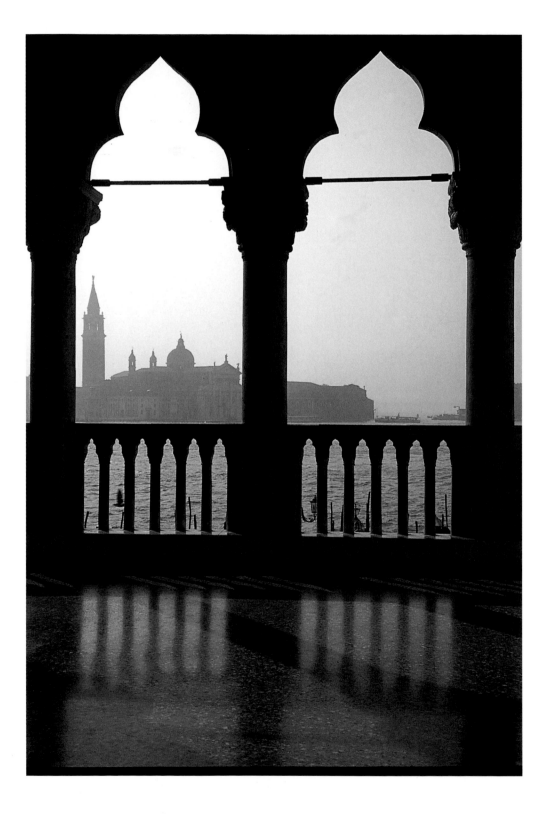

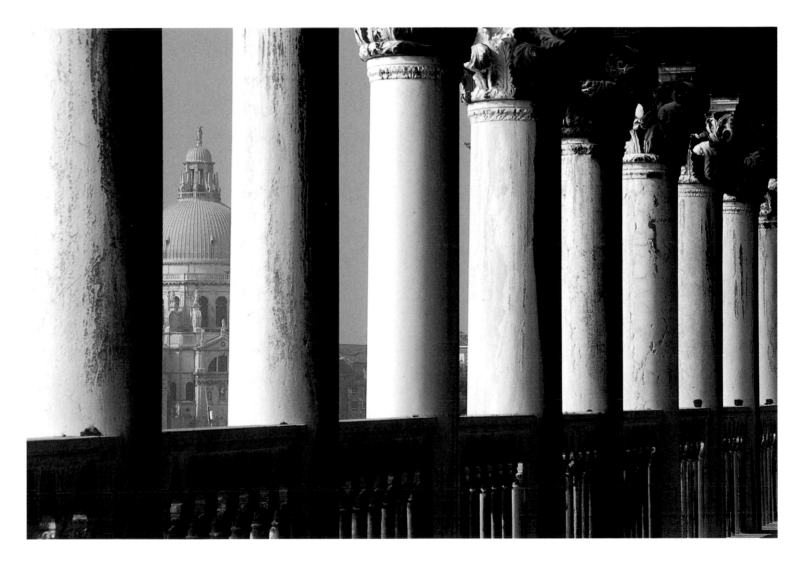

ABOVE:

LA SALUTE SEEN FROM THE LOGGIA
OF THE DOGE'S PALACE

◆ ◆ ◆

Venice

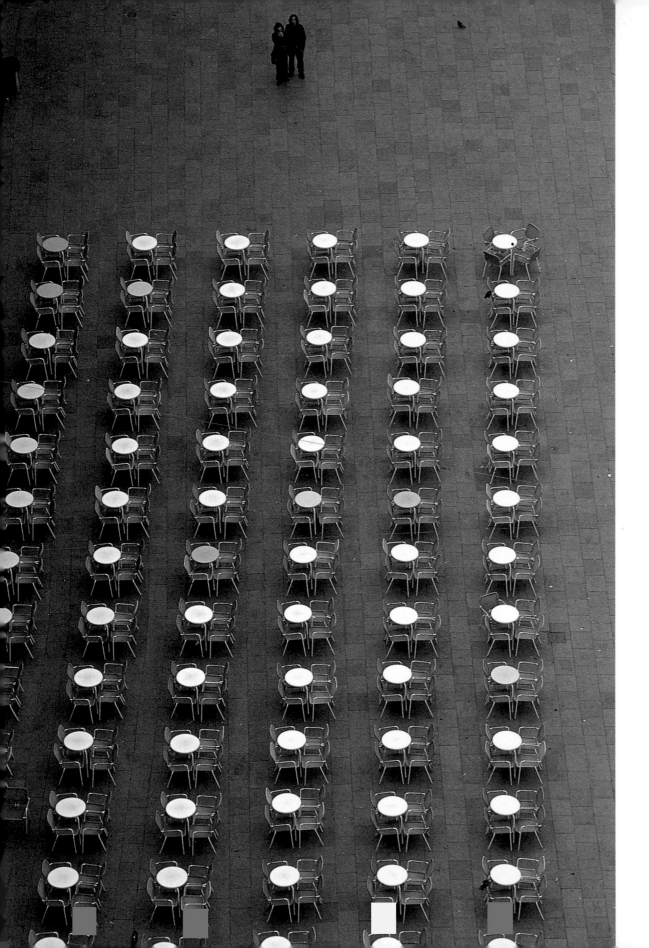

DESERTED CAFE IN THE
EARLY MORNING
◆ ◆ ◆
Venice

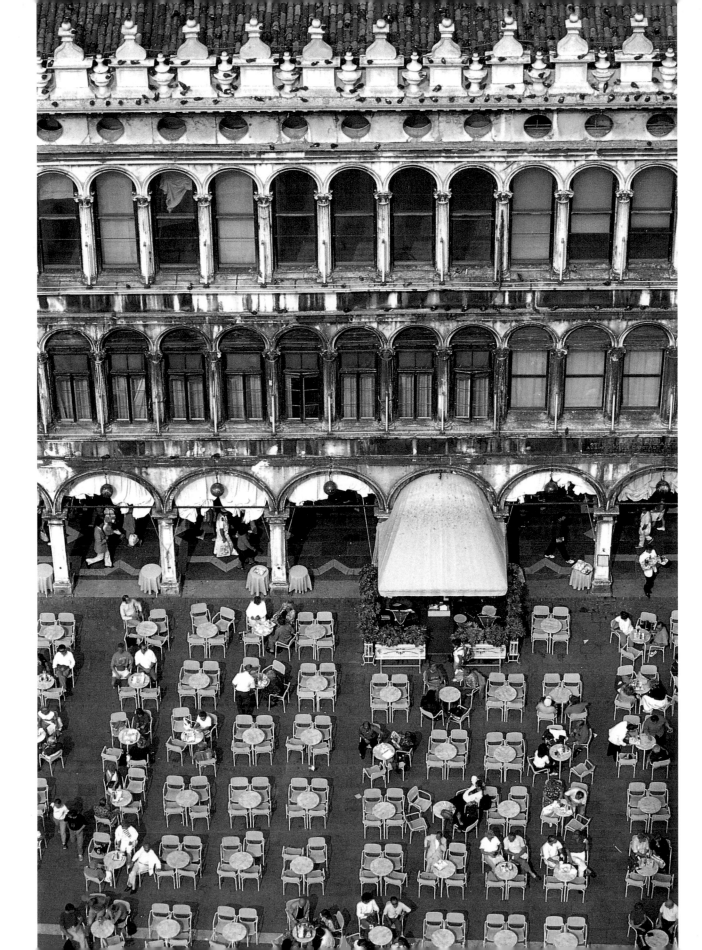

CAFE TABLES FROM
THE CAMPANILE
◆ ◆ ◆
Venice

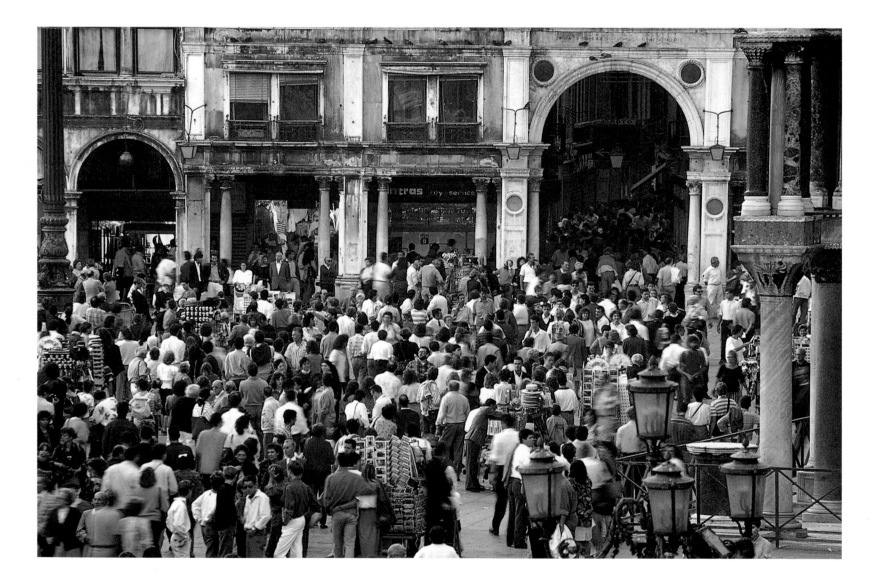

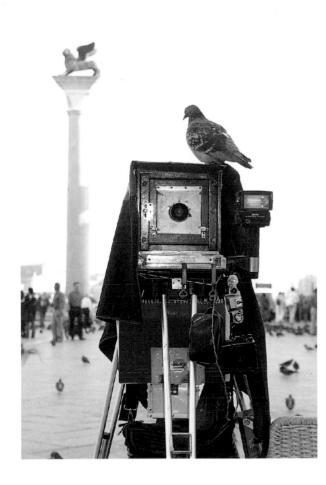

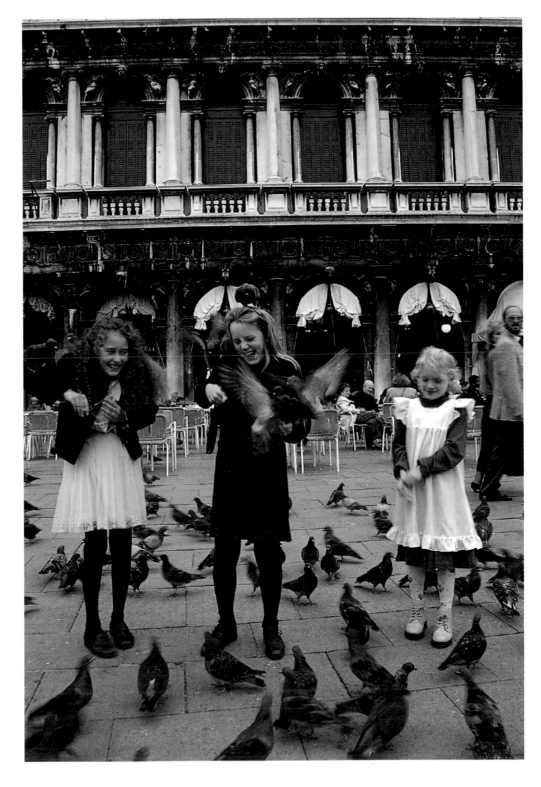

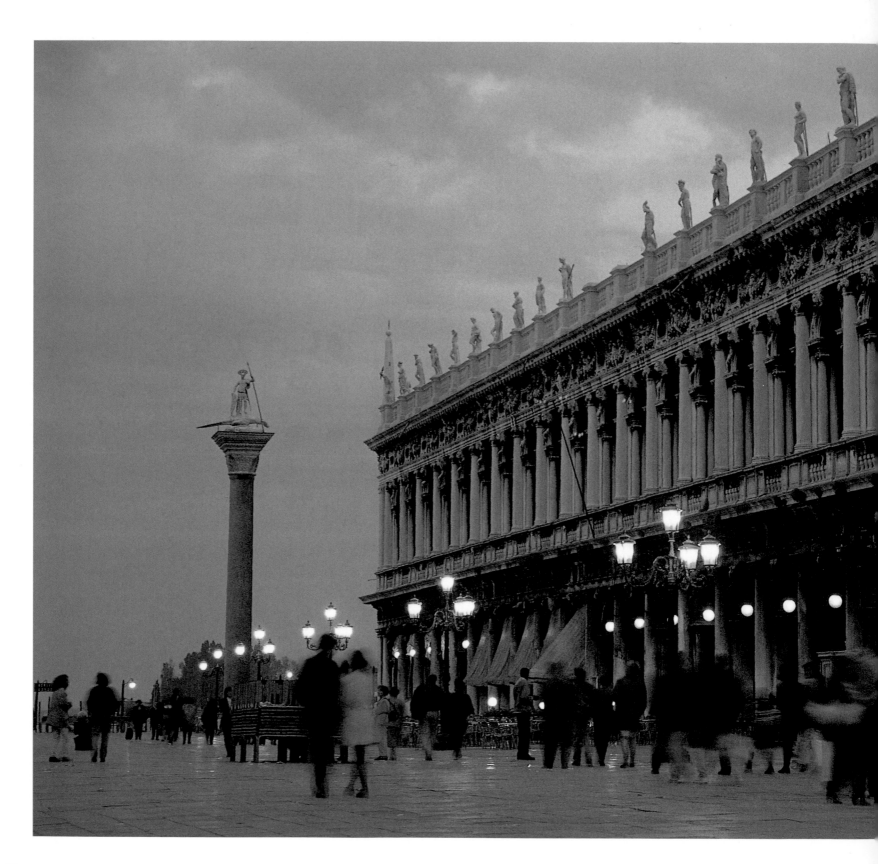

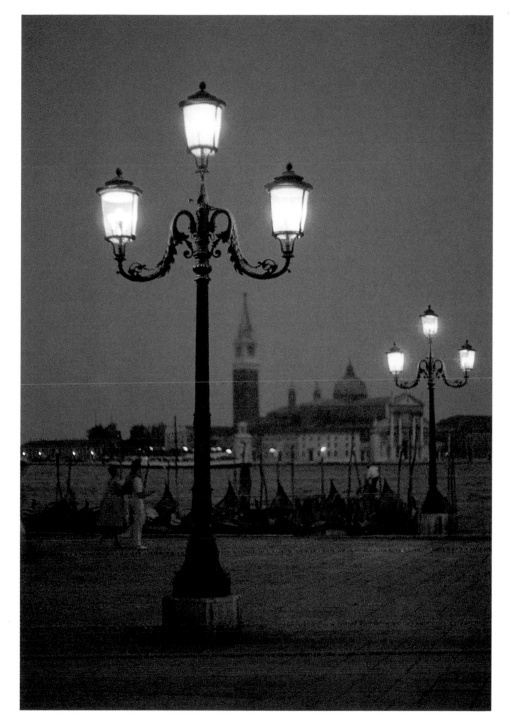

LEFT AND ABOVE:

THE PIAZZETTA AT NIGHTFALL

◆ ◆ ◆

Venice

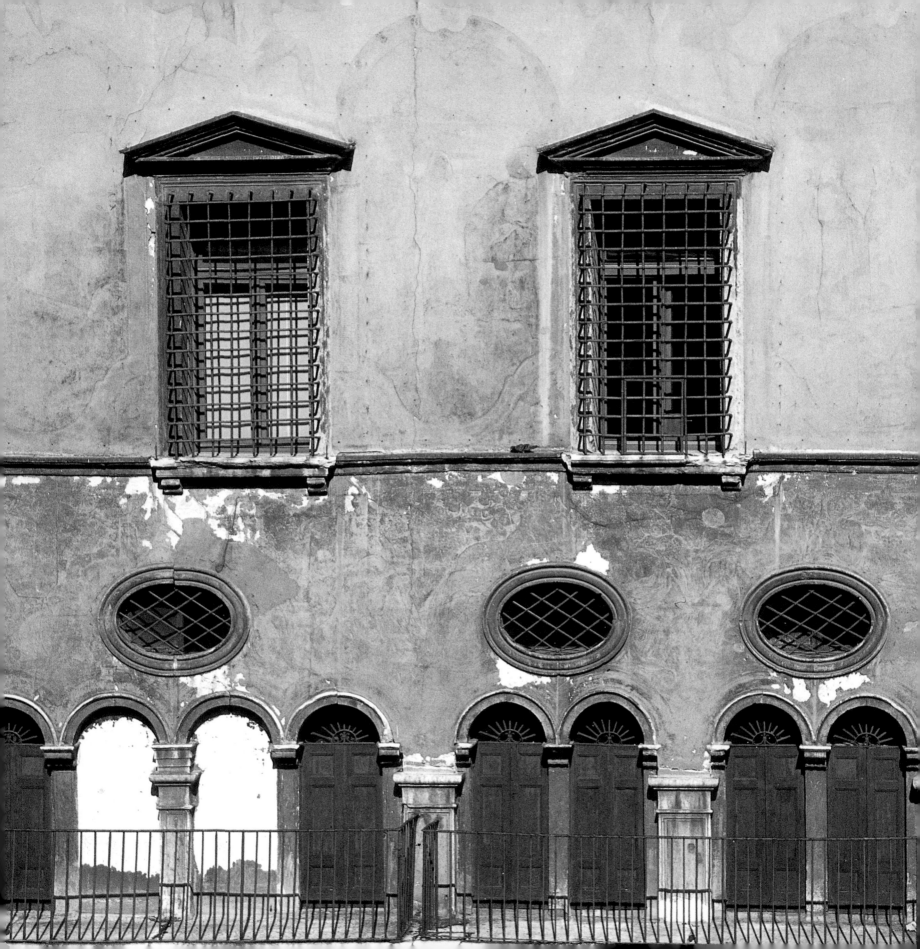

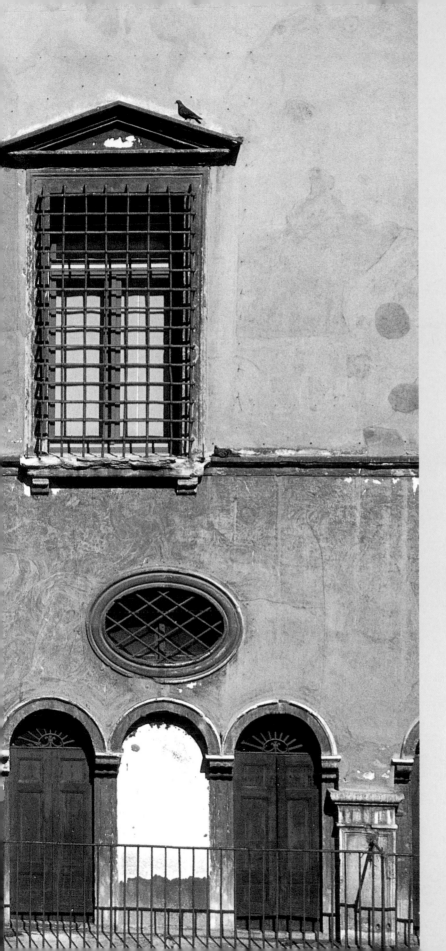

WINDOWS

Square or round, oblong or rectangular, defended by cast-iron gratings or slatted wooden shutters, surrounded by white Istrian stone or framed by ivy, the windows of the city pique foreigners' curiosity about Venetians' private lives. It is only when you lean out of the city's windows, balconies, and terraces that you realize that Venice is herself a balcony on the Adriatic.

PAGES 74–75:
WINDOWS ON THE
PIAZZA DEI SIGNORI
◆ ◆ ◆
Vicenza

OPPOSITE:
GARDEN ON A WINDOWSILL
◆ ◆ ◆
Burano

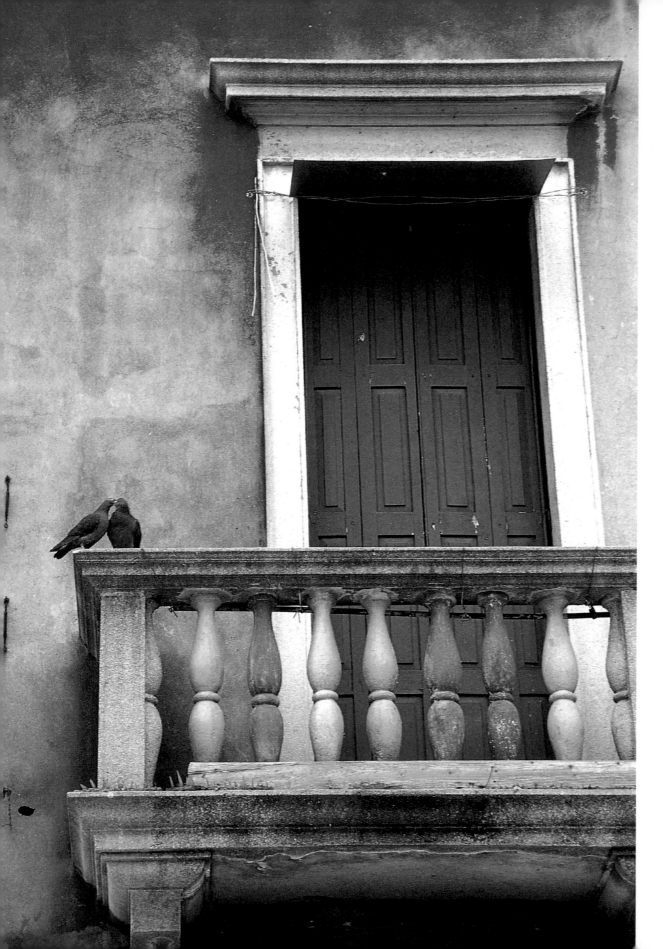

IN THE GHETTO
◆ ◆ ◆
Venice

OPPOSITE, TOP:
A WATCHFUL CAT
◆ ◆ ◆
Venice

OPPOSITE, BOTTOM:
ON THE GRAND CANAL
◆ ◆ ◆
Venice

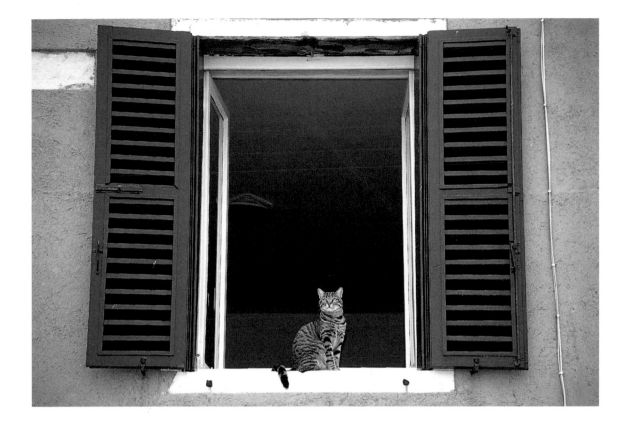

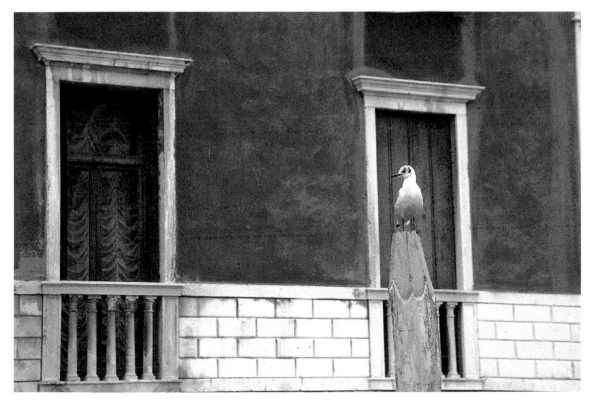

WINDOW

◆ ◆ ◆

Venice

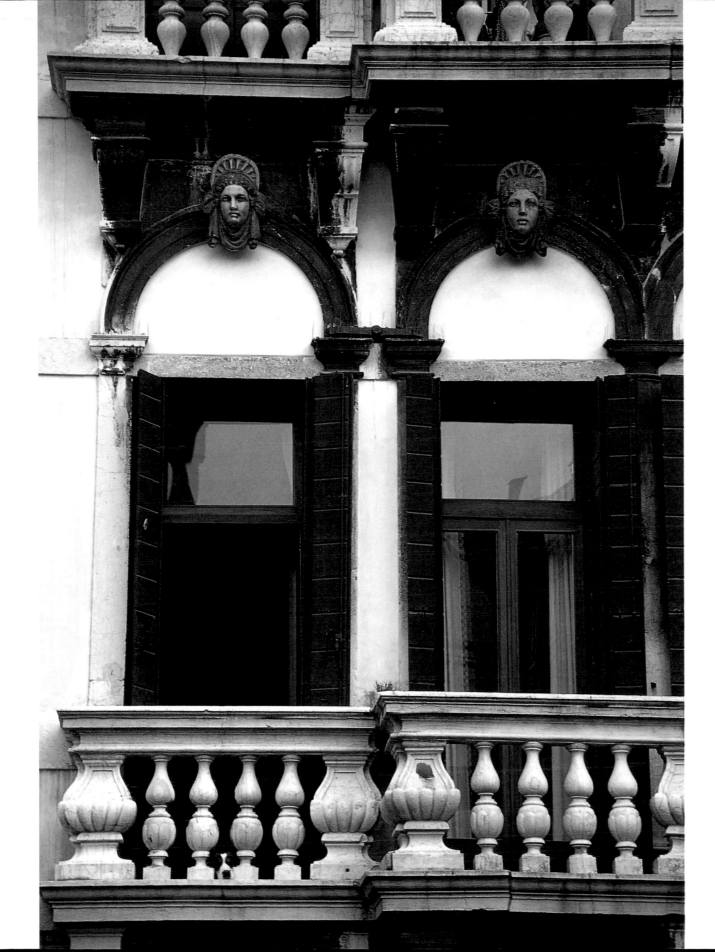

WINDOWS
◆ ◆ ◆
Venice

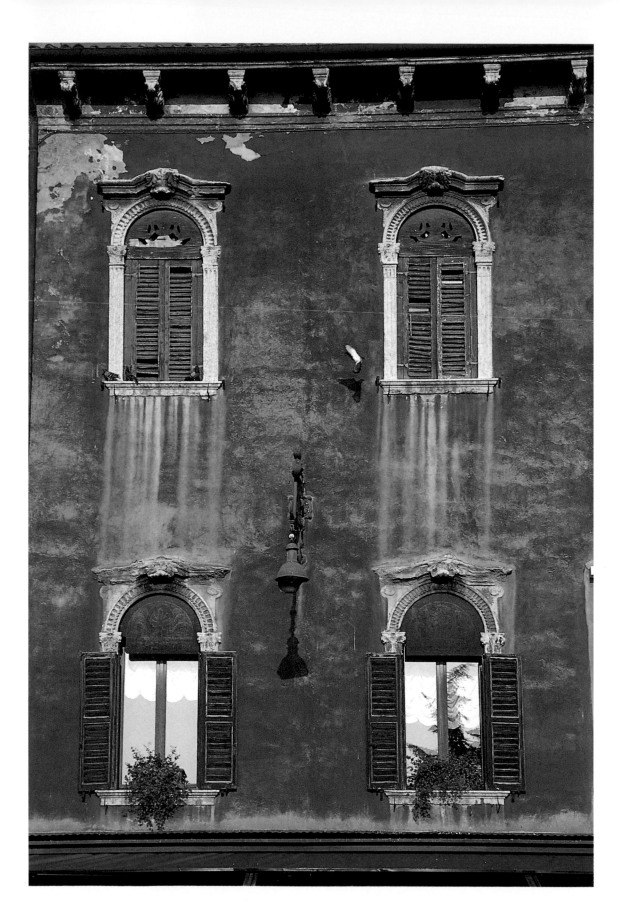

ON THE PIAZZA BRA
◆ ◆ ◆
Verona

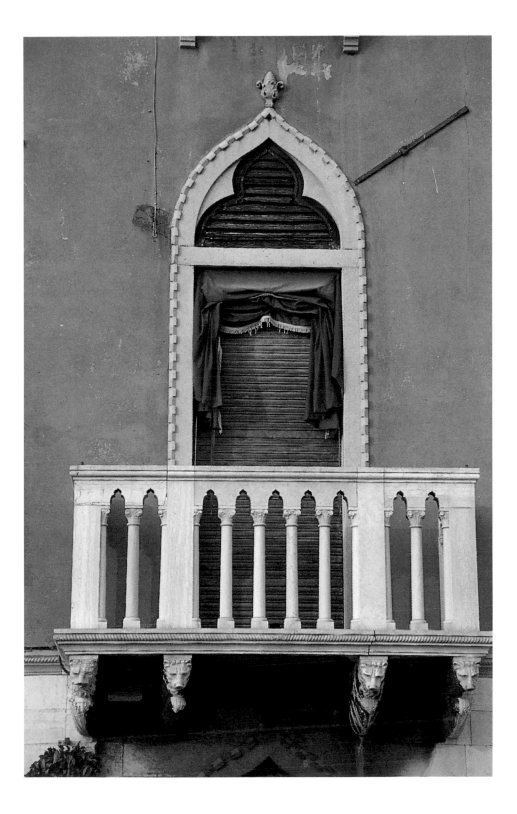

OVERLOOKING THE
RIVA DEGLI SCHIAVONI
◆ ◆ ◆
Venice

PAGES 84–85:
WALL OF THE TEATRO OLIMPICO
◆ ◆ ◆
Vicenza

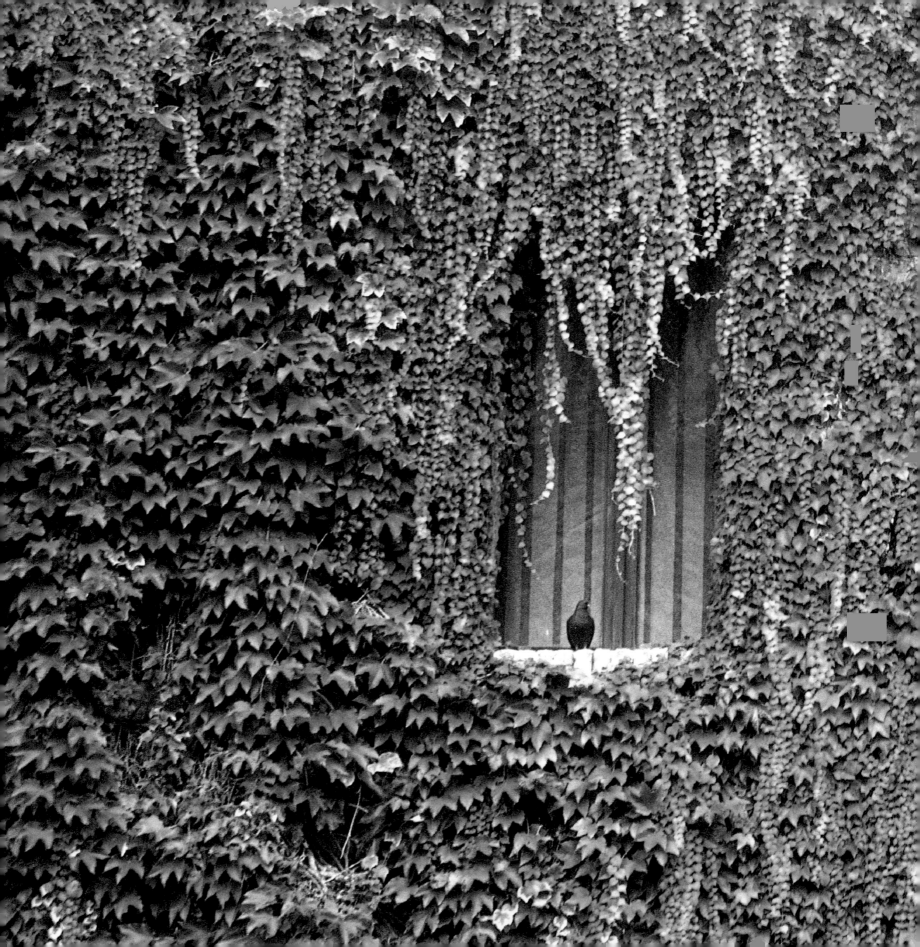

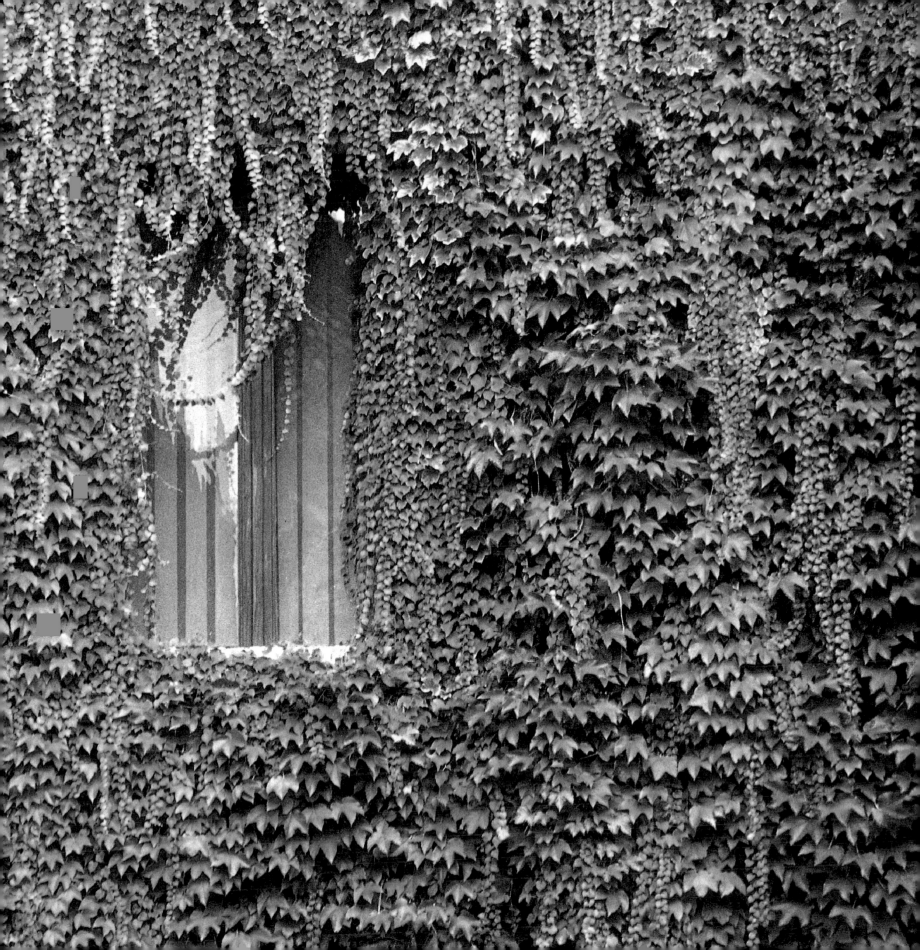

ALONG THE GIUDECCA CANAL
◆ ◆ ◆
Venice

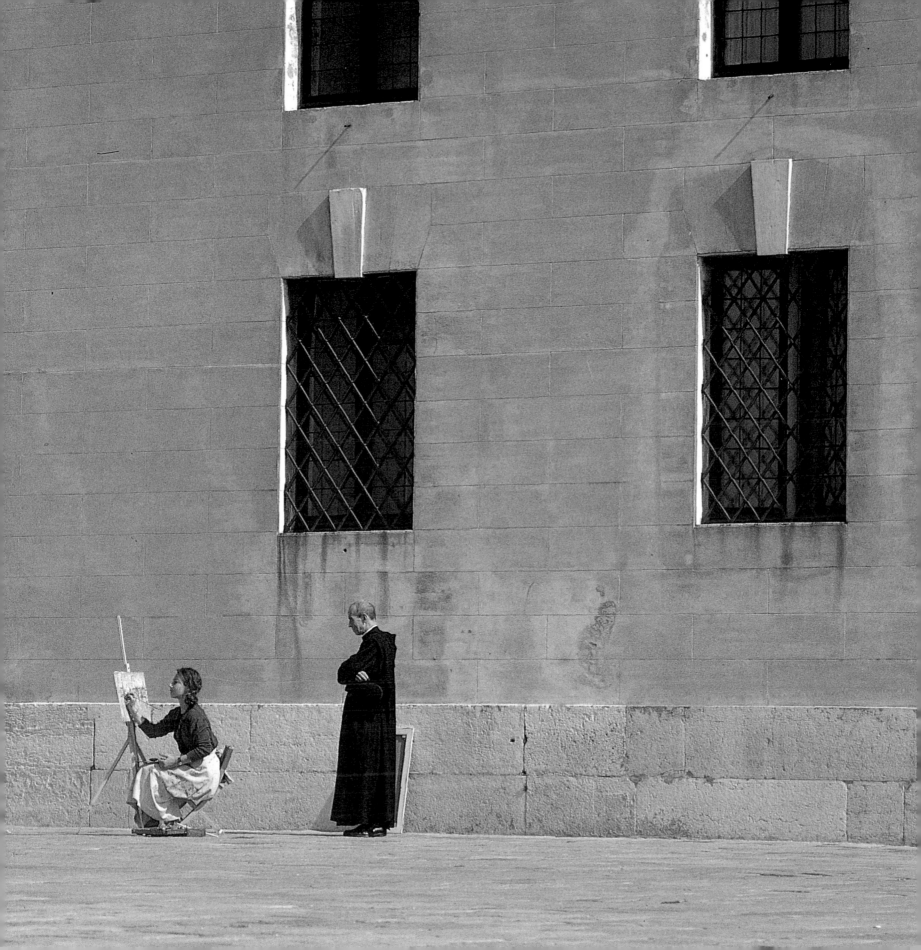

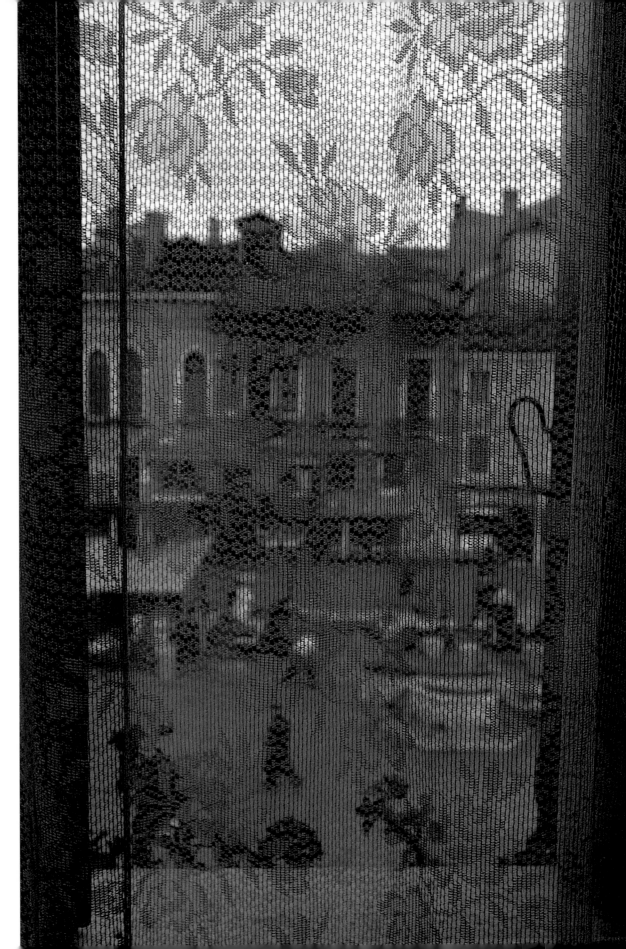

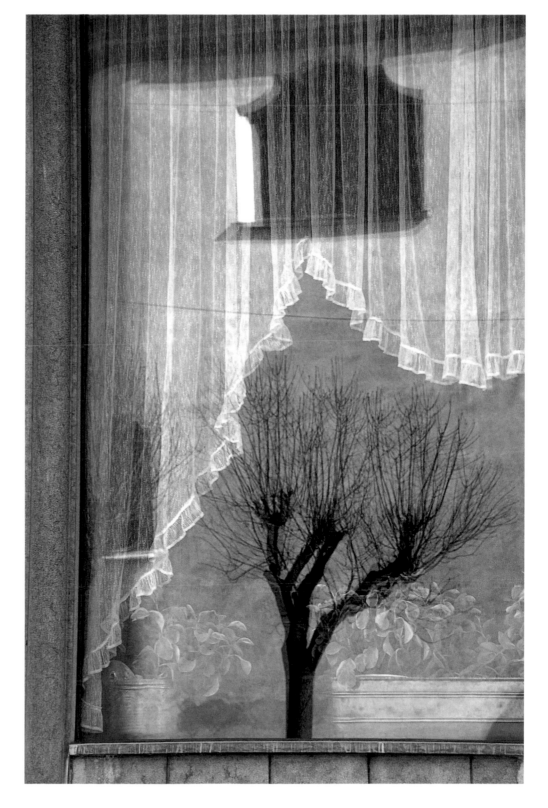

OPPOSITE:
VIEW ONTO A CAMPO
◆ ◆ ◆
Venice

RIGHT:
THE HOTEL MONTANA
◆ ◆ ◆
Cortina d'Ampezzo

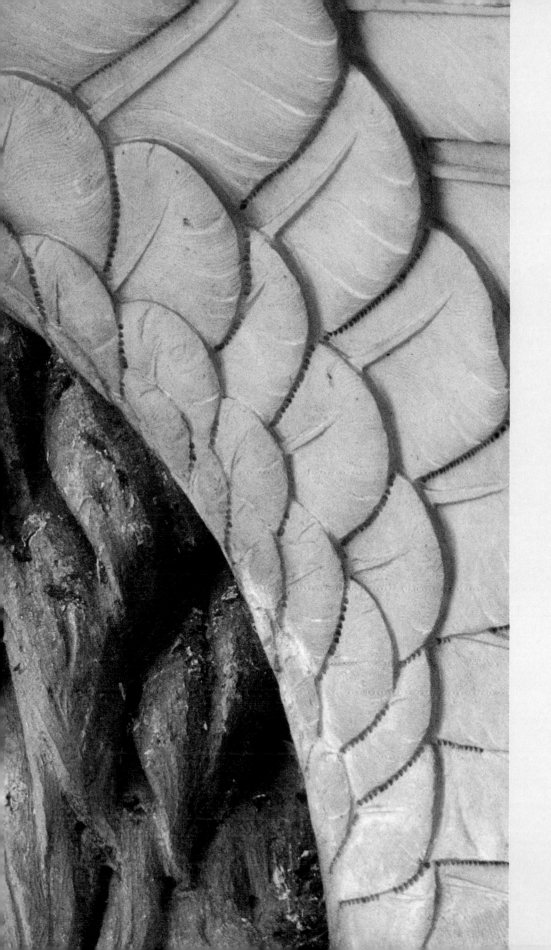

A
BESTIARY

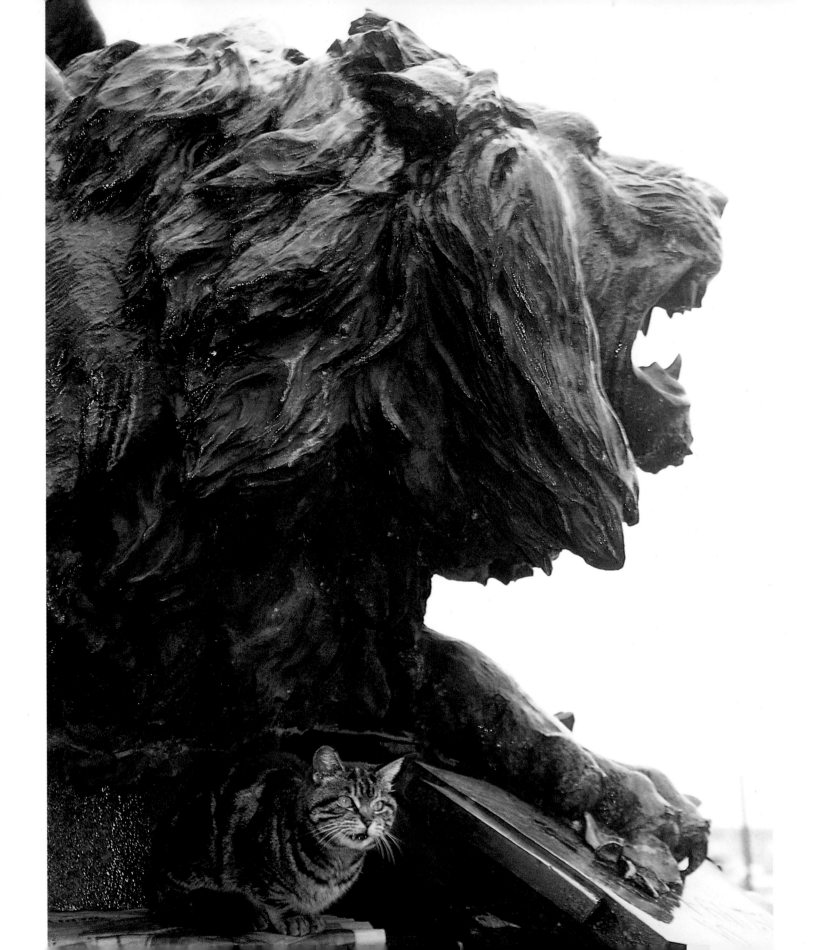

The nonhuman creatures in-
habiting Venice, either real beasts or fantastic monsters, form
a wildly varied bestiary. Faced with so many lions, griffins,
horses, sea horses, dragons, dolphins, sirens, serpents, swans,
phoenixes, creatures of the night, and even ordinary animals,
one begins to feel the border between dream and reality,
happy illusion and nightmare, fading away.

PAGES 90-91:
ST. MARK AND THE LION

◆ ◆ ◆

Venice

OPPOSITE:
MONUMENT TO VITTORIO EMANUELE II

◆ ◆ ◆

Venice

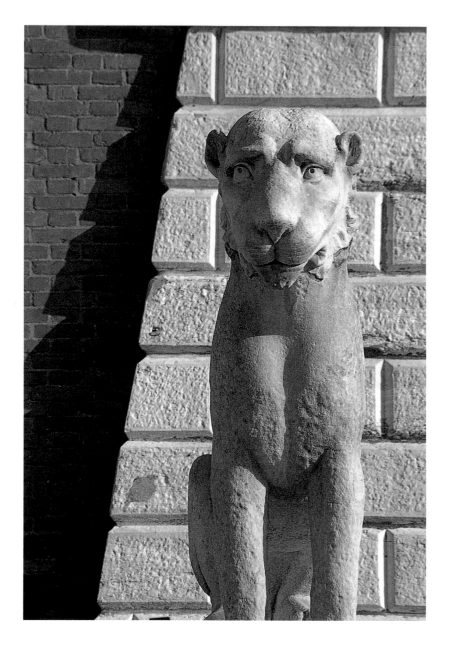

ENTRYWAY LION AT THE ARSENALE

◆ ◆ ◆

Venice

OPPOSITE:

VIEW FROM THE LOGGIA OF THE DOGE'S PALACE

◆ ◆ ◆

Venice

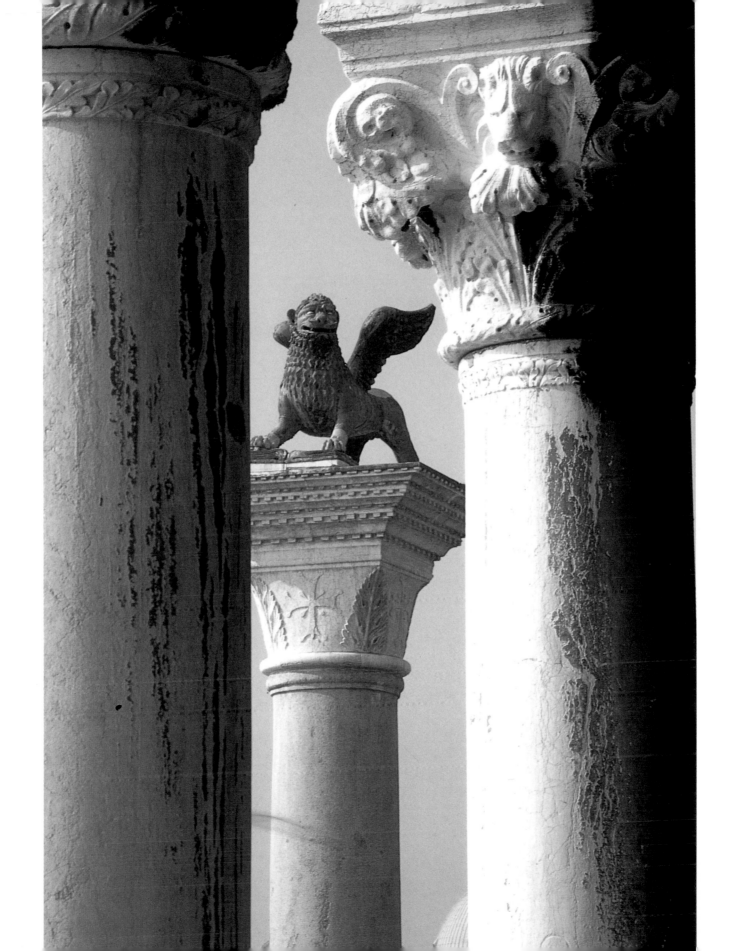

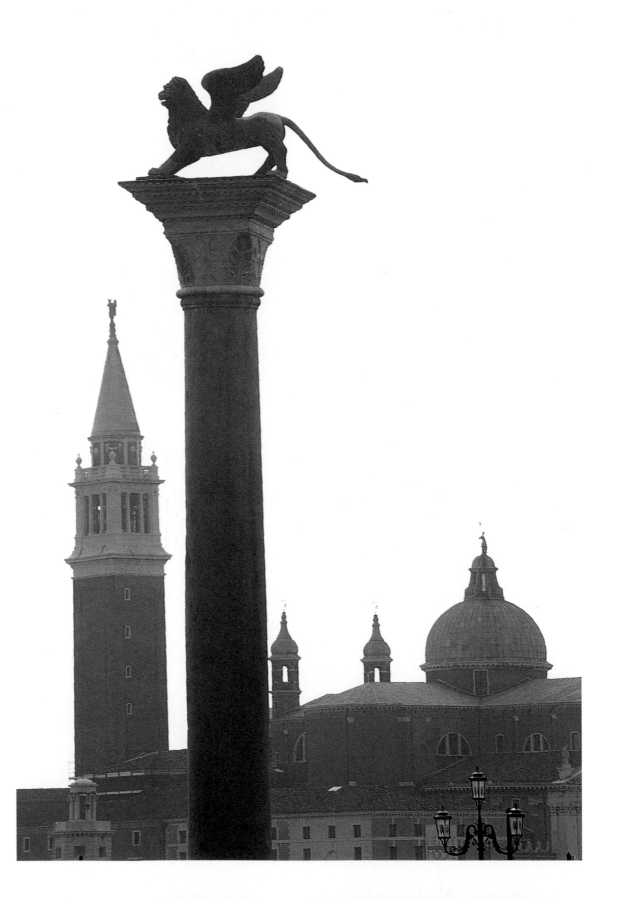

RIGHT:
LION COLUMN IN
THE PIAZZETTA
◆ ◆ ◆
Venice

OPPOSITE, TOP:
VENETIAN LION IN
PIAZZA DEI SIGNORI
◆ ◆ ◆
Vicenza

OPPOSITE, BOTTOM:
GRIFFIN ATOP THE
CAFFE PEDROCCHI
◆ ◆ ◆
Padua

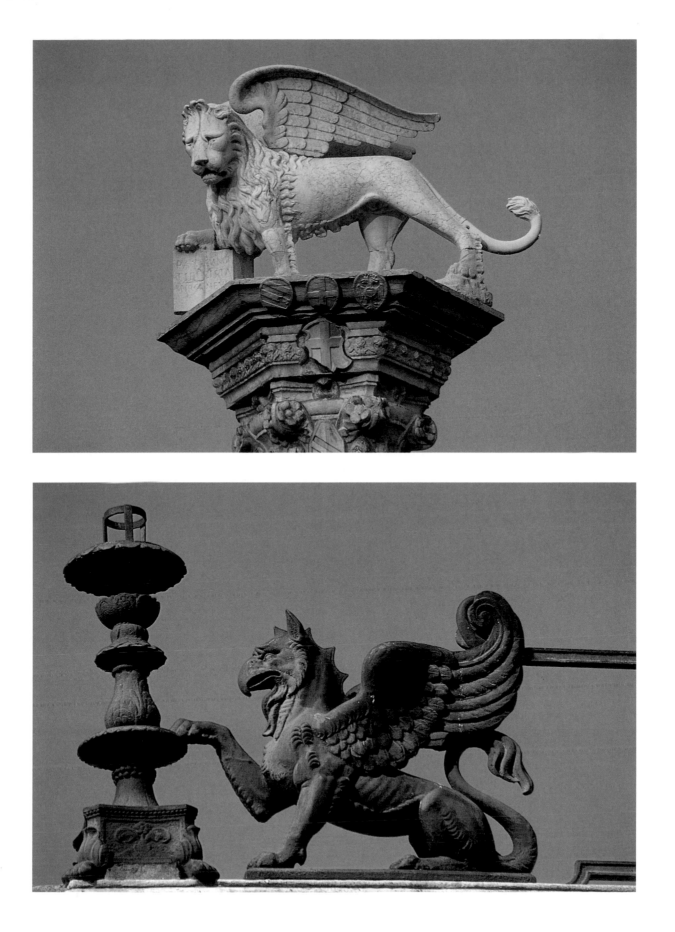

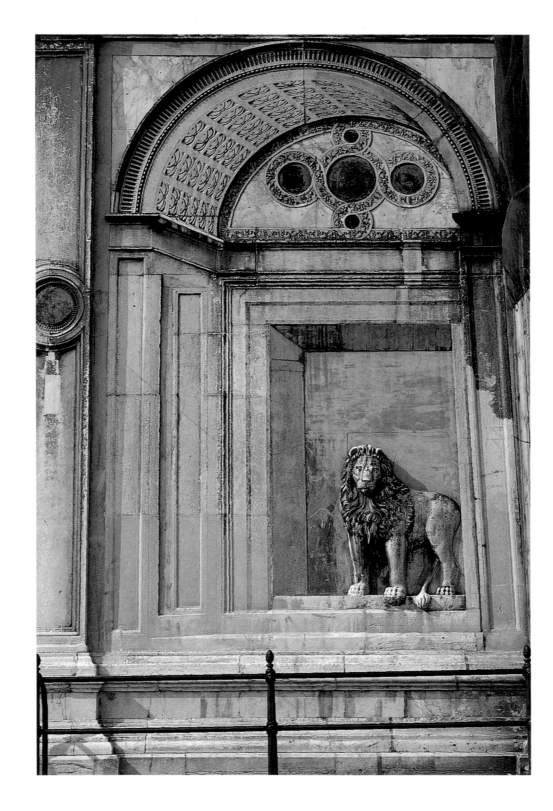

FACADE OF THE
SCUOLA GRANDE DI
SAN MARCO
◆ ◆ ◆
Venice

FOUNTAIN IN THE GIARDINI PUBBLICI

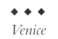

Venice

THE DOGE'S PALACE

◆ ◆ ◆

Venice

ON THE STRADA NOVA

◆ ◆ ◆

Venice

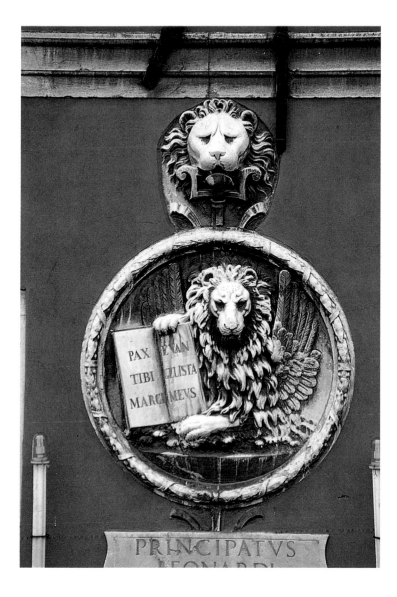

NEAR THE RIALTO BRIDGE

◆ ◆ ◆

Venice

ST. GEORGE AND THE DRAGON

◆ ◆ ◆

Venice

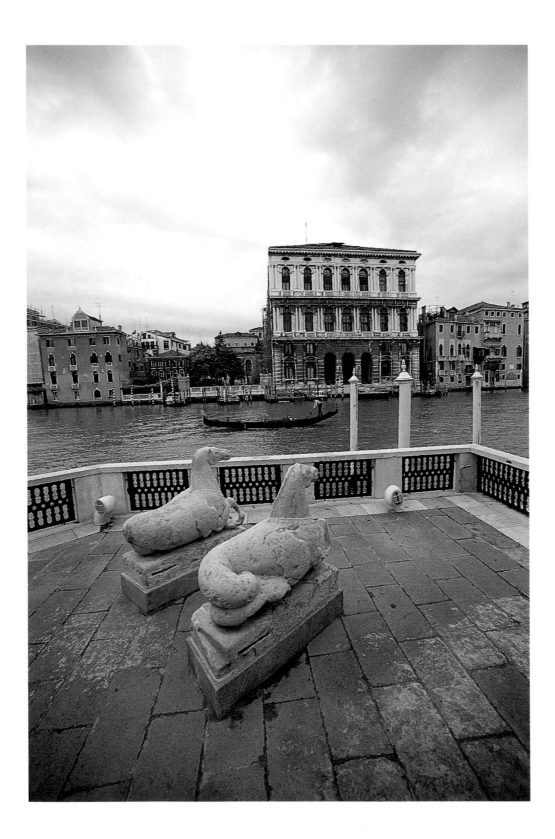

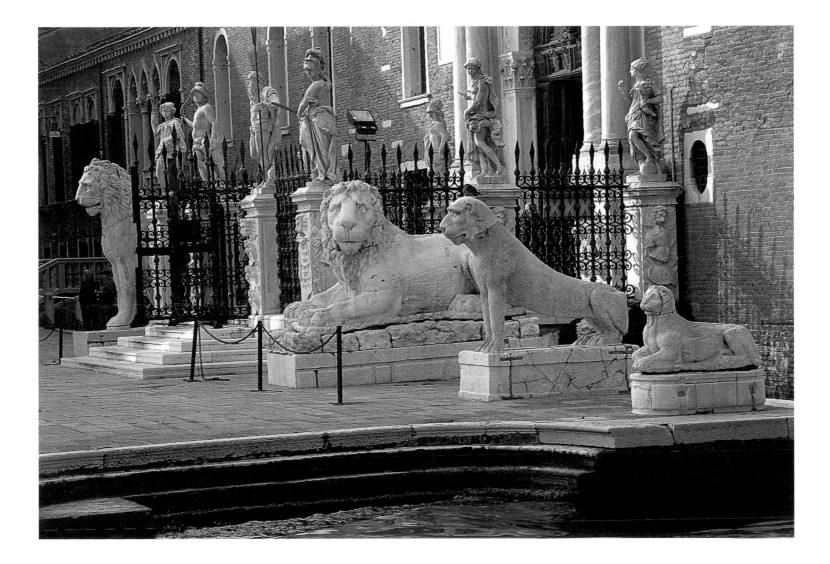

ARSENALE LIONS

◆ ◆ ◆

Venice

OPPOSITE:

THE TERRACE OF THE PEGGY GUGGENHEIM COLLECTION

ON THE GRAND CANAL

◆ ◆ ◆

Venice

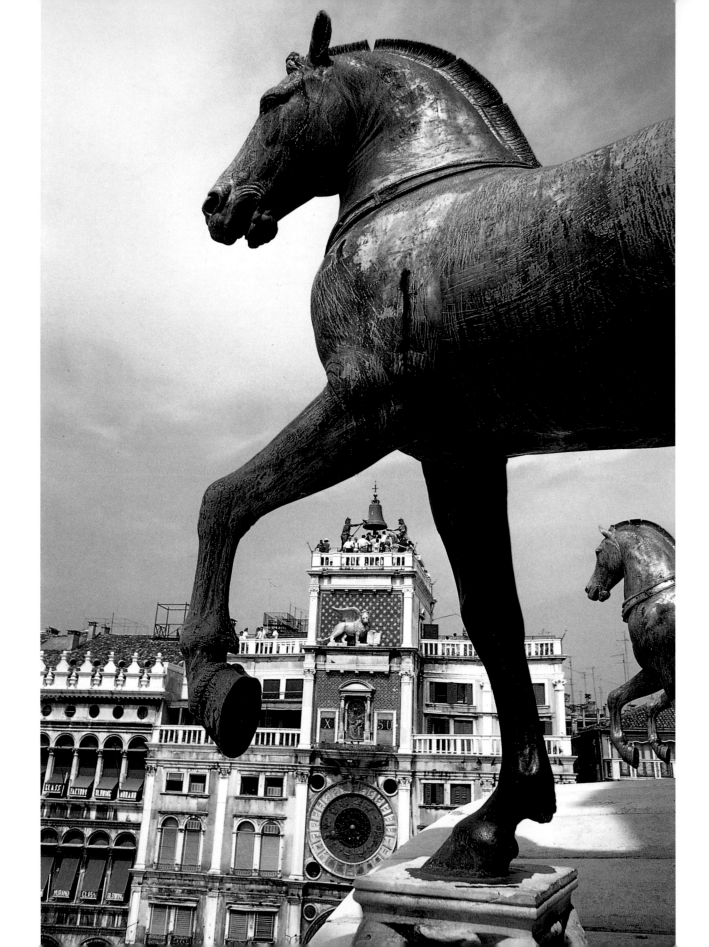

BRONZE HORSES
ATOP SAN MARCO
◆ ◆ ◆
Venice

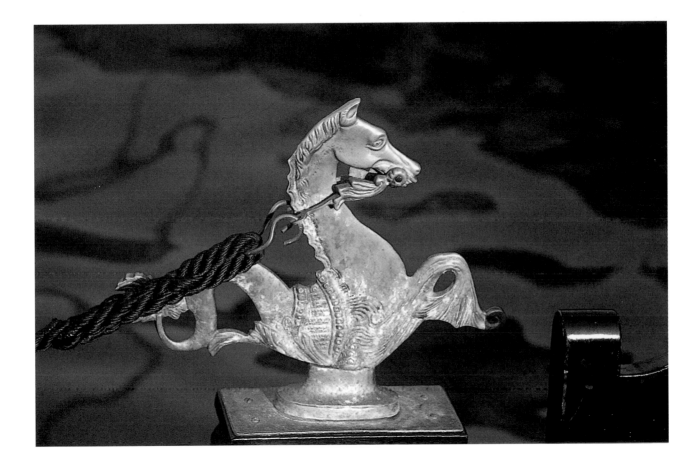

GONDOLA DETAIL

◆ ◆ ◆

Venice

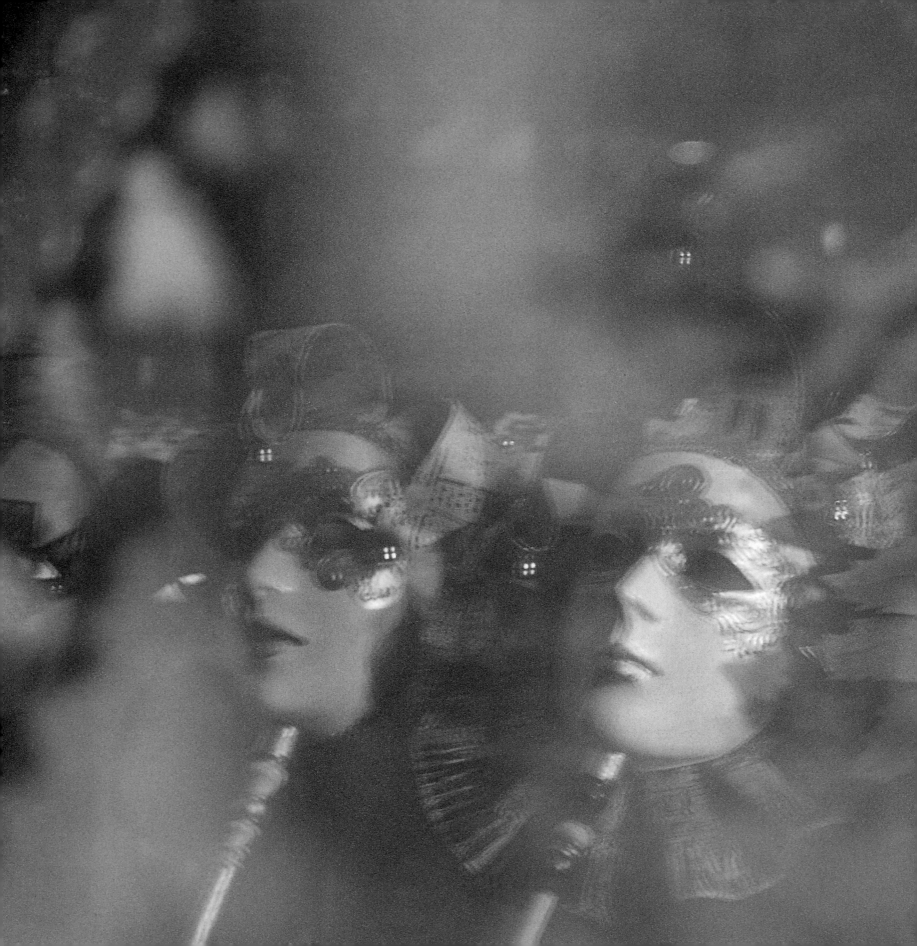

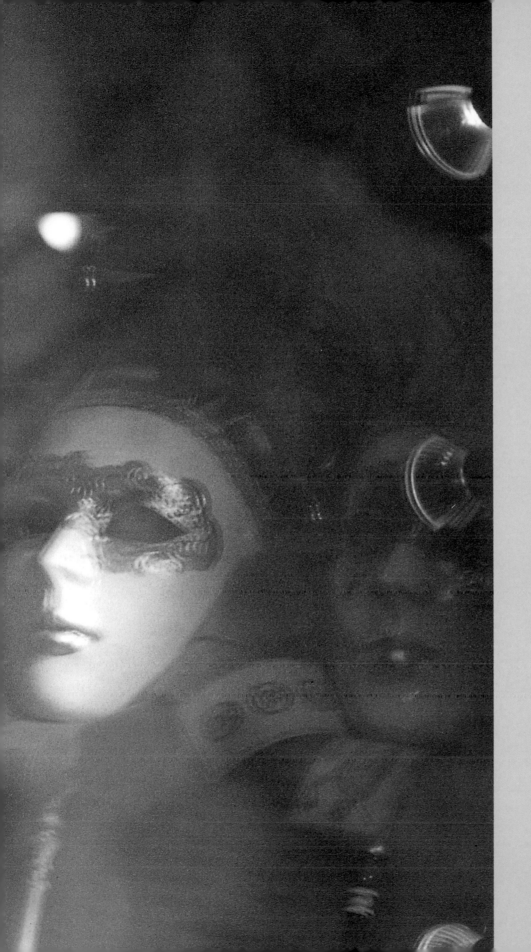

FACES
AND
MASKS

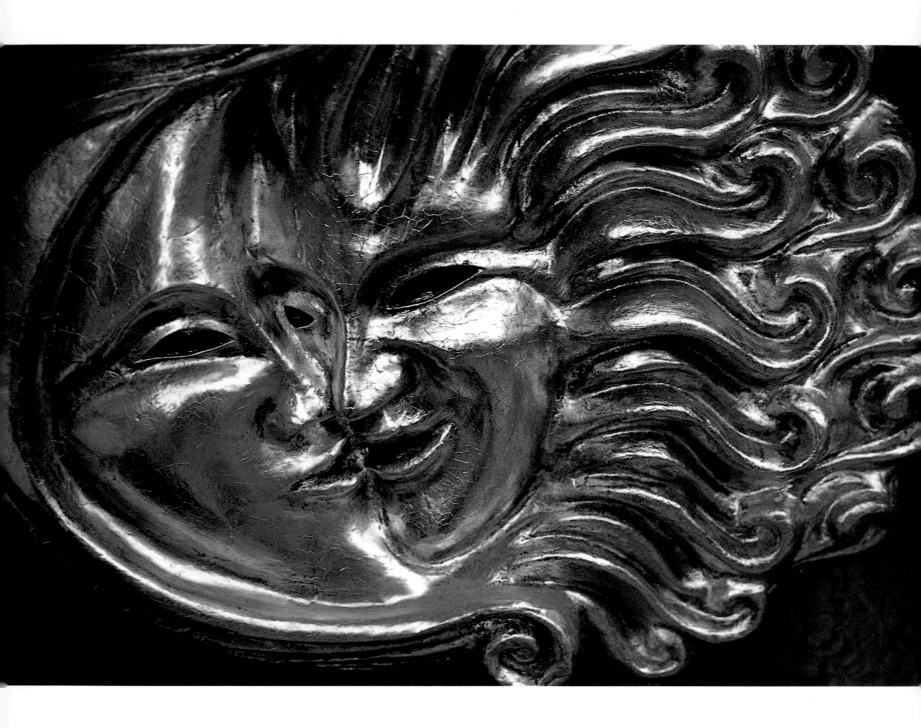

Blank or expressive masks, stone heads, and papier-mâché faces haunt a city that can strike visitors as mere trompe-l'oeil, all facades and reflections. Might Venice be the capital of ambiguity? According to sociologist Georg Simmel, it is more complex than that: "Ambiguous, too, is the double life of the city, at once a maze of alleyways and a maze of canals, so that the city belongs to neither land nor water—rather each appears like the protean garment, with the other concealed behind it, tempting as the true body."

PAGES 106–7:

CARNIVAL MASKS IN A SHOP WINDOW

◆ ◆ ◆

Venice

OPPOSITE:

SUN–MOON MASK

◆ ◆ ◆

Venice

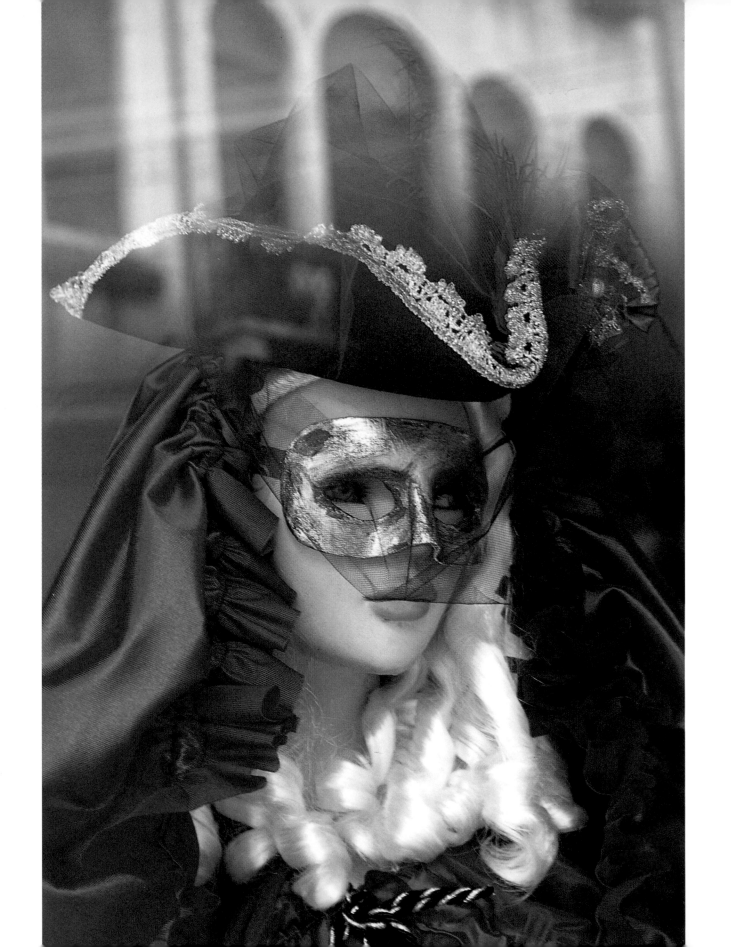

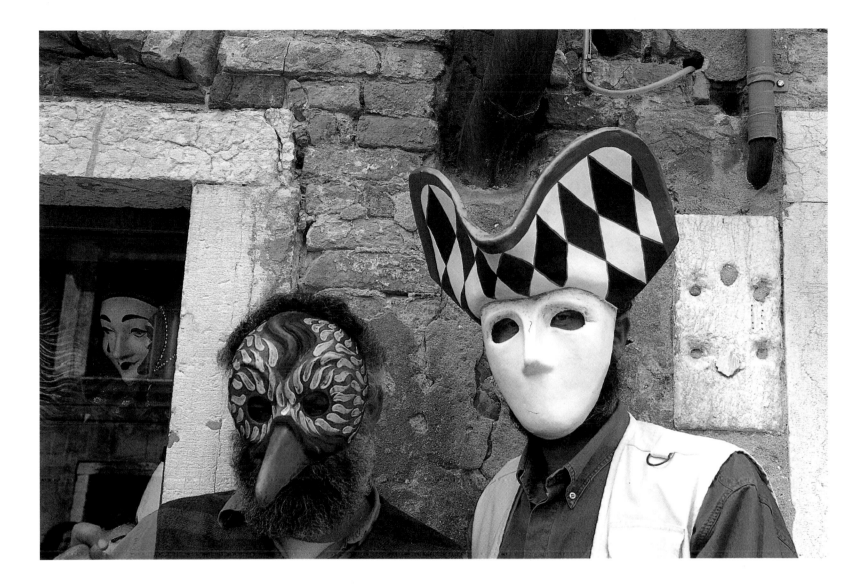

MASKS BY MONDO NOVO

◆ ◆ ◆

Venice

OPPOSITE:

MASK AND REFLECTION OF SAN ZACCARIA

◆ ◆ ◆

Venice

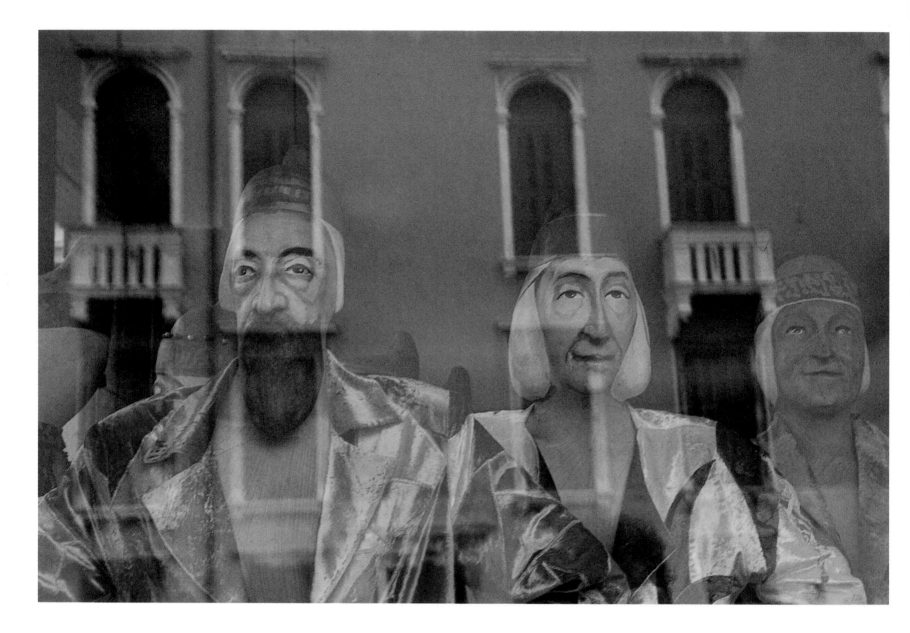

MASKS AND REFLECTIONS IN TWO SHOP WINDOWS

♦ ♦ ♦

Venice

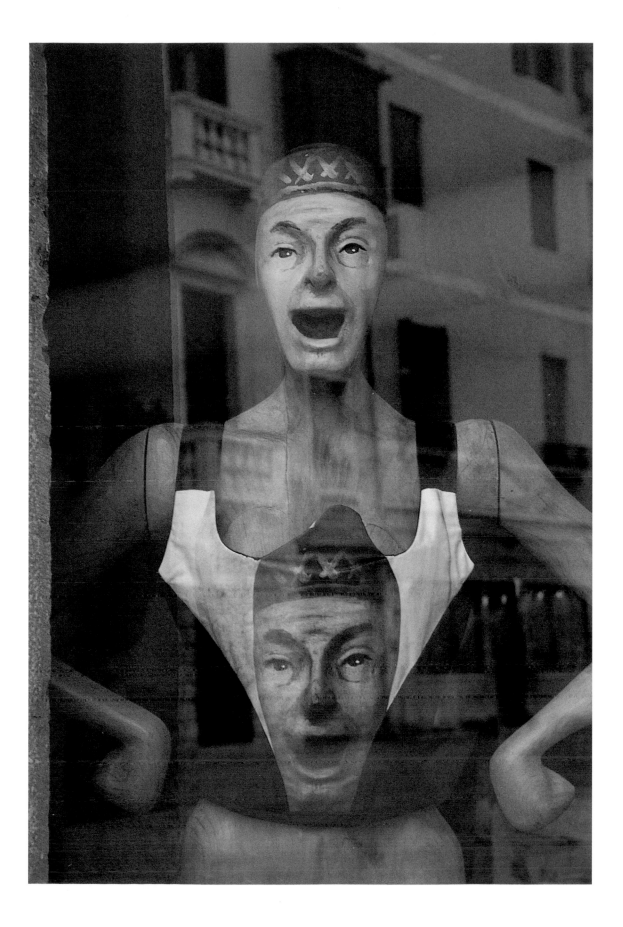

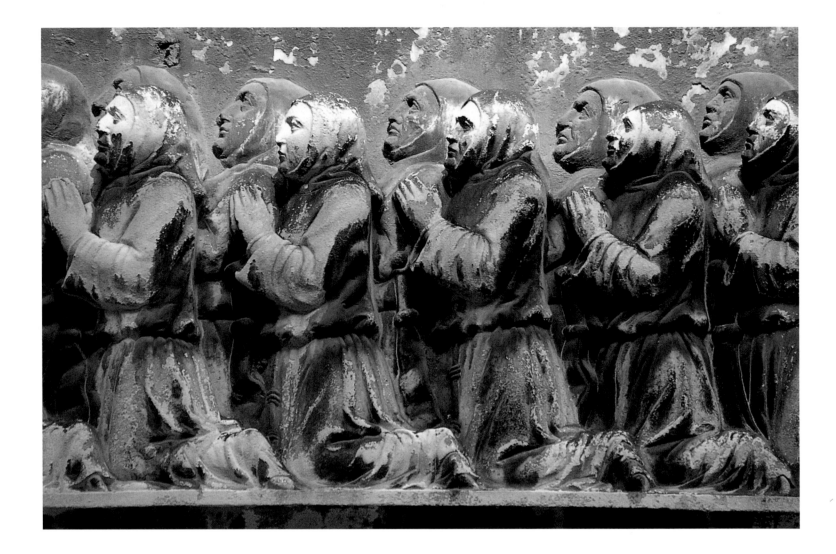

FIFTEENTH-CENTURY STONE RELIEF AT THE
SCUOLA GRANDE DI SAN GIOVANNI EVANGELISTA

◆ ◆ ◆

Venice

OPPOSITE, TOP ROW:
STONE RELIEFS

◆ ◆ ◆

Venice

OPPOSITE, MIDDLE AND BOTTOM ROWS:
MASKS

◆ ◆ ◆

Venice

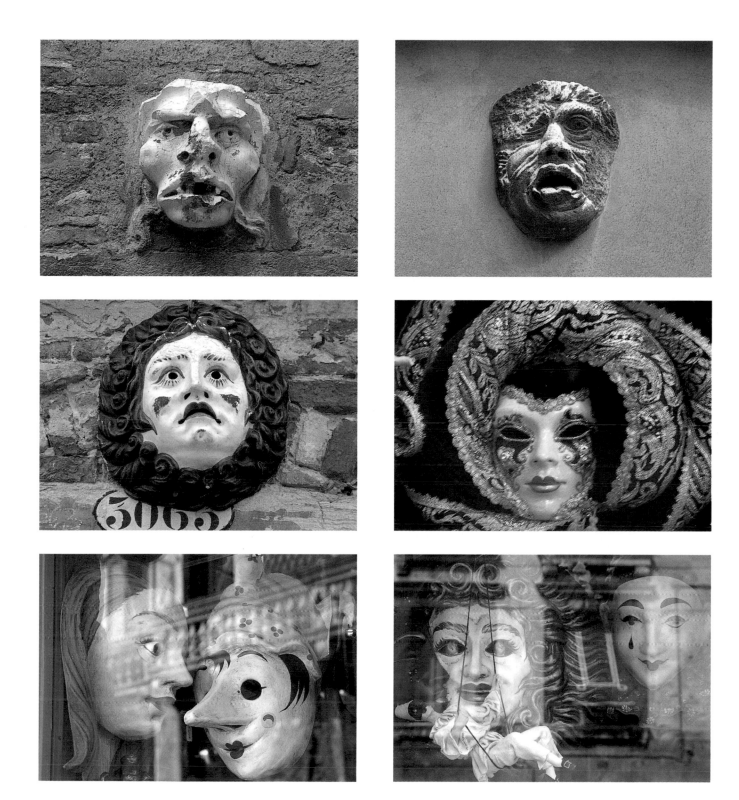

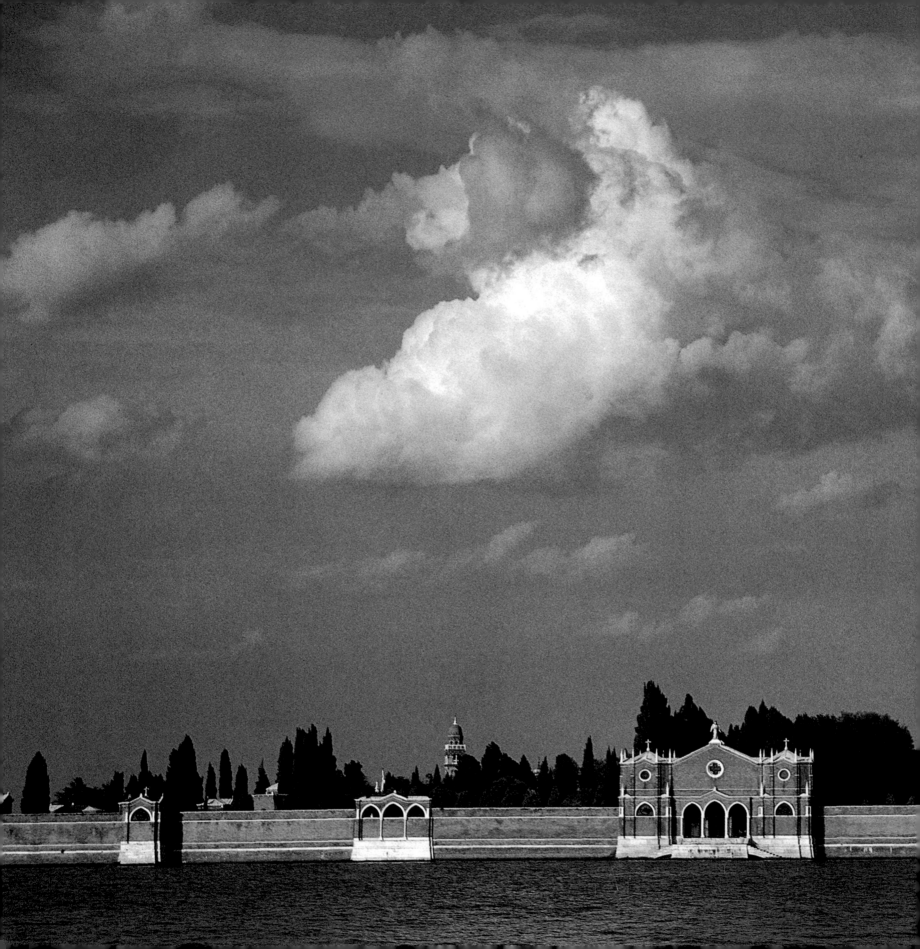

THE
ISLANDS

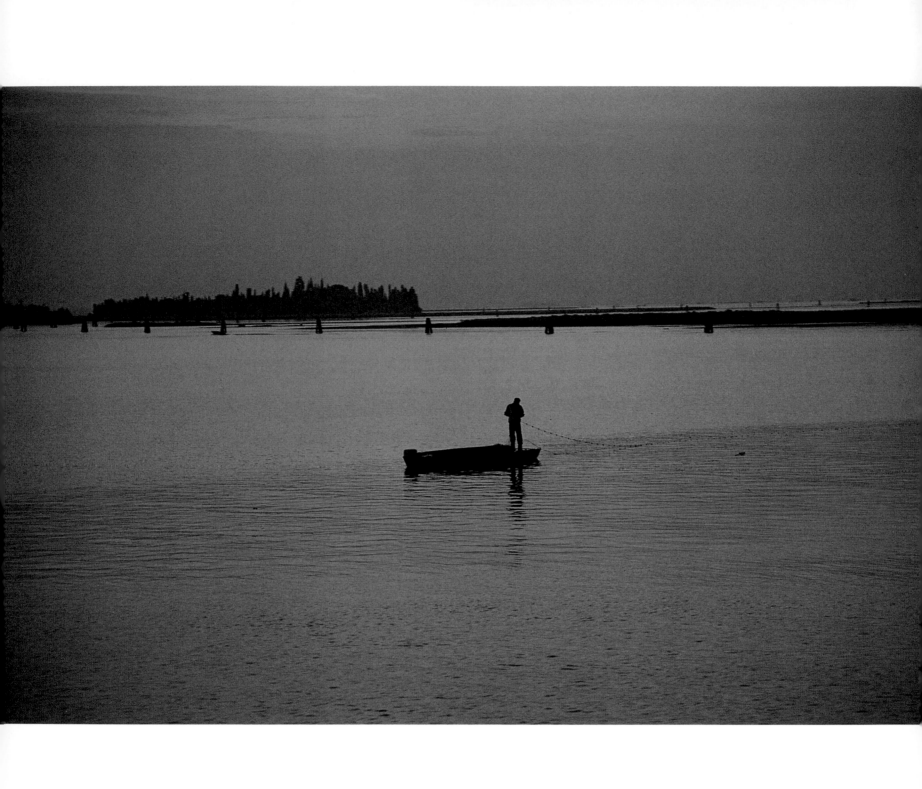

Serenely luminous on one day, dramatically blustery on another, the lagoon is ever changing. Visually it offers a kaleidoscope of living pictures, displaying an endless variety of images. Visitors eager to enjoy the lagoon's many pleasures need only view the bright colors on the houses of the island of Burano, the blues and deep reds of Murano's glassware, or the bright greenery of San Michele, the Lido, and Torcello.

PAGES 116–17:

CEMETERY

◆ ◆ ◆

San Michele

OPPOSITE:

ON THE WATER JUST BEFORE SUNSET

◆ ◆ ◆

Venetian lagoon

PAGES 120–21:

VIEW TOWARD THE ISLAND OF SAN MICHELE

◆ ◆ ◆

Burano

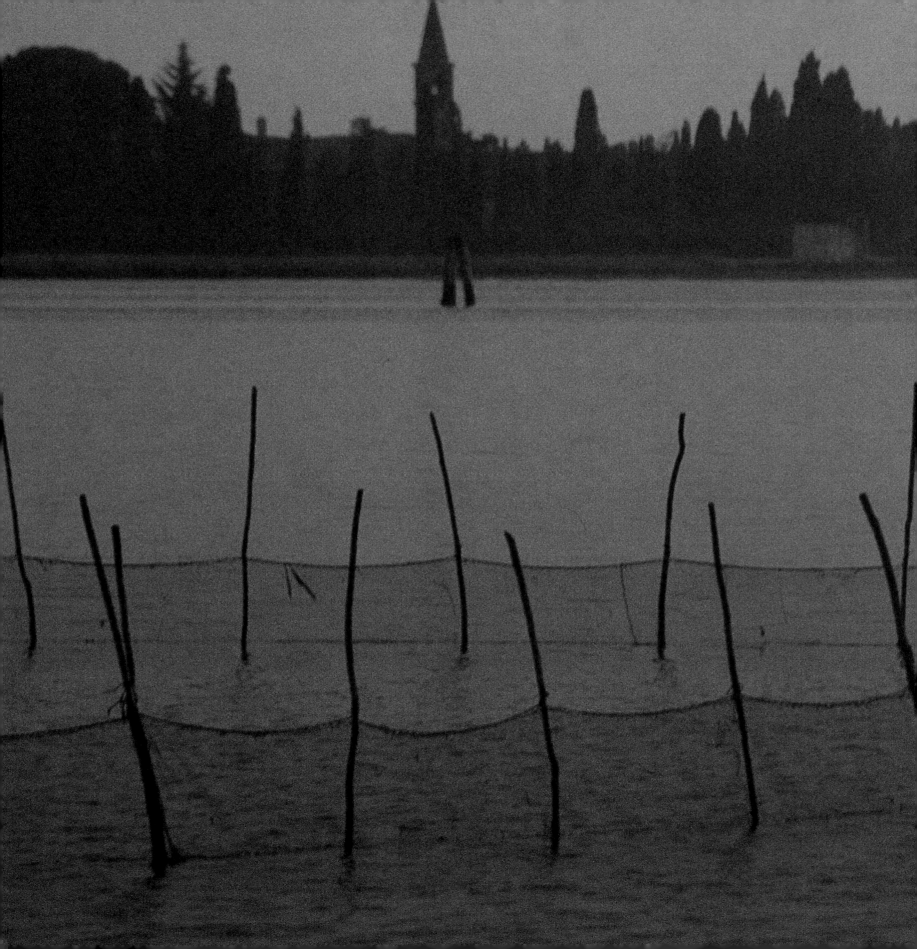

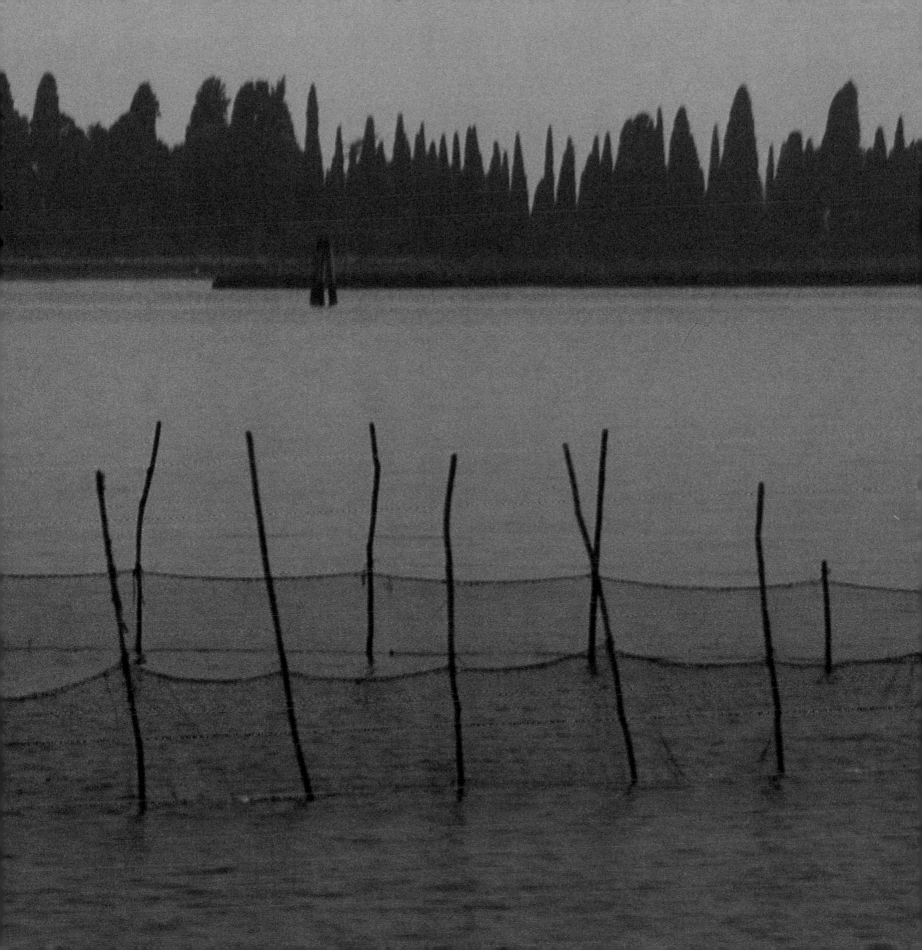

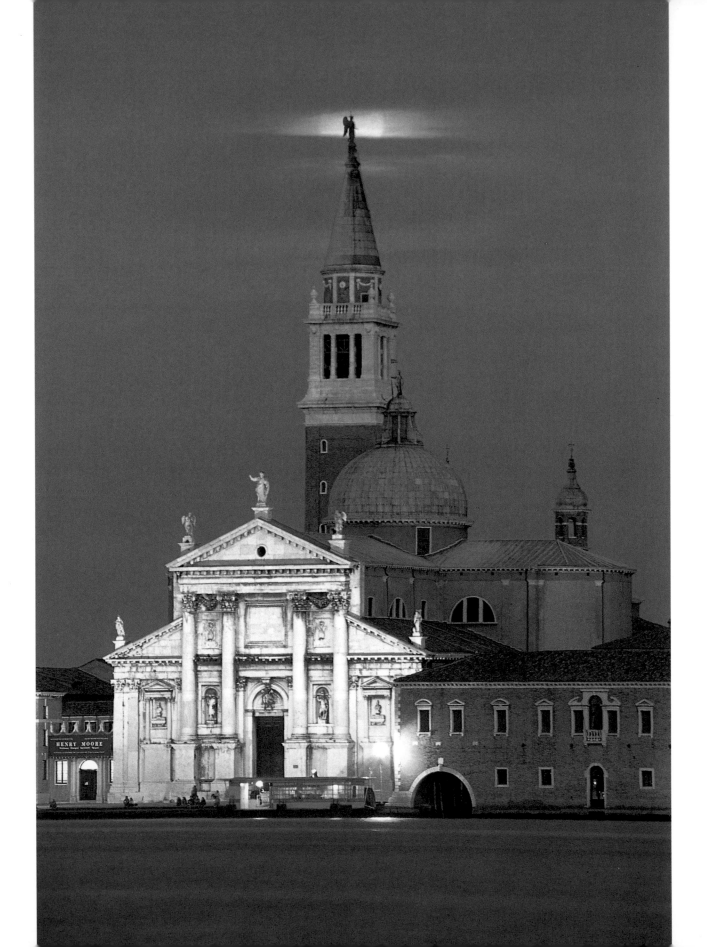

CLOISTER OF SAN
GIORGIO MAGGIORE
◆ ◆ ◆
San Giorgio Maggiore

OPPOSITE:
MOONRISE AT CHURCH
OF SAN GIORGIO
MAGGIORE
◆ ◆ ◆
San Giorgio Maggiore

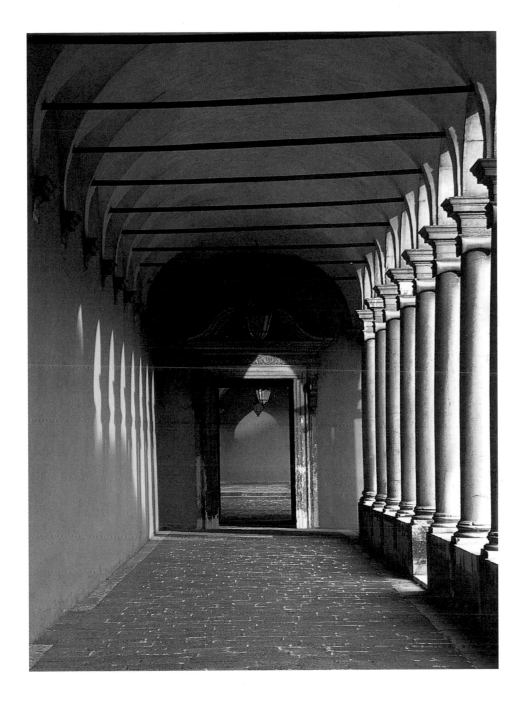

GLASSWARE

◆ ◆ ◆

Murano

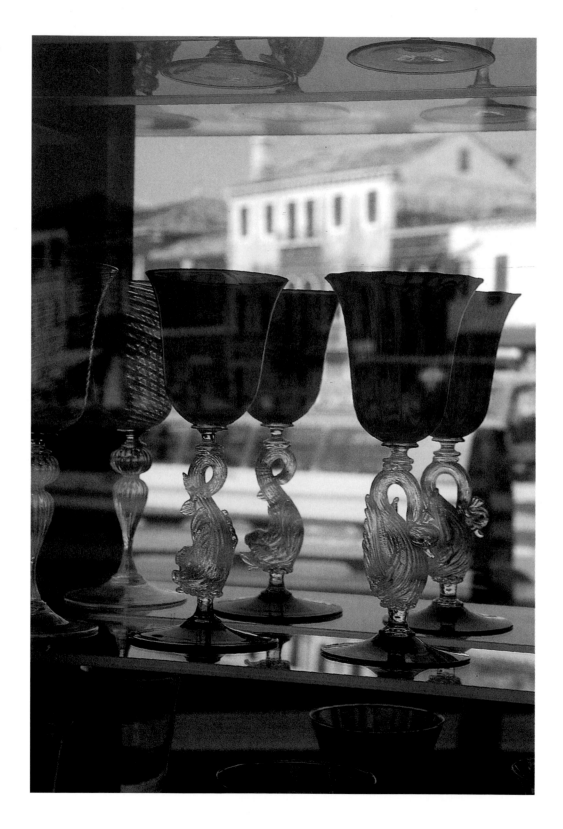

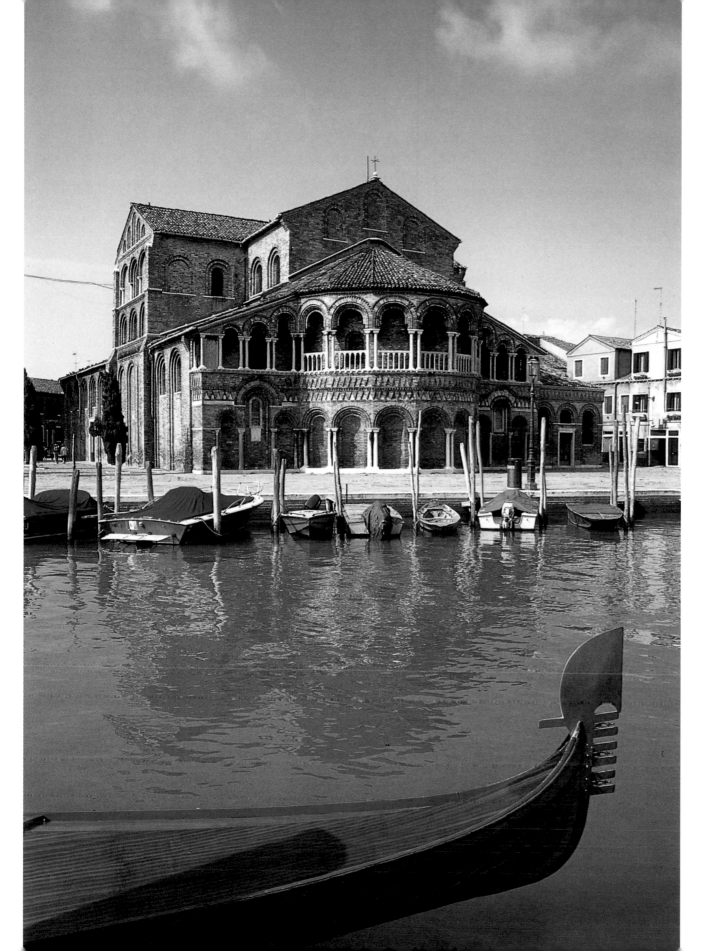

BASILICA OF SAINTS
MARIA AND DONATO
◆ ◆ ◆
Murano

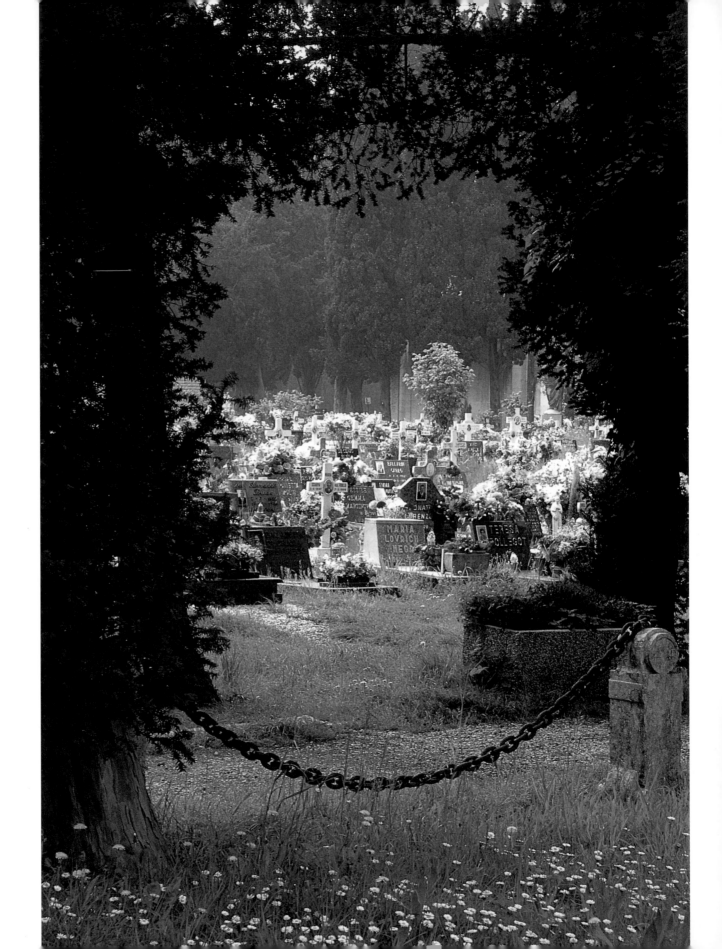

CEMETERY
◆ ◆ ◆
San Michele

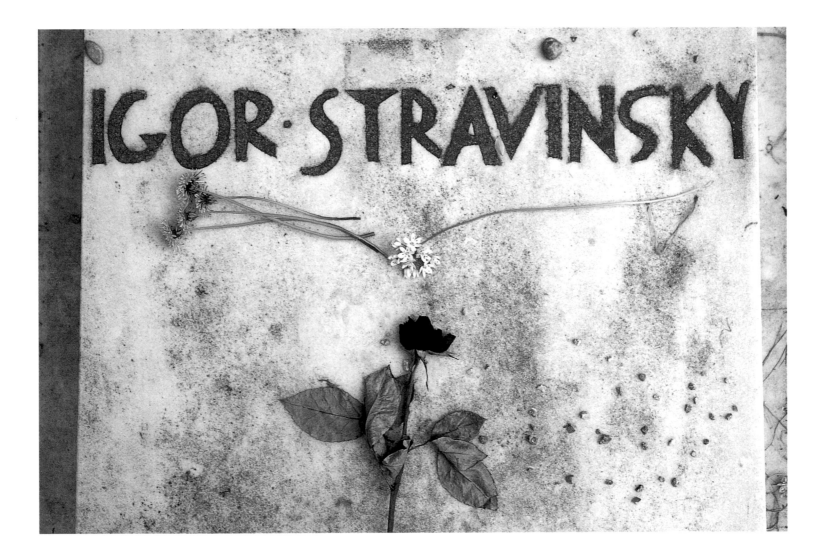

GRAVESTONE

◆ ◆ ◆

San Michele

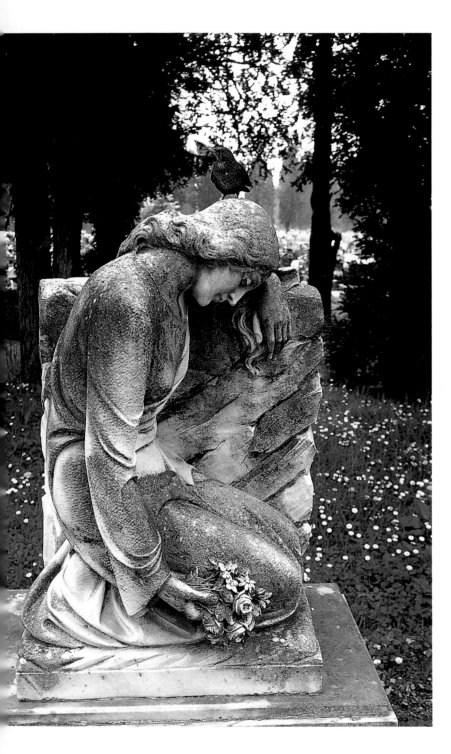

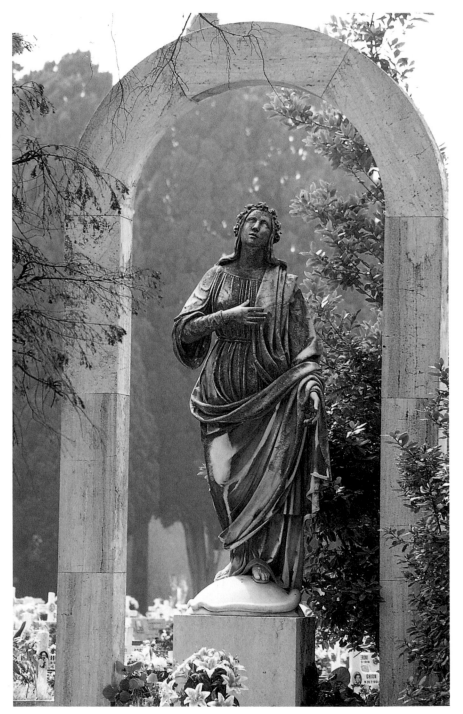

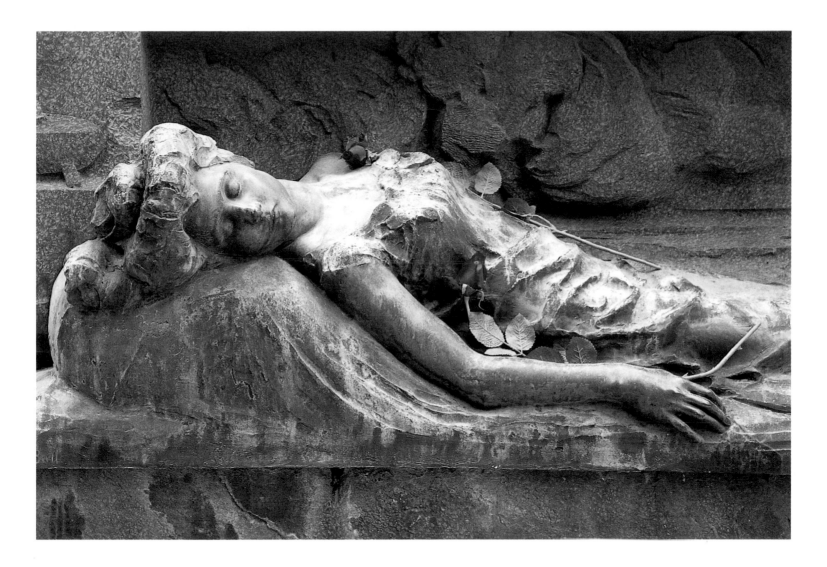

TOMB SCULPTURES

◆ ◆ ◆

San Michele

RIGHT:

MAIN CANAL

◆ ◆ ◆

Burano

BELOW AND OPPOSITE:

VILLAGE

◆ ◆ ◆

Burano

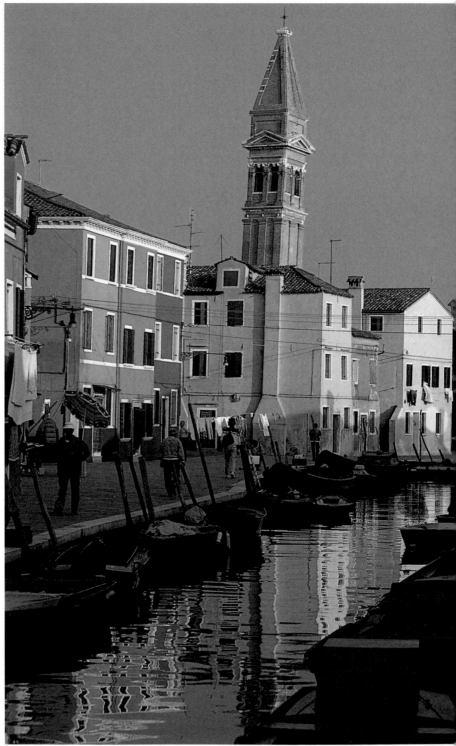

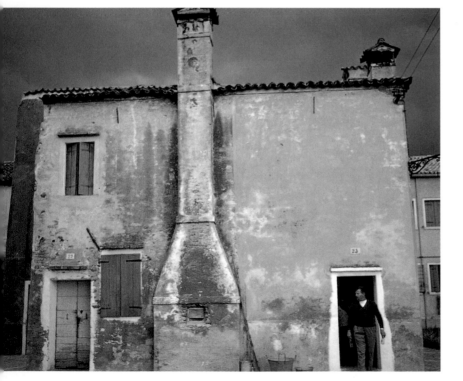

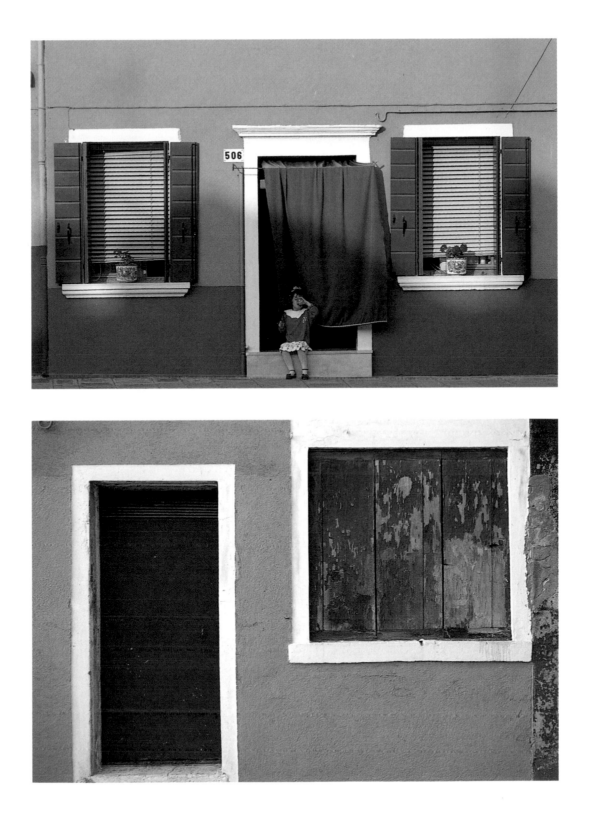

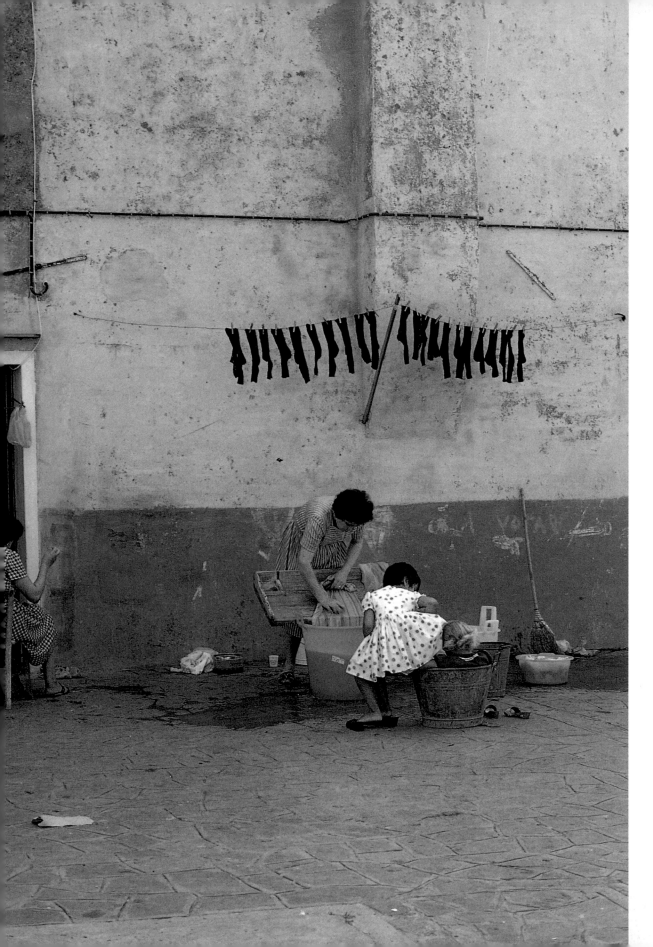

LAUNDRY DAY
◆ ◆ ◆
Burano

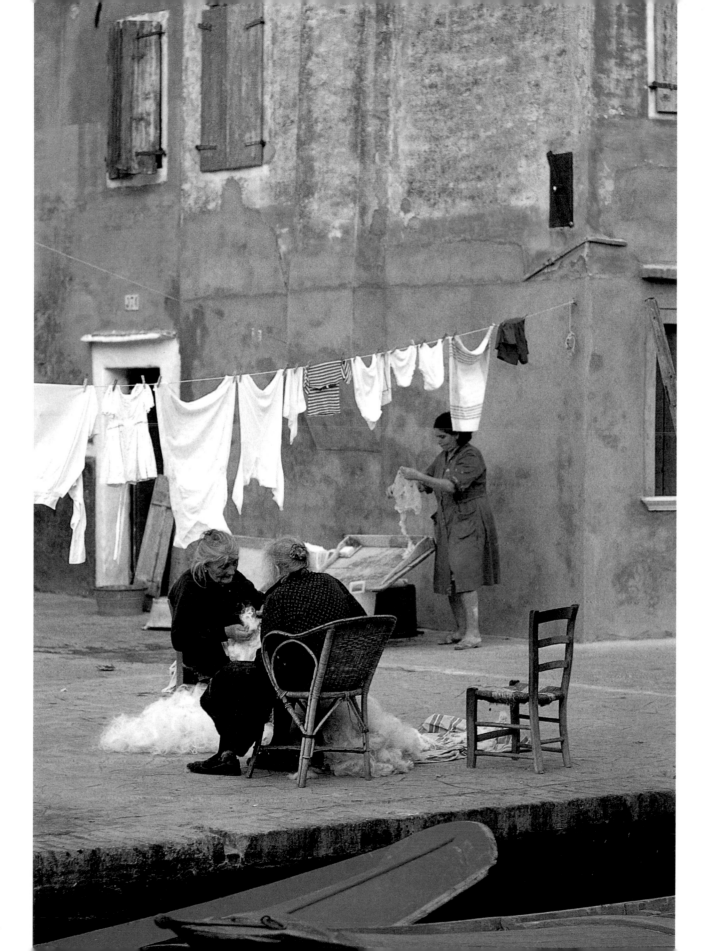

MENDING NETS
◆ ◆ ◆
Burano

DOORWAYS, WALLS, AND WINDOWS
◆ ◆ ◆
Burano

LAGOON PLANTS
◆ ◆ ◆
Torcello

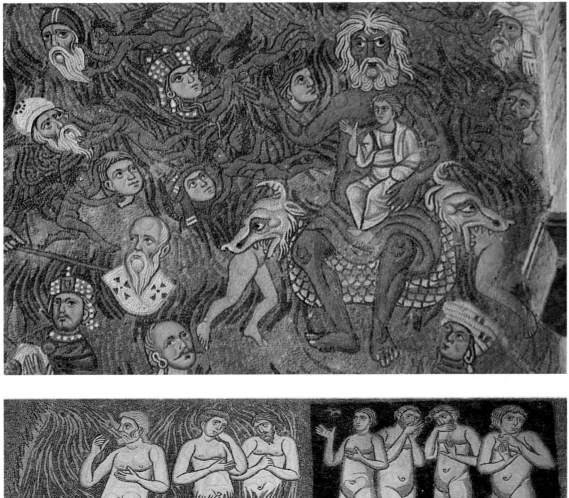

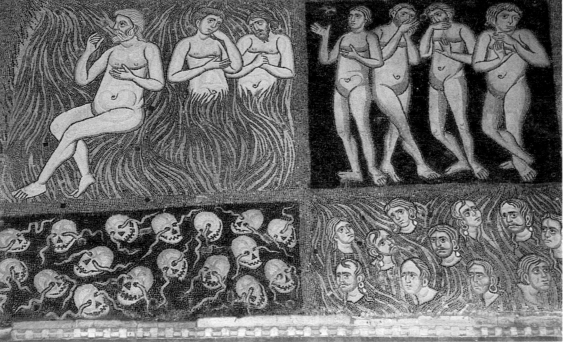

LAST JUDGMENT MOSAIC
IN THE CATHEDRAL
◆ ◆ ◆
Torcello

WINDOW

◆ ◆ ◆

San Pietro di Castello

CHURCH OF SAN PIETRO DI CASTELLO

◆ ◆ ◆

San Pietro di Castello

HOTEL HUNGARIO
◆ ◆ ◆
The Lido

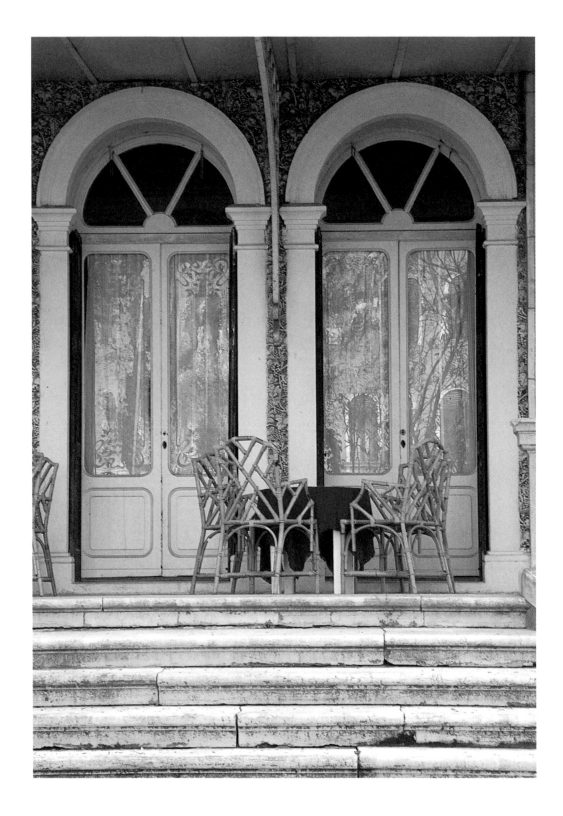

STONE IN THE JEWISH CEMETERY
◆ ◆ ◆
The Lido

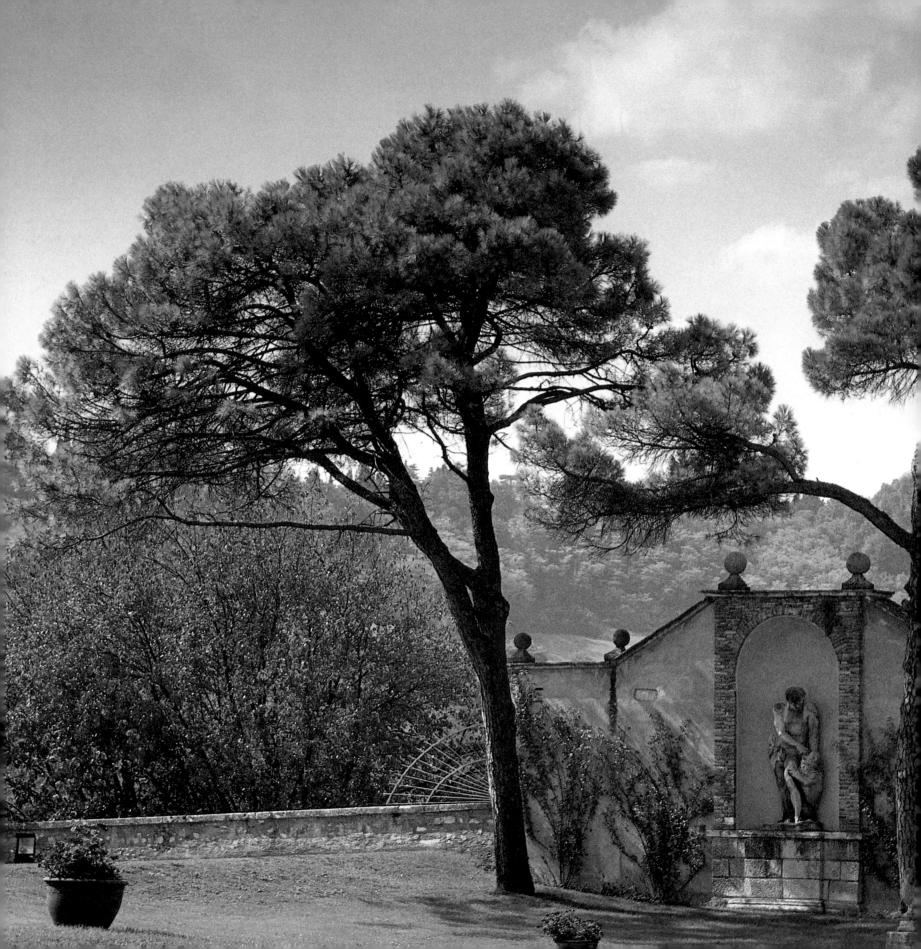

VILLAS AND VILLAGES OF THE VENETO

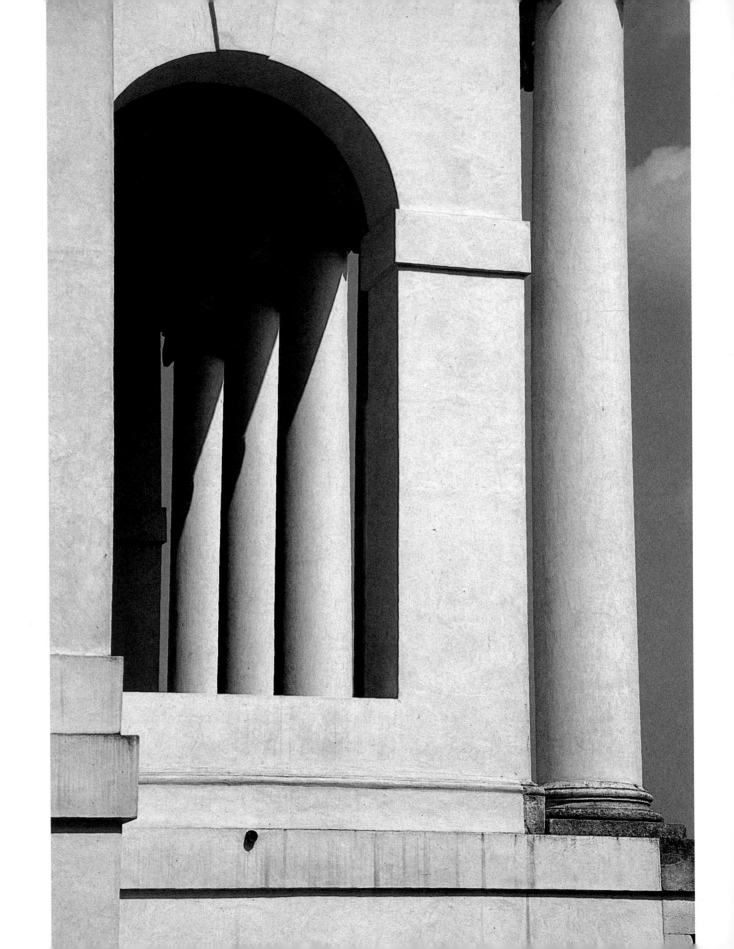

The Veneto is no mere backdrop, nor simply the inverse of Venice. With its towns and large villages, and especially its architectural wonders—Verona's Roman amphitheater, Marostica's medieval rampart, Treviso's ancient arcades, the numerous Palladian villas scattered throughout the countryside—the Veneto offers many faded and fresh glories to travelers.

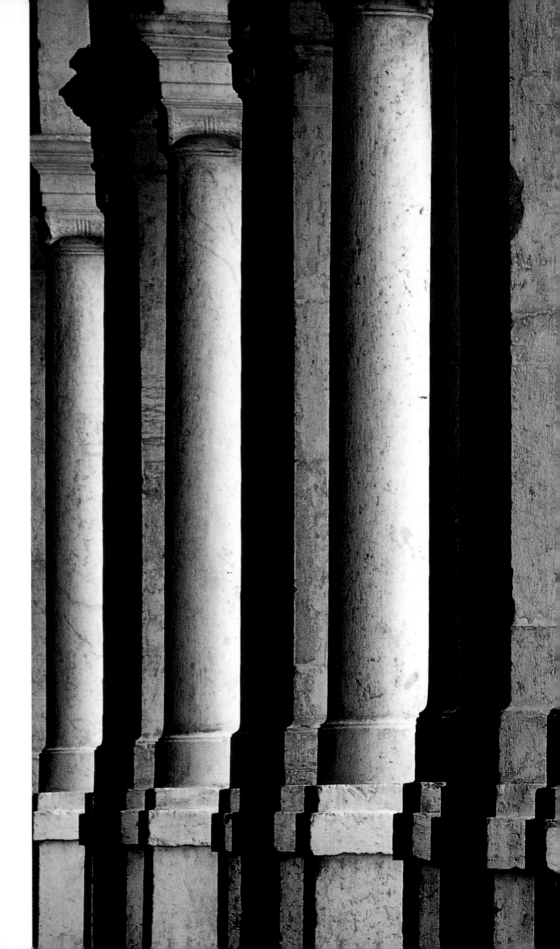

THE LOGGIA OF PALLADIO'S
CIVIC BASILICA
◆ ◆ ◆
Vicenza

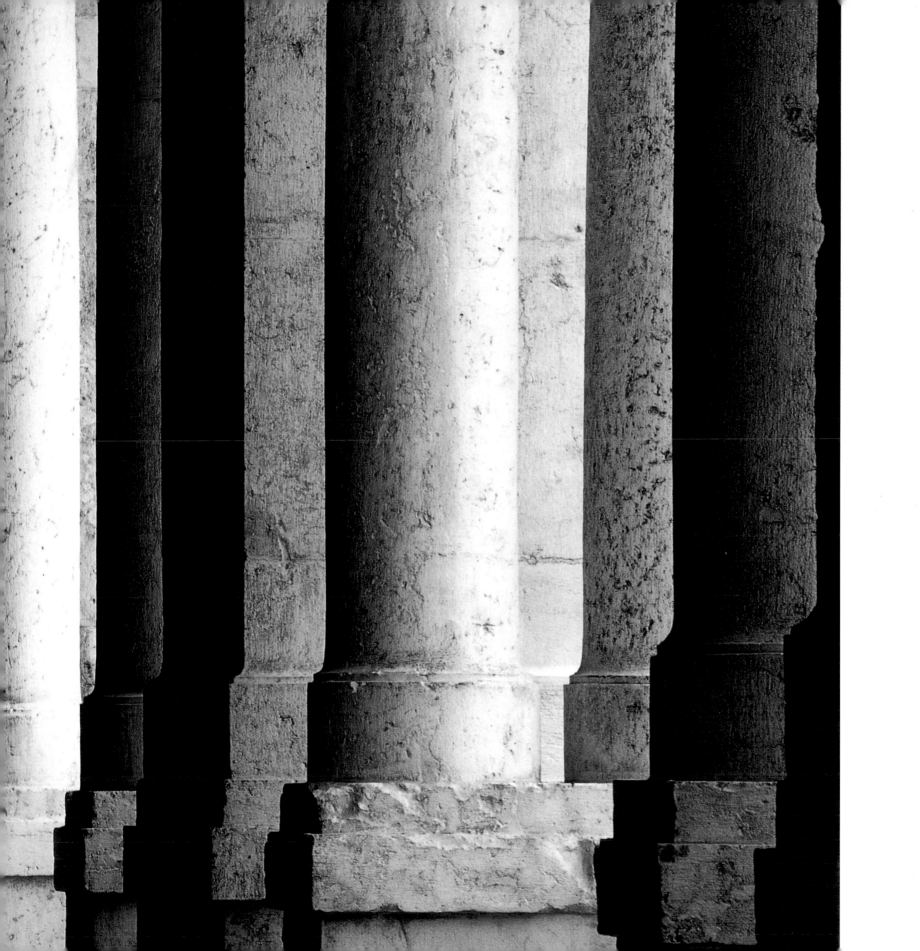

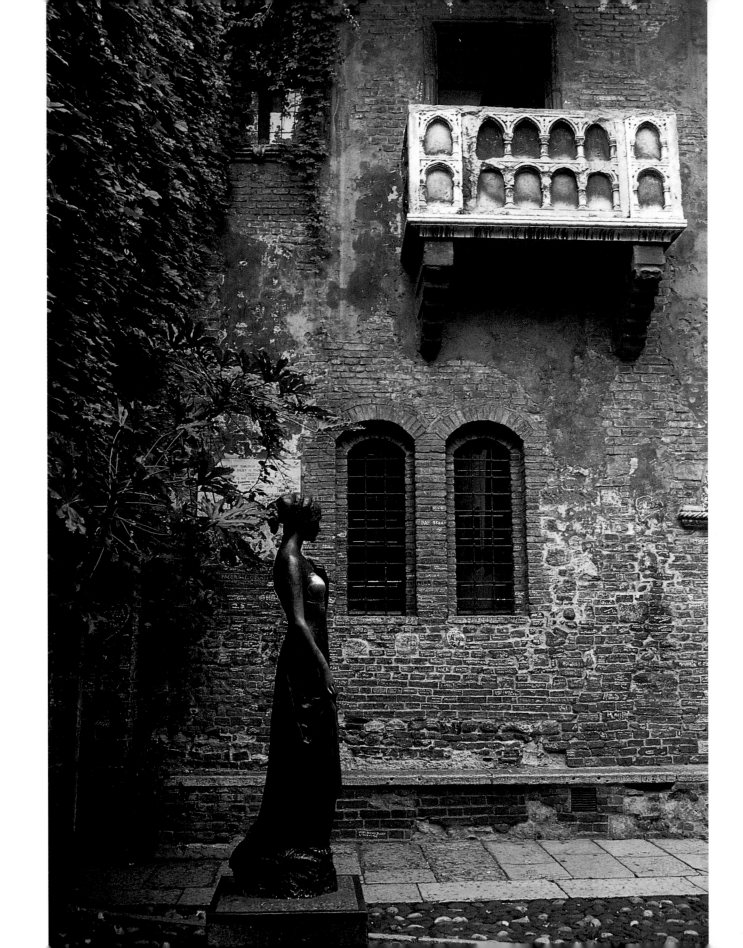

JULIET'S
BALCONY
◆ ◆ ◆
Verona

148

WEDDING DAY

◆ ◆ ◆

Bassano del Grappa

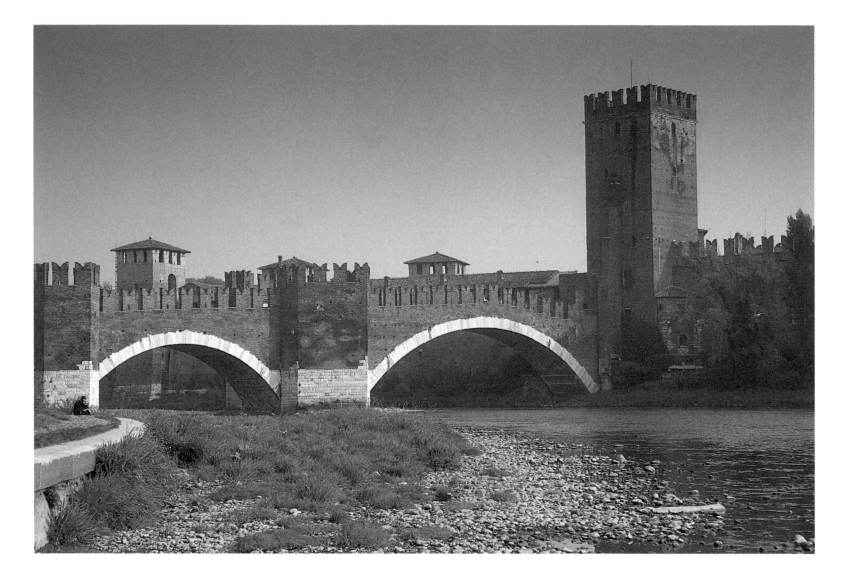

MEDIEVAL SCALIGERI BRIDGE AND CASTELVECCHIO

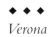

Verona

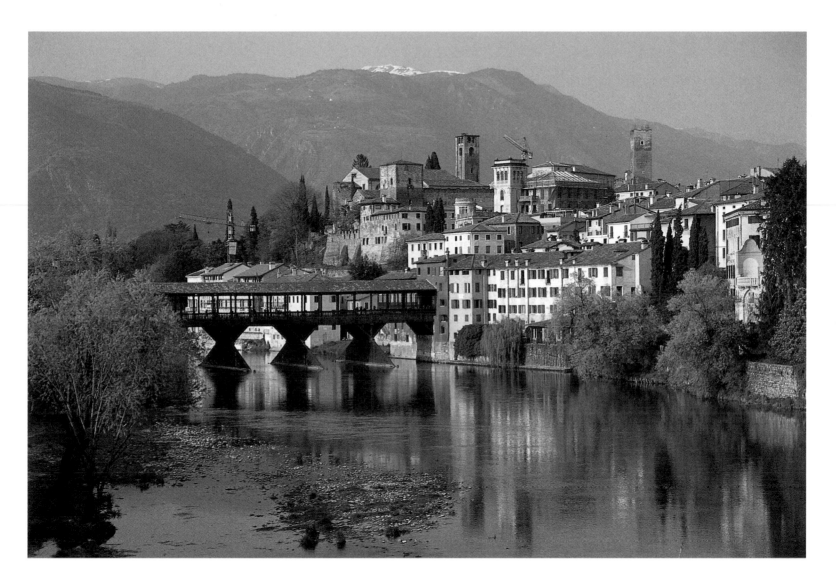

PONTE DEGLI ALPINI

◆ ◆ ◆

Bassano del Grappa

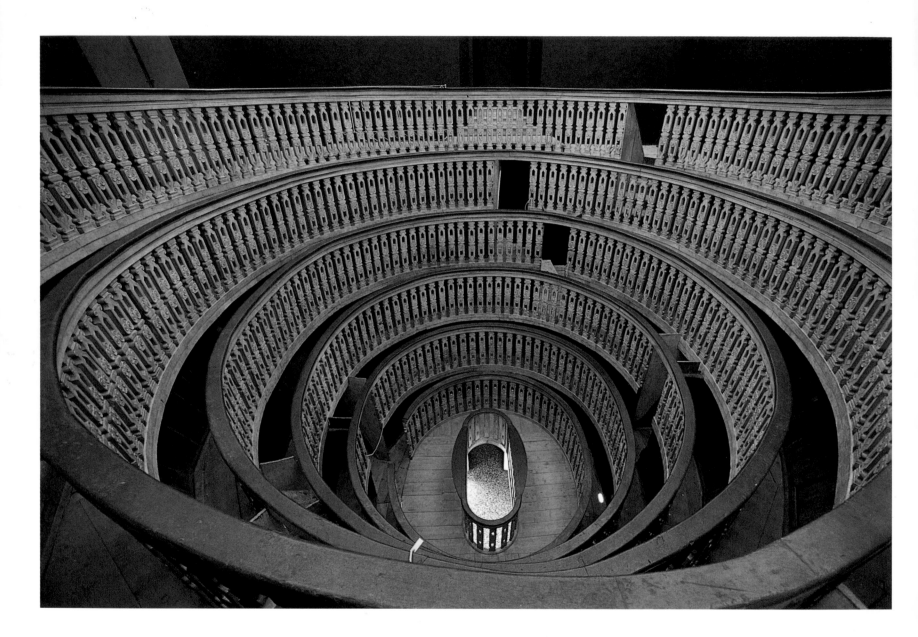

ANATOMICAL THEATER IN THE UNIVERSITY

◆ ◆ ◆

Padua

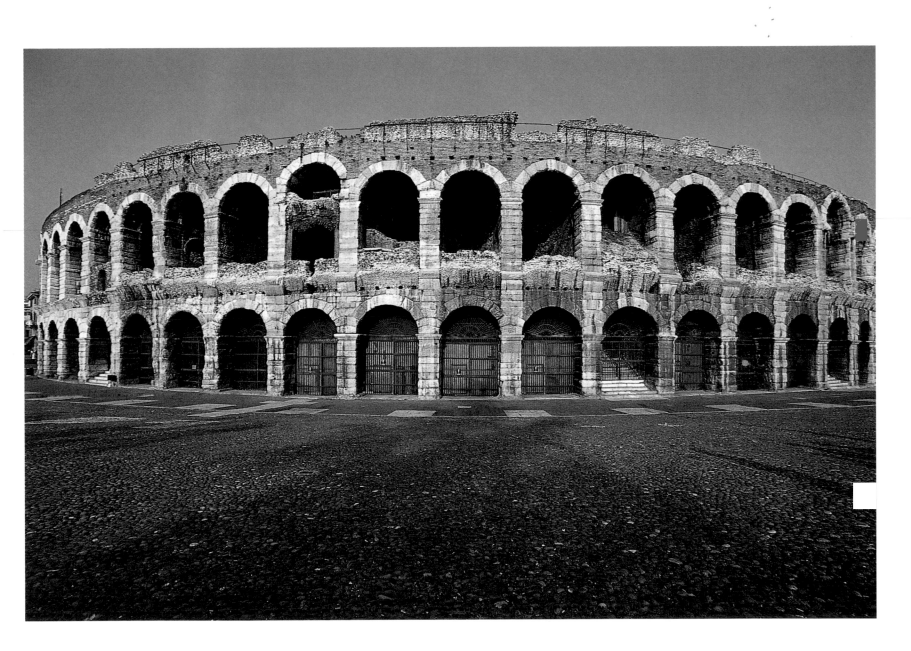

ROMAN ARENA

◆ ◆ ◆

Verona

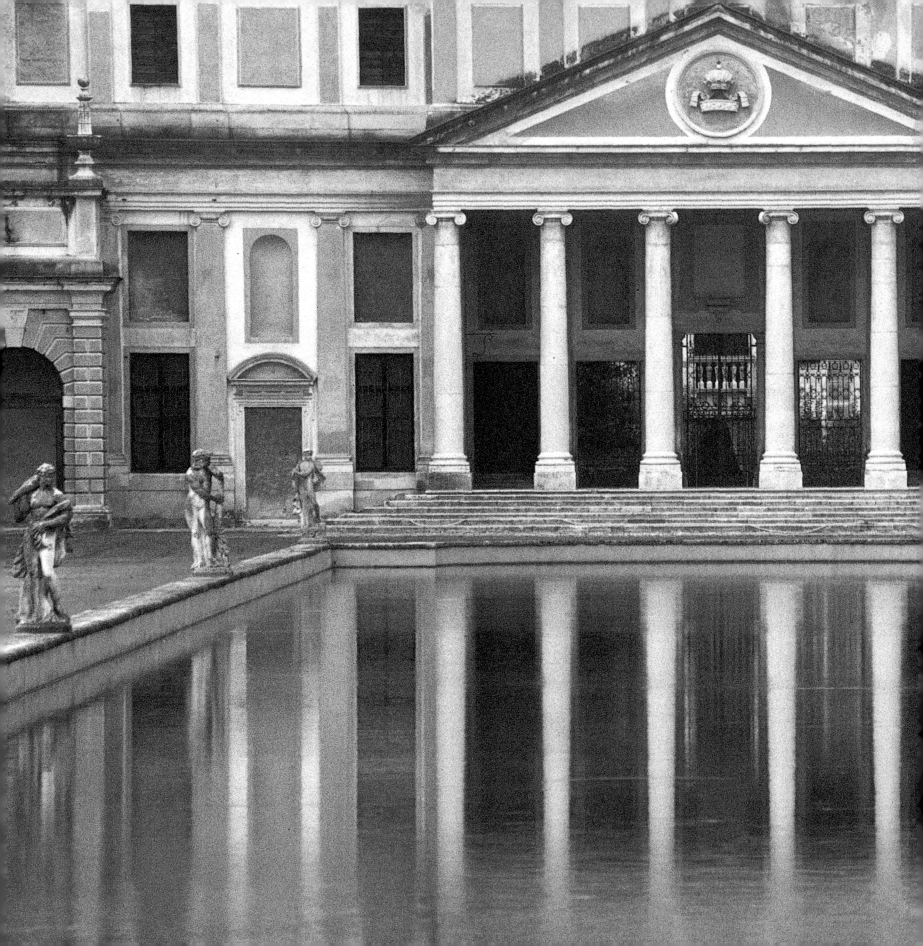

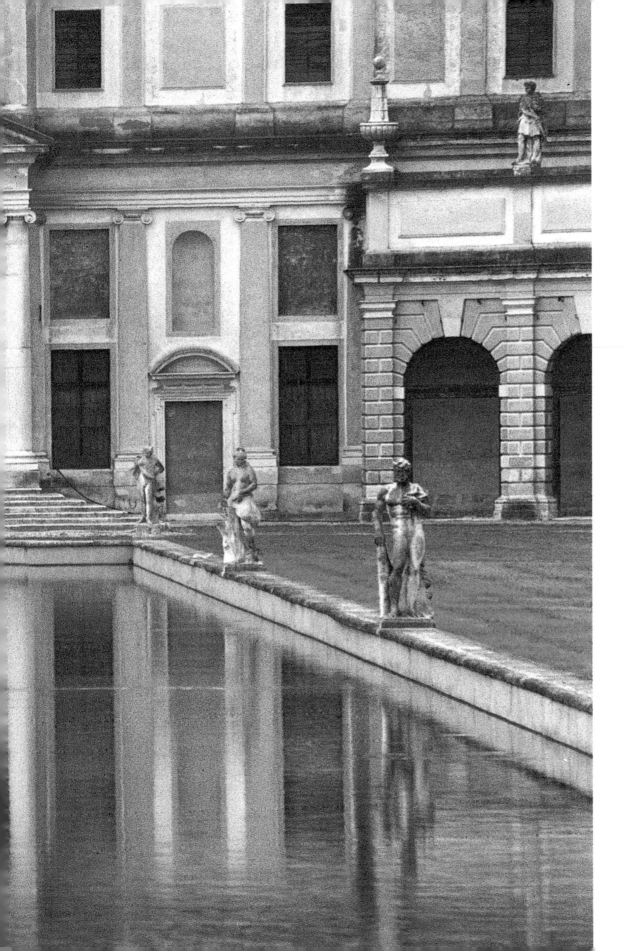

VILLA PISANI AT STRA

◆ ◆ ◆

Padua

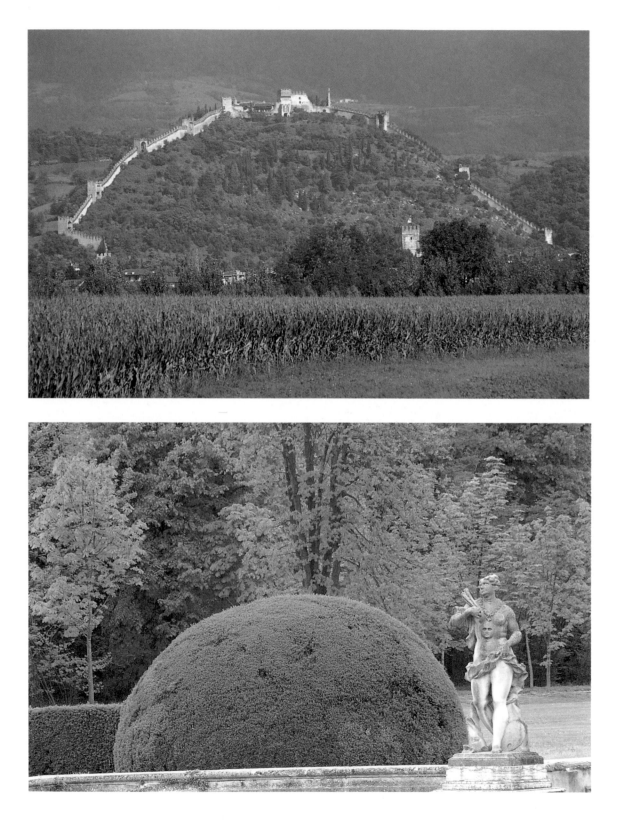

TOP:

RAMPARTS

◆ ◆ ◆

Marostica

BOTTOM:

GARDEN OF THE VILLA
PISANI AT STRA

◆ ◆ ◆

Padua

OPPOSITE:

VIEW FROM VILLA
CIPRIANI

◆ ◆ ◆

Asolo

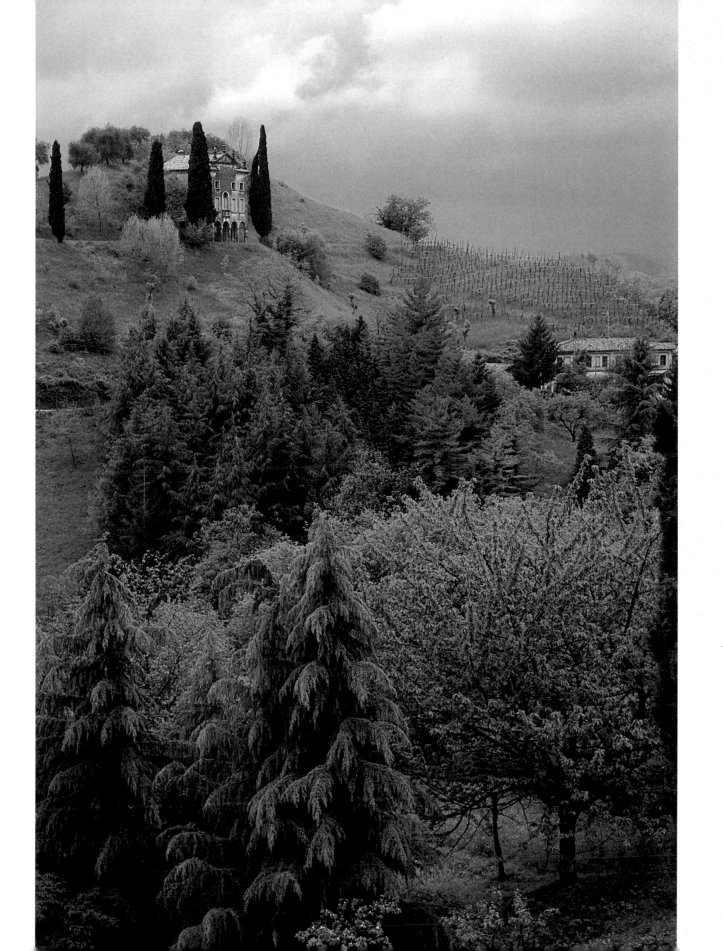

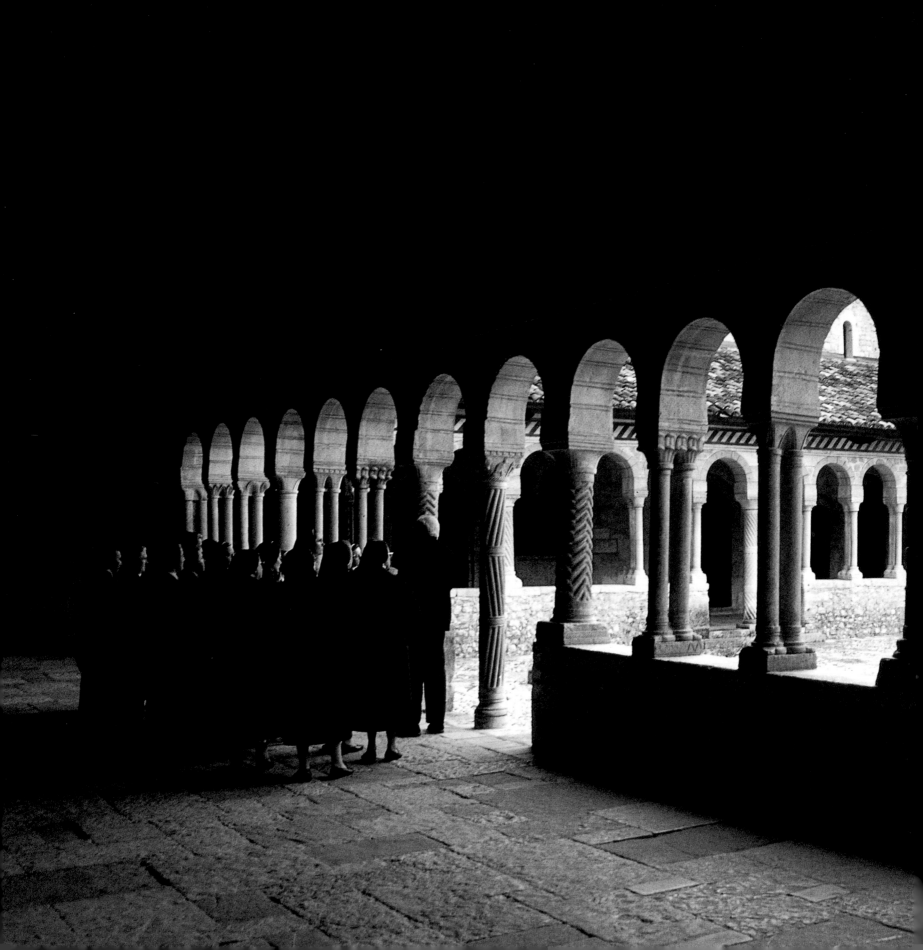

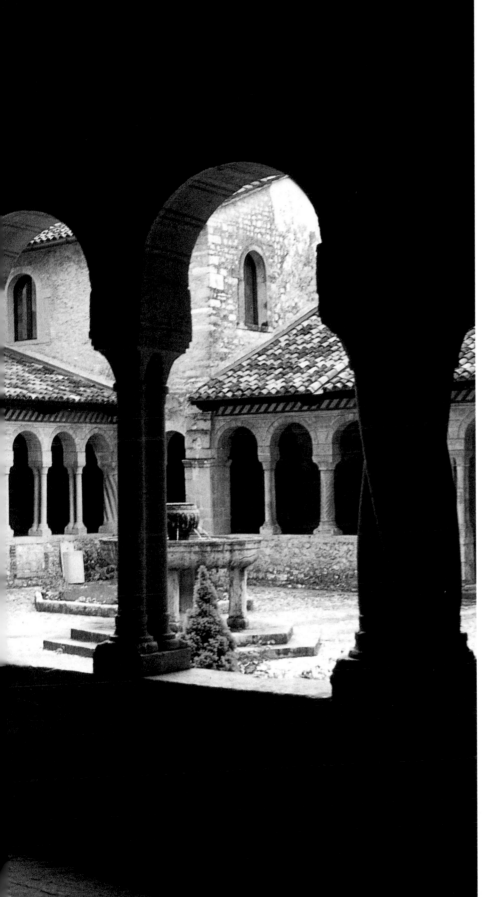

THIRTEENTH-CENTURY ABBEY
◆ ◆ ◆
Follina

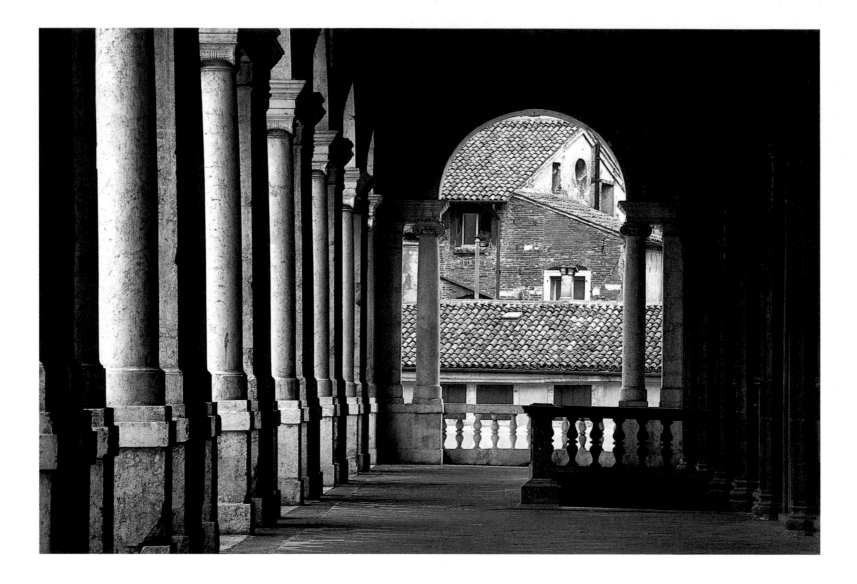

PALLADIO'S BASILICA
◆ ◆ ◆
Vicenza

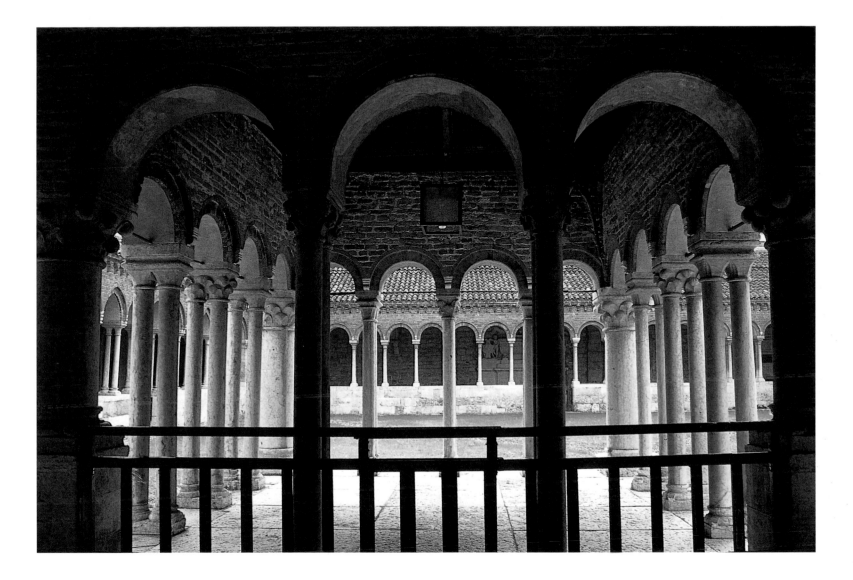

CLOISTER OF SAN ZENO MAGGIORE

◆ ◆ ◆

Verona

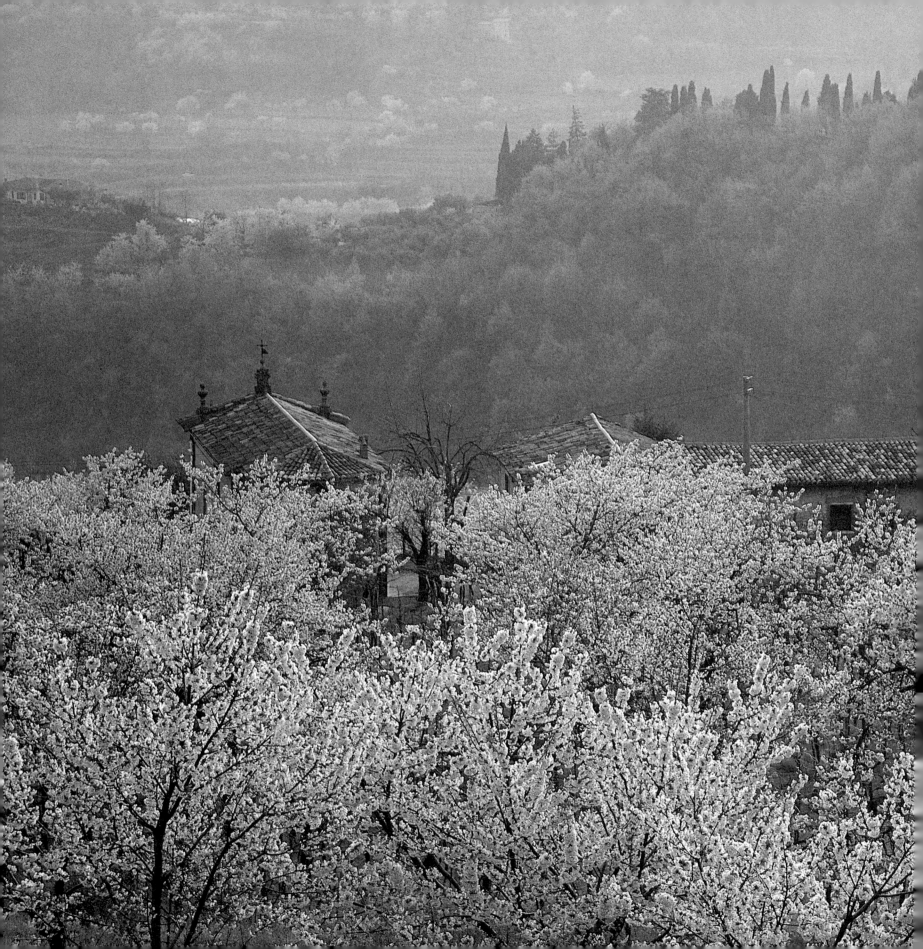

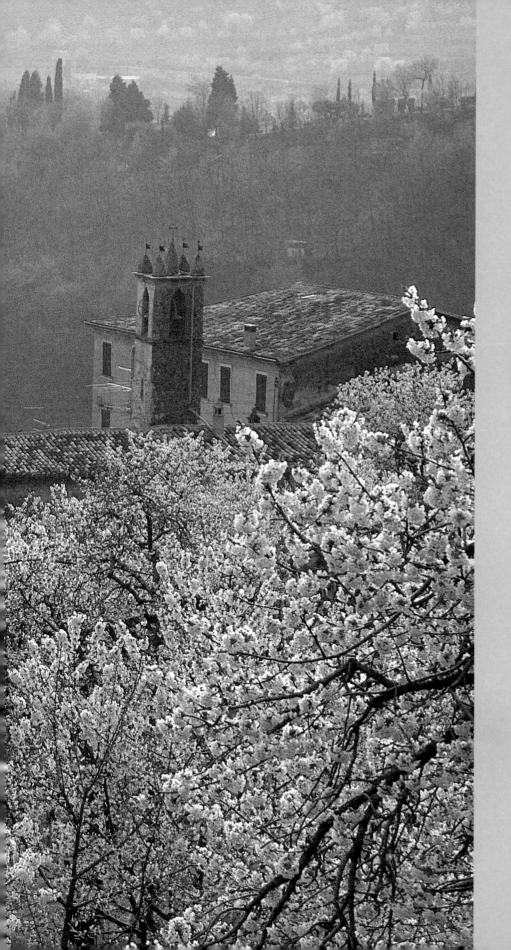

LANDSCAPES OF THE VENETO

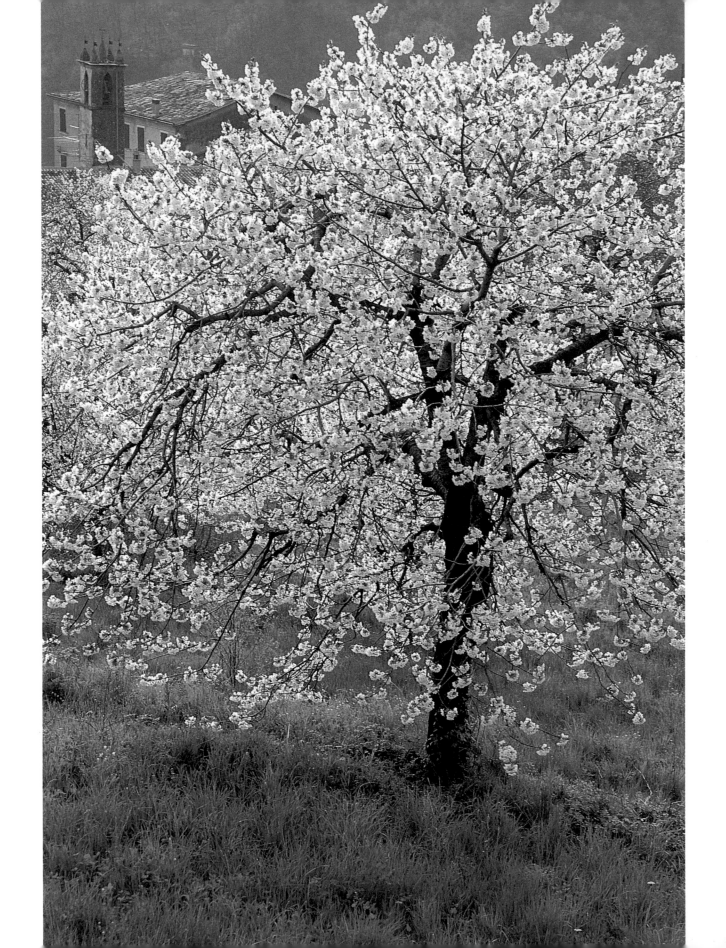

To wander over terra firma is to step straight into the landscapes seen in the paintings of Cima da Conegliano or Giovanni Bellini—the spectacular Dolomites, the rolling hills surrounding Asolo, Mount Berici near Vicenza, the Colli Euganei close to Padua, the grape-vines of Soave and Valpolicella, the meadows of Negrar. The Veneto has everything you might long for should you grow weary of the lagoon.

OPPOSITE AND PAGES 162–63:
CHERRY TREES BLOSSOMING IN SPRING
◆ ◆ ◆
Negrar

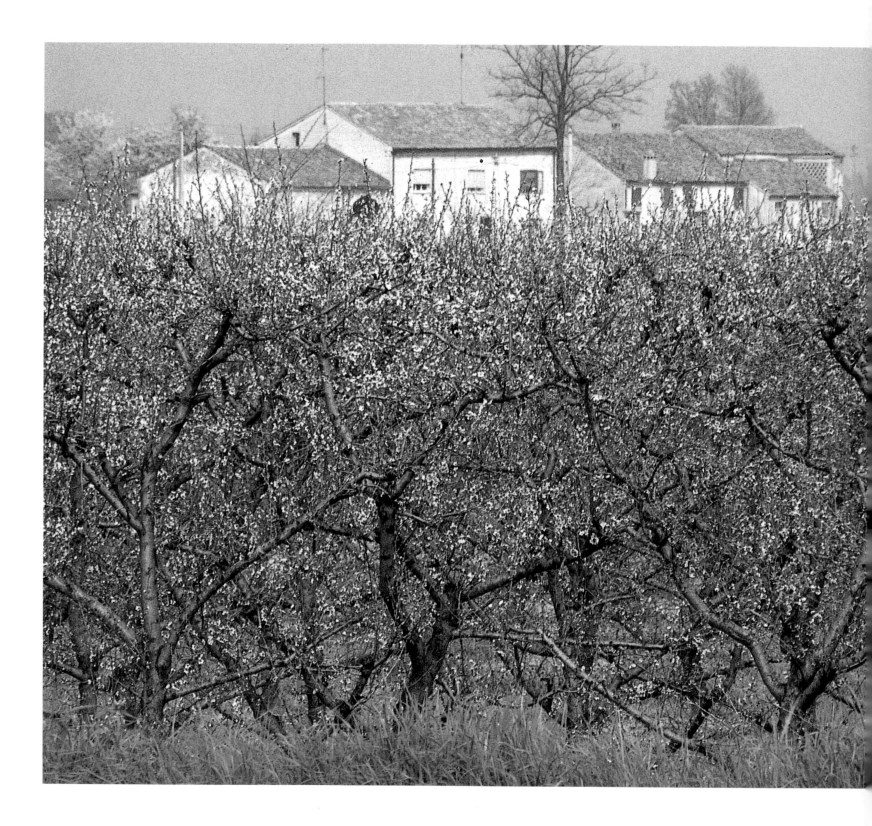

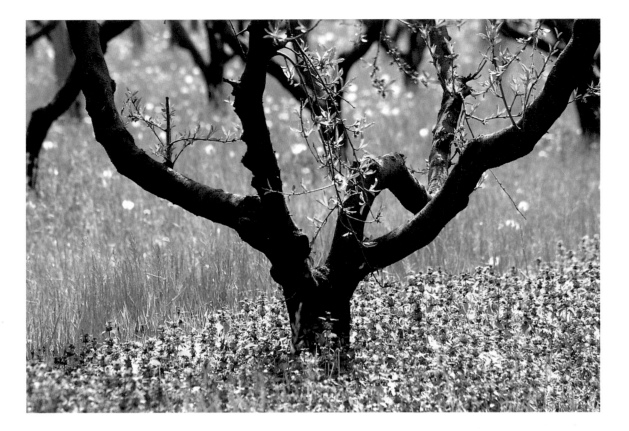

ABOVE:
FRUIT TREES AND NETTLES

◆ ◆ ◆

Valpolicella

LEFT:
PEACH TREES IN BLOOM

◆ ◆ ◆

Po River Valley

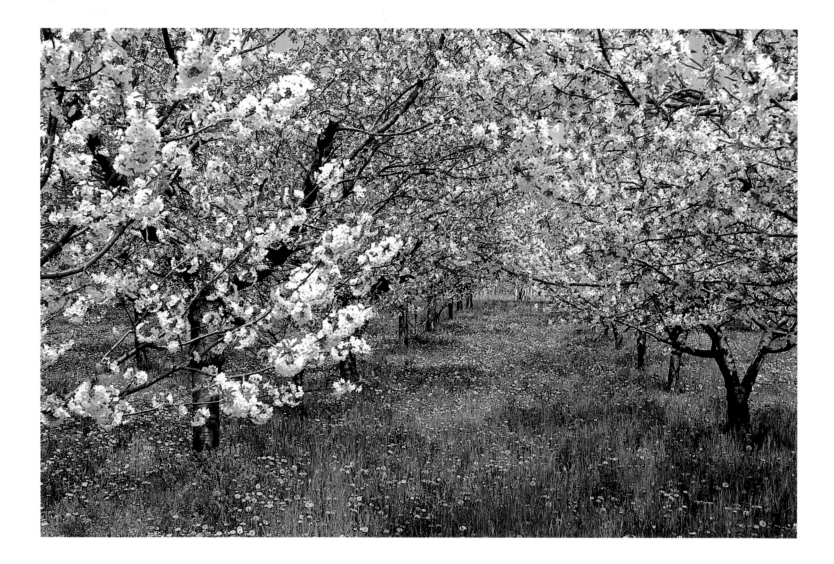

CARPET OF DANDELIONS BENEATH CHERRY TREES

◆ ◆ ◆

Negrar

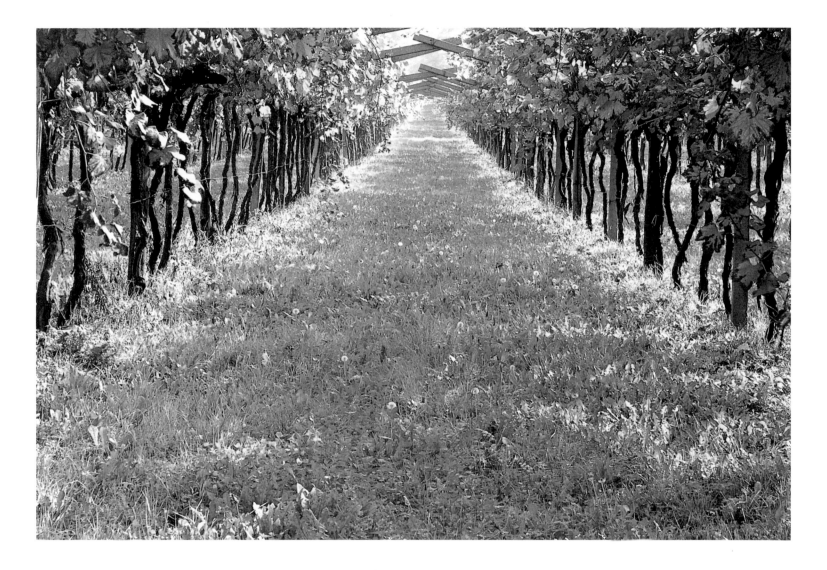

GRAPEVINES IN AUTUMN

◆ ◆ ◆

Valpolicella

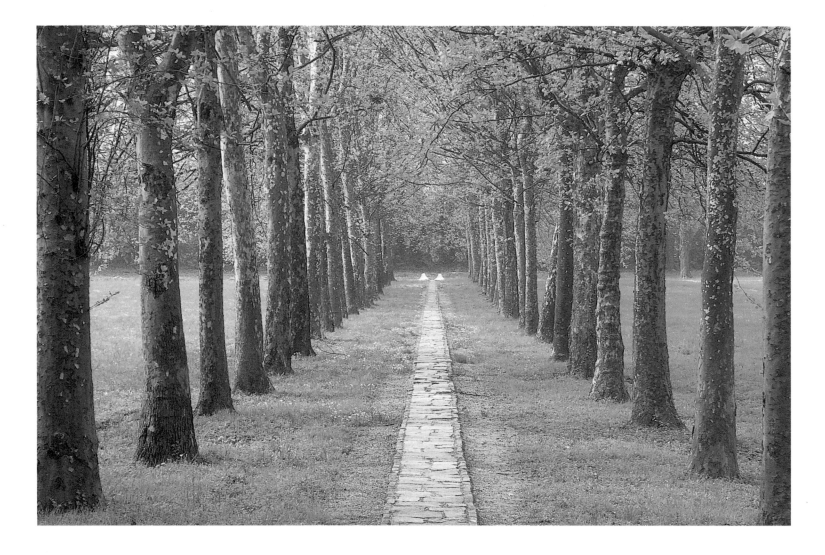

GARDEN OF VILLA FOSCARI,
"LA MALCONTENTA"

◆ ◆ ◆

Brenta Canal

OPPOSITE:

SPRINGTIME TREES

◆ ◆ ◆

Lake Garda

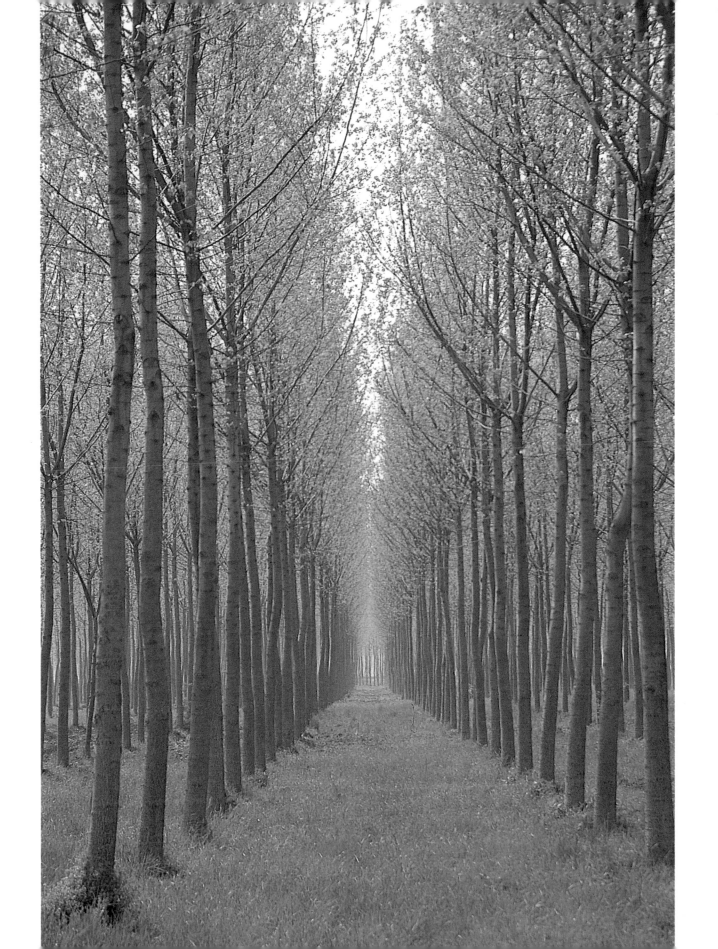

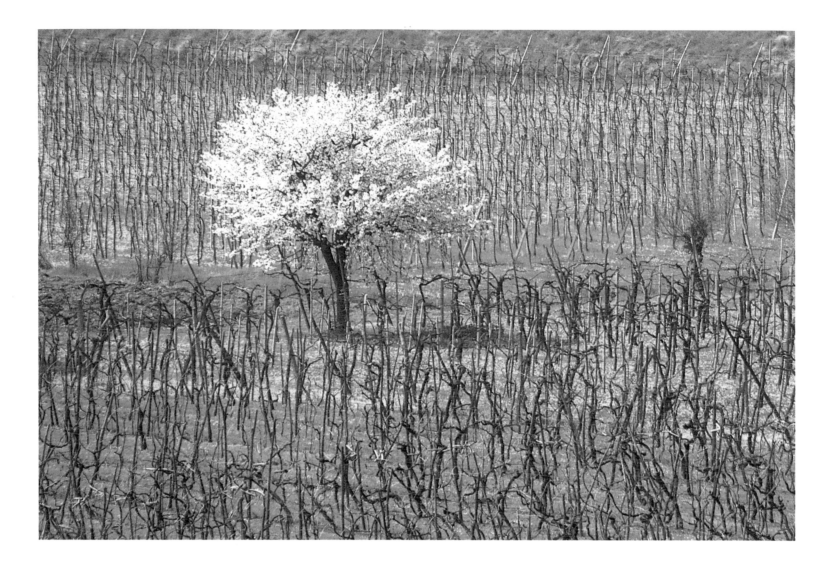

VINEYARD

◆ ◆ ◆

Soave

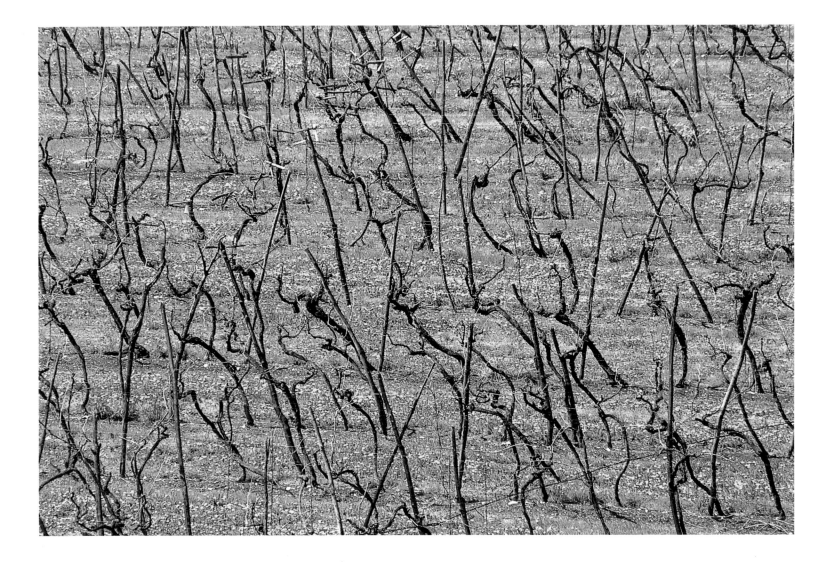

VINEYARD

◆ ◆ ◆

Soave

POLLARDED TREES
◆ ◆ ◆
Lake Garda

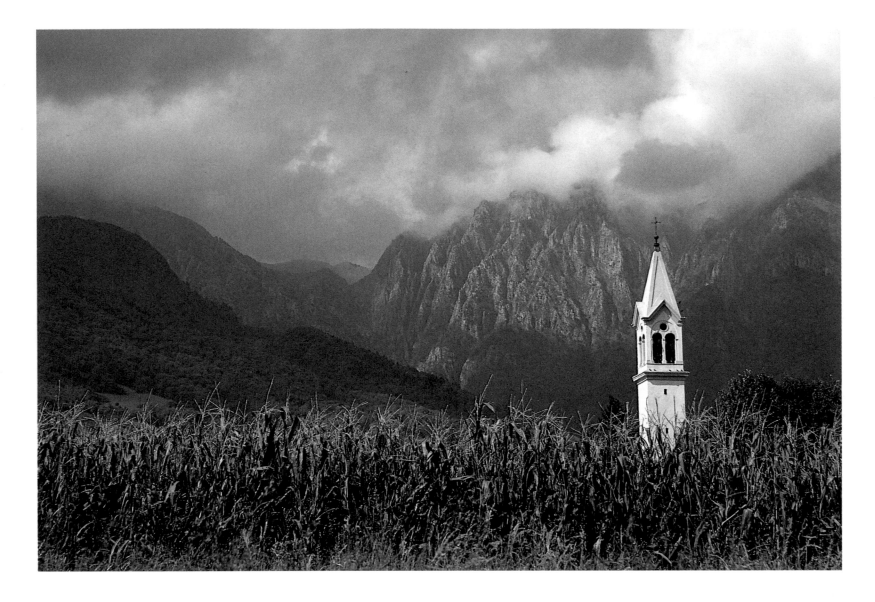

FIELD AT FIETTA–PADERNO

◆ ◆ ◆

Asolo

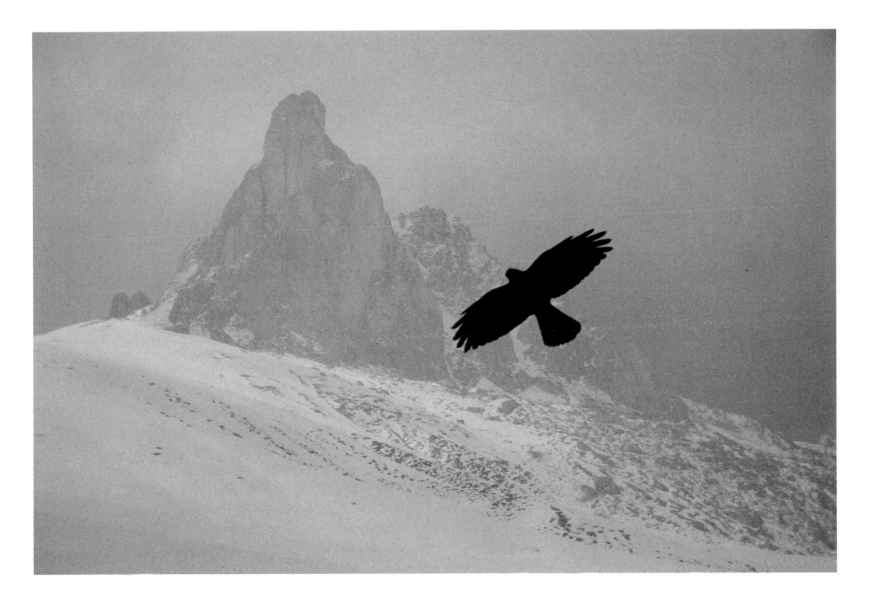

GIAU PASS NEAR CORTINA D'AMPEZZO

◆ ◆ ◆

The Dolomites

AFTERWORD AND ACKNOWLEDGMENTS

Venice is an improbable dream of haunting contradictions. It rises from the waters, and yet it is sinking. The ebb and flow of the sea give it life, yet threaten to destroy it. It was and is the crossroads of cultures and commerce, of East and West. While tourism supports it, tourism also overwhelms it. Venice is the world's ultimate outdoor and indoor museum. Perhaps the world will be wise enough to help preserve it, or perhaps some miracle will save it.

Our first glimpse of Venice, this improbable dream, was in 1962. Over the ensuing decades we have been drawn back many times—as if by a magnet—to La Serenissima. On these pages we present our tribute to this captivating city. We are thankful that Venice and the outlying region exist, as we truly love them.

◆ ◆ ◆

We would first like to thank Grace Mayer for the inspiration and joy of roaming through Venice with her. Thanks also to Bianca and Giovanni Gabbrielli for their special insight and to Diane and Mario Modestini for their many helpful hints. We appreciate the help and support of Edoardo Francati of ENIT New York and Cesare Battisti of ENIT Venice. A very special thanks to Giampaolo Padovan for giving us invaluable information and for making us feel at home in Venice as did Marina Cecchini.

We are grateful to our friends for their patience and advice, particularly to those at The IMAGE Bank; to Fran Ahders and Niki Jankulow; and to the many wonderful people we met in Venice and the Veneto: Lupi Assunta, Angelo Bianco, Dana and Tom Bulaty, Severino De Prieri and Silvano Balarin at the Cini Foundation; Conte Lodovico da Valmarana of the Villa La Rotonda in Vicenza; Roberto Corrado of Serego Alighieri in Valpolicella; Gabriele Carraro of the Hotel Burchiello; Saschka, Stephanie and Raphaella Hoffmann; Ziva Kraus; Katia Didona and Roberto Luison, Marinella De Moretto, and Mara Filippi in Bassano del Grappa; Sisto Menardi in Cortina d'Ampezzo; Mondo Novo Maschere's Giano Lovato, Giorgio Spiller, and Mariangela; Roberto Pilla, Licia Poletto, Anna Prosdocini, Joan Reifsnyder, Sottoprova of Via Garibaldi; Elda Tallin of San Gregorio nelle Alpi; Tullio Vallery; Adriana and Luciano Vistosi of Murano; Sonja and Michele Zanini; and the many other friendly Venetians who helped us understand the mazes of Venice and the Veneto.

And most of all special thanks are due to Bob Abrams for giving us the chance to realize our dream and letting us share *Venice and the Veneto* with others; to Susan Costello for being a great editor who once again guided us through the intricacies of putting this book together; to Nai Chang for his considerable creative input and patience; and to our other good friends at Abbeville Press: Abigail Asher, Mark Magowan, Marike Gauthier, Myrna Smoot, Patricia Fabricant, Lou Bilka, Vicki Russell, and Dorothy Gutterman.

Photographs are available from the Witkin Gallery, Inc., New York (212) 925-5510 and from Hunter Editions, Maine (888) 278-4747 (toll free).

SONJA BULLATY AND ANGELO LOMEO

INDEX

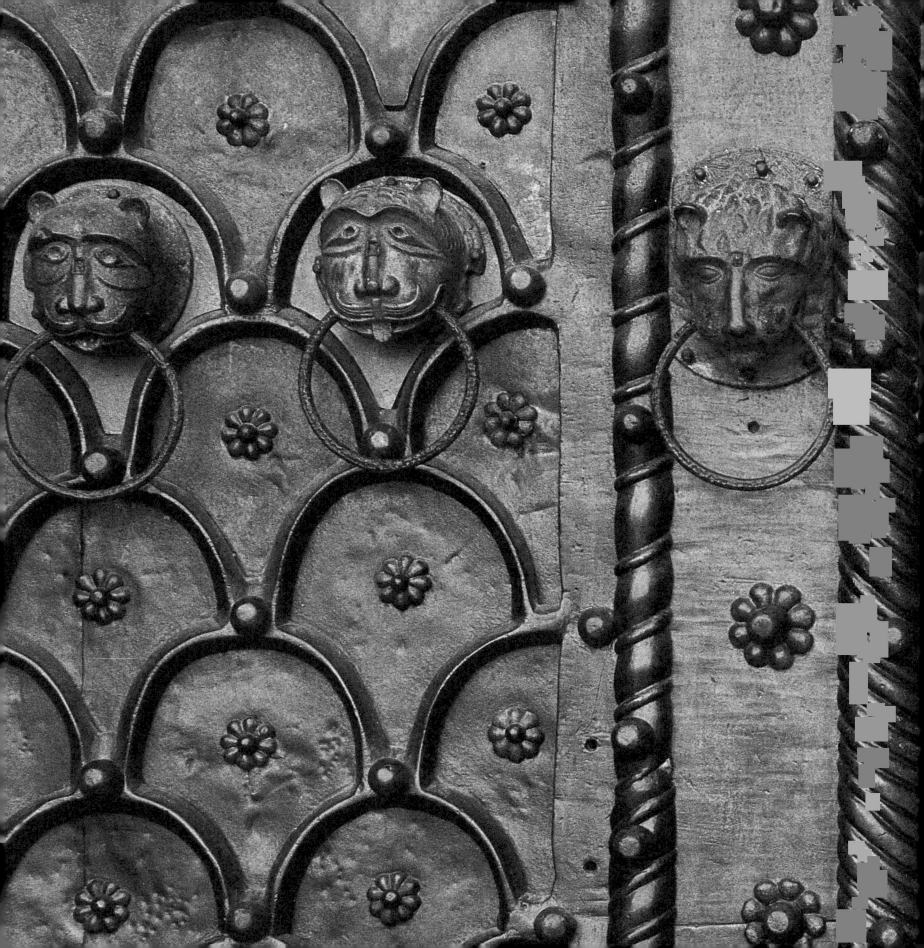